THE VIEW FROM THE TOP

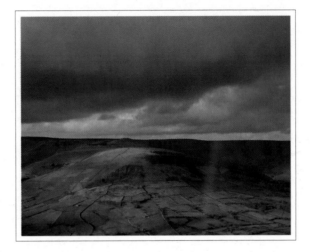

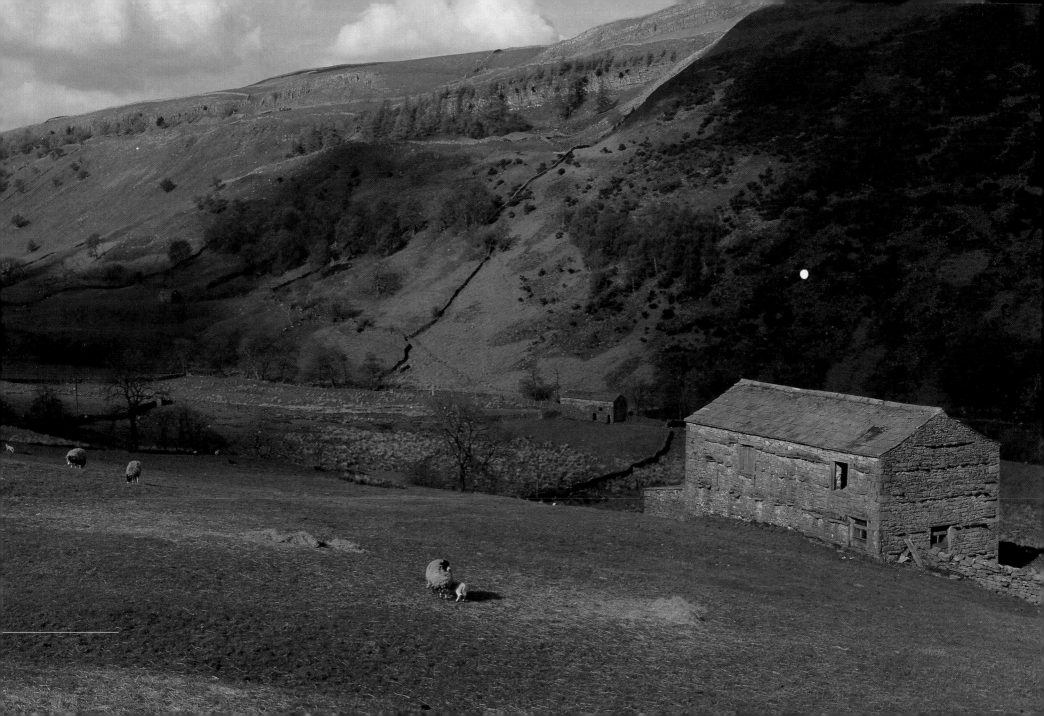

THE VIEW FROM THE TOP
A PANORAMIC PORTRAIT OF BRITISH LANDSCAPE

Richard Girling

WITH PHOTOGRAPHY BY PAUL BARKER

LITTLE, BROWN AND COMPANY
Boston · New York · Toronto · London

AUTHOR'S ACKNOWLEDGEMENTS

Nobody but me is responsible for the errors in this book. Many people, however, gave generously of their time and knowledge in helping me to keep the mistakes to a minimum. In particular I would like to offer my thanks to Brian Jackman, for his advice on Cornwall and Dorset, and to: Gillian Taylor, of the Dartmoor National Park Authority; Jos Joslin, of the Countryside Service, Oxford; Barbara Jones, of the Snowdonia National Park; Andrew Greenwood, of the Peak National Park; Peter Davies, of the Lake District National Park; Steve Hounsham, of the Yorkshire Dales National Park; Jackie Ellis, of Berwick-upon-Tweed Borough Council; Andy Walters, of Mid-Sussex District Council; Phil Belden, of the Sussex Downs Conservation Board; Roger Stevens, of the Brecon Beacons National Park; Peter Bryan and Robert Whitcomb, of the North York Moors National Park; Lucy Williams, of the Broads Authority; Stuart MacPherson, of the Aviemore & Spey Valley Tourist Board; and Christy MacKinnon of the Isle of Skye and SW Ross Tourist Board.

I must also thank Christine Walker, travel editor of the *Sunday Times*, in whose pages early versions of many of these pieces first appeared; Caroline McGhie for her sensitive midwifery of the infant text; my editors, Viv Bowler and Mari Roberts, for their hawk-eyed attention to detail; the designer, Andrew Barron, for bringing the book to life; and, most of all, to Paul Barker for the meticulous detailing of his landscape photography.

Page one: The view from Rushup Edge towards Edale Head, Peak District
Page two: Hooker Mill Scar, near Thwaite, Swaledale
Page six: Looking towards Aviemore from the Northern Corries, Cairn Gorm

A LITTLE BROWN BOOK

First published in Great Britain in 1997
by Little, Brown and Company (UK)

Text copyright © 1997 by Richard Girling
Photographs copyright © 1997 by Paul Barker

The rights of Richard Girling and Paul Barker to be identified as the author and photographer of this work have been asserted by them in accordance with the Copyright, Designs and Patents Act 1988

A CIP catalogue record for this book is available from the British Library

ISBN 0-316-87936-3

10 9 8 7 6 5 4 3 2 1

Designed by Andrew Barron and Collis Clements Associates
Printed and bound in Italy

UK companies, institutions and other organizations wishing to make bulk purchases of this or any book published by Little, Brown should contact their local bookshop or the Special Sales department at the address below. Telephone 0171 911 8000. Facsimile 0171 911 8100.

Little, Brown and Company (UK)
Brettenham House Lancaster Place London WC2E 7EN

CONTENTS

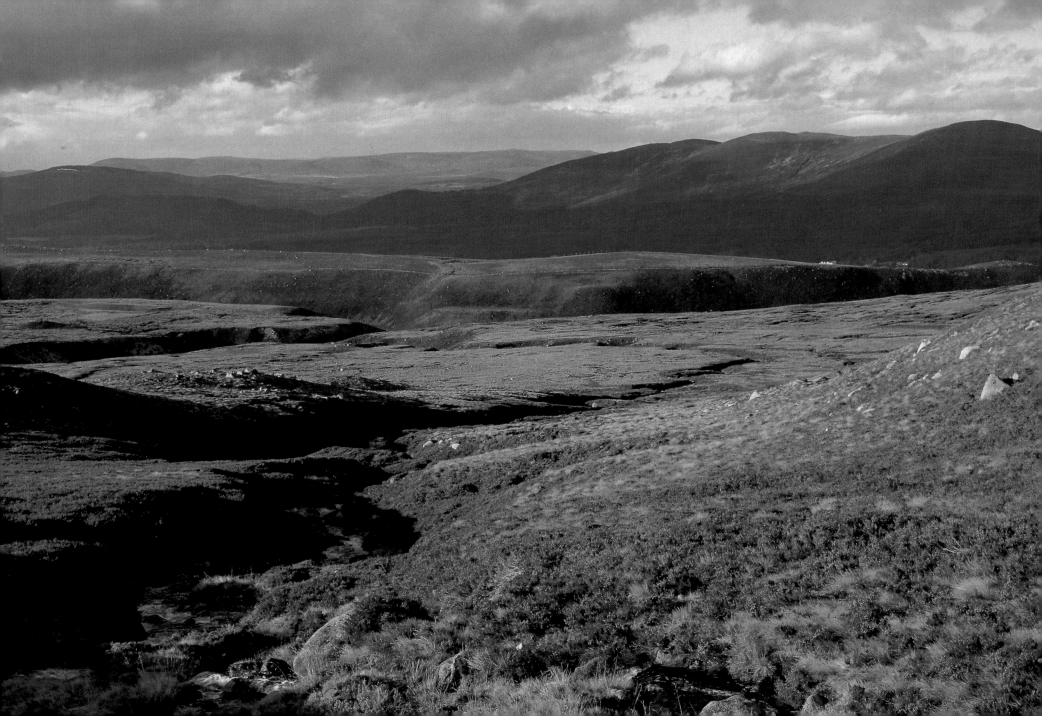

INTRODUCTION
This is not a Landscape

In the Los Angeles County Museum hangs one of the most commonly reproduced paintings of the twentieth century. *The Treason of Images*, by the Belgian Surrealist René Magritte, is often quoted as a kind of nutshell manifesto for modern art.

The image, painted with photographic realism, is of a gentleman's tobacco pipe, beneath which are written the words *Ceci n'est pas une pipe* – 'This is not a pipe'.

The fact that the original is very much larger than copies of it might suggest is not the only characteristic it shares with the landscapes in this book. A photograph, too, is a trick – no more a real landscape than a painting is literally what it depicts. *Ceci n'est pas un paysage*. It, too, is calculated to enchant and to deceive.

Also like a painting, however, a photograph can stimulate thought and provoke questions in ways which the familiar, living landscape itself often may not. Looking at a picture, even when it is one of Paul Barker's brilliantly observed panoramas, is no substitute for real exposure to a real landscape. Yet, like the best human portraiture, a landscape photograph can see through mere prettiness to the harder realities of age and character that lie beneath.

That Britain contains some of the best and most varied landscape in the world is a truism. That these landscapes are under pressure – from changes in agricultural practice, unsuitable development,

mineral extraction and the sheer weight and volume of people who want to see them – is a well-established *causus belli* for an army of conservation-minded campaigners who range all the way from officially funded quasi-governmental organizations to modern-day rural guerrillas cast in the mould of the Kinder Scout trespassers (see page 60).

From the perpendicular thrills of the Scottish Highlands to the improbable, anti-gravitational conjuring tricks of the Norfolk Broads, most of the landscapes described in this book enjoy a degree of legal protection. Many of them are within National Parks. Others are in designated Areas of Outstanding Natural Beauty, or contain National Nature Reserves or Sites of Special Scientific Interest. All are of a quality and importance sufficient to justify their inclusion in a selection, albeit a personal one, of 'the best'.

To this extent – and to this extent only – they are exceptional. Their shape and condition are matters of chance, depending on countless aeons of geological, climatic and historical accident. The same might be said of any patch of earth, rock, sand or concrete anywhere on the planet.

Their importance in catching the public eye is as ambassadors to a wider, more cynical world in which smaller, less exalted scraps of land or habitat are not always seen as having value. Yet it could be argued

that a forgotten fragment of wetland, ancient meadow or native woodland, beleaguered on the urban fringe, has a special value enhanced by its very rarity. Landscapes are much like buildings. They may be large or small, humble or majestic, deliberate or accidental in their charm. Like buildings, they are human creations made from the materials that nature provides, and they deserve to be respected and cherished in exactly the same way. If an ordinary vernacular cottage, in an ordinary village in Middle England, deserves the protection of the law, then so too does the land on which it stands.

Understanding the nature and history of the land is an important factor both in coming to value it properly and in drawing from it all the fascination, pleasure and fulfilment that it can offer. The purpose of this book, in the gentlest way possible, is to feed that fascination by telling the intimate life histories of fifteen of the best-loved landscape views in England, Scotland and Wales.

It does not pretend that the accurate naming of parts is essential to proper enjoyment or love of the landscape, or that the pleasures of a book are a serious rival to a walk in the hills.

Ceci n'est pas un paysage.

But if it makes you want to take a walk, and perhaps to look with a fresh or more wondering eye along the way, then it will have achieved all that its writer and photographer could have hoped for.

THE VIEW FROM HUNTER'S TOR, DARTMOOR

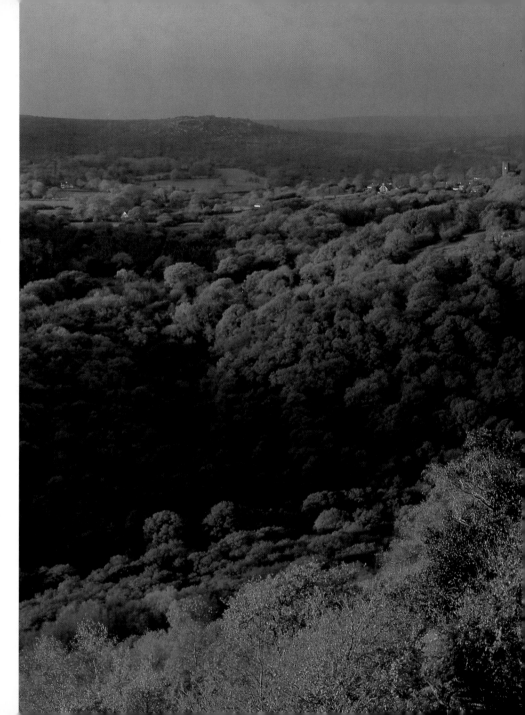

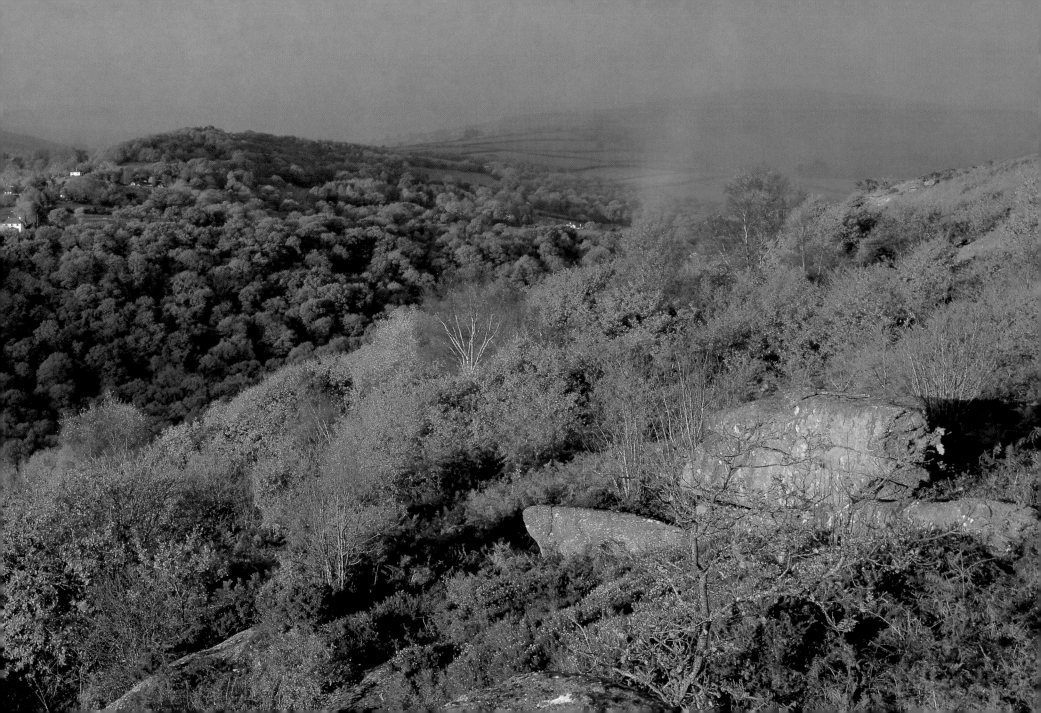

THE YORKSHIRE DALES
Swaledale

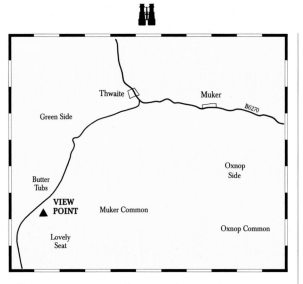

I T COULD BE nowhere else in the world. The colours may vary with the seasons, and the further hills may vanish in the rain, but everything about the view overleaf, photographed from the road above Thwaite, says Yorkshire Dales.

Ask a hundred *aficionados* of the Dales for the best view, and you risk getting a hundred different answers. Insist upon accessibility, however, plus a value-for-money concentration of scenic pleasures, then there is only one answer. It has to be Swaledale.

With this, as with any other ancient landscape whose hard edges have been blurred by time, there is a temptation to fall for what might be called the Creationist theory of landscape – the assumption that it is all of a piece, all made by the same people at the same time and with a unity of purpose. You might imagine, for example, that the field patterns came with the settlements, or that the water-scoured gashes on the valley slopes are themselves all as ancient as the hills. But it is not so. There is harmony, but it is the harmony of happy accident, like a dawn chorus; not the symphonic harmony of grand design.

This is limestone country, and it took a whole toolkit of elemental forces to make it. The hardest thing to imagine, as you lean into a bare-knuckled Pennine gale, is that 300 million years ago this was the

THE PANORAMIC VIEW OF SWALEDALE (OVERLEAF) OPENS UP AS YOU APPROACH THWAITE ON THE SCENIC ROAD FROM HAWES IN WENSLEYDALE. THE EXACT POINT IS JUST TO THE EAST OF THE ROAD, NEAR THE BUTTER TUBS AND BELOW LOVELY SEAT.

bed of a teeming tropical sea. Yet it is to the billions of marine animals which lived in it that the Dales owes its greatest debt. The calcareous remains of their bodies, compressed one upon another, layer after layer, were the very substance of the forming limestone. On top of this were dumped river-borne deposits of sandstones, shales, grits and more layers of limestone, the whole of which was later fractured and

uplifted in a sequence of shattering earth movements to form the hard keel of the Pennines.

Next you have to imagine the whole thing bound in ice. If earth and sea were the hammer and nails, it was the ice – and the rivers it left behind it – that were chisel and plane. There were times during the various freezes when the glaciers may have been over 3000 feet thick. This is not easy to visualize, though your imagination does at least get a little prompting from what you can see. The steep sides and flat bottoms of the valleys are the classic telltales of glacial erosion. Classic, too, are the long scars gouged by the ice and subsequent rivers along the valley walls. Clear examples, typical of the Dales, can be seen on the far side of the valley near the centre of the panorama overleaf.

The key to understanding the inner mechanisms of the Dales is knowing that limestone slowly dissolves in water. The action of water cutting into stone has created three more of Yorkshire's signature landscape features – the flat-topped, deeply creviced limestone pavements, some of them on ice-scalped hilltops (the one at Malham Cove is the most famous); the many dramatic waterfalls, and the cheese-mite warrens of caves and potholes.

After chisel and plane came the axe. Man seems to

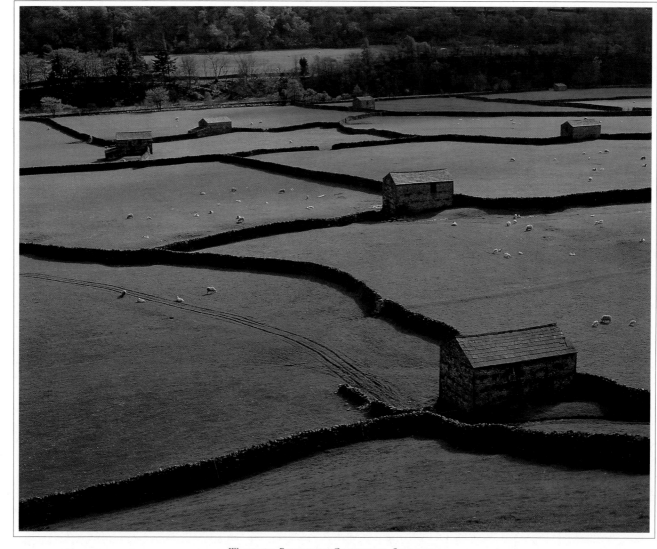

WALLS AND BARNS NEAR GUNNERSIDE, SWALEDALE

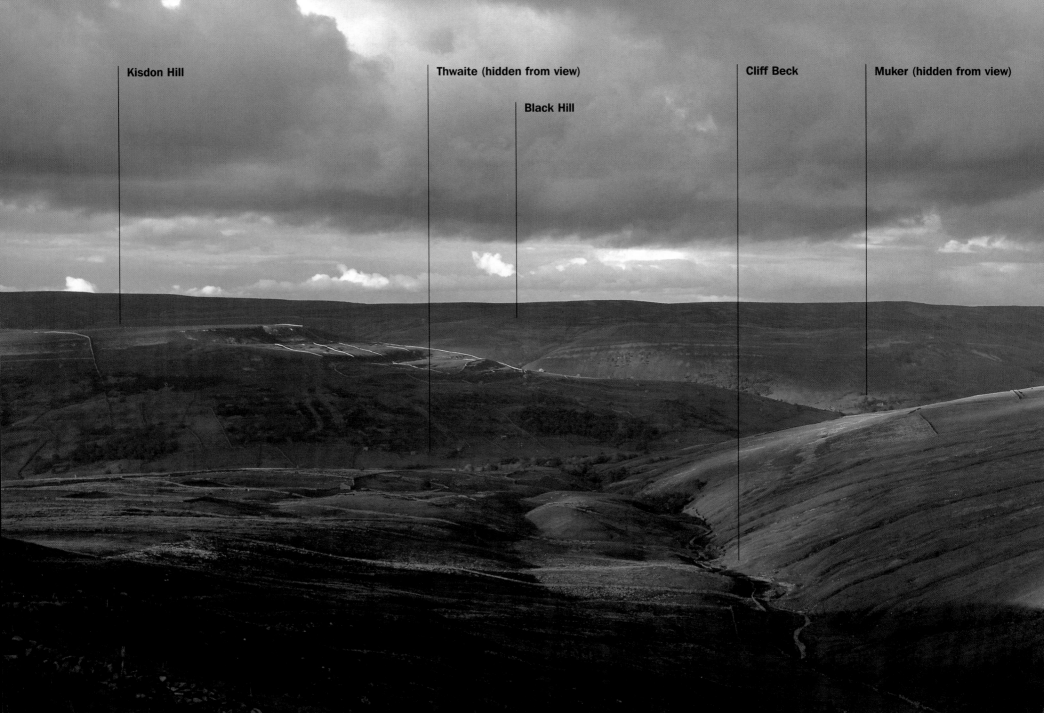

Kisdon Hill

Thwaite (hidden from view)

Black Hill

Cliff Beck

Muker (hidden from view)

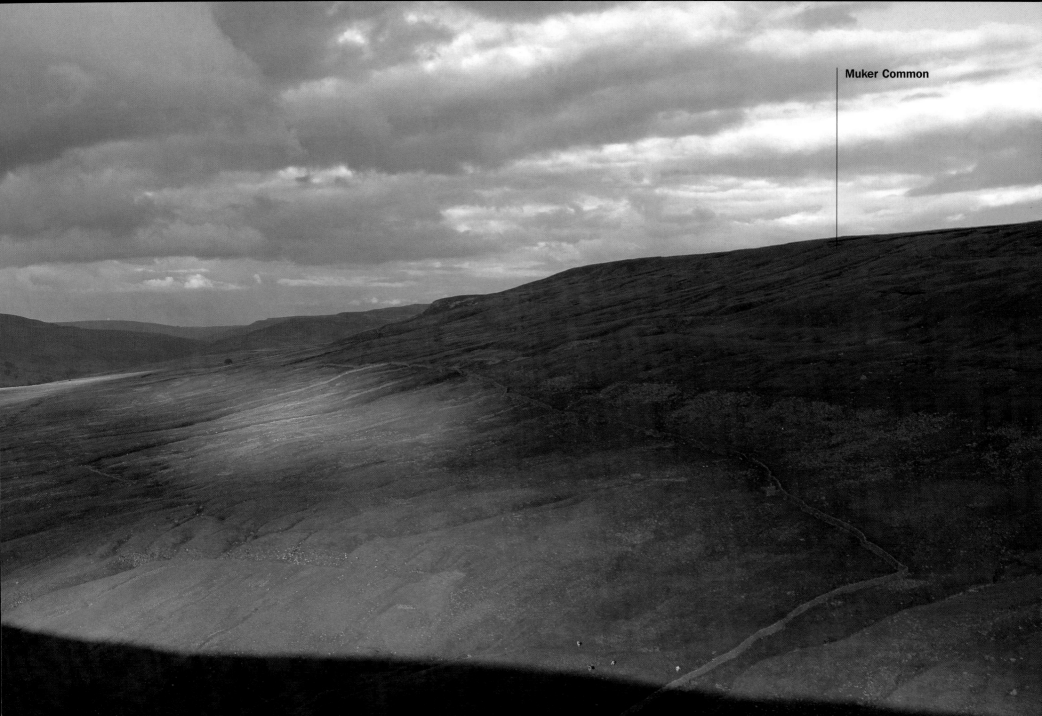

Muker Common

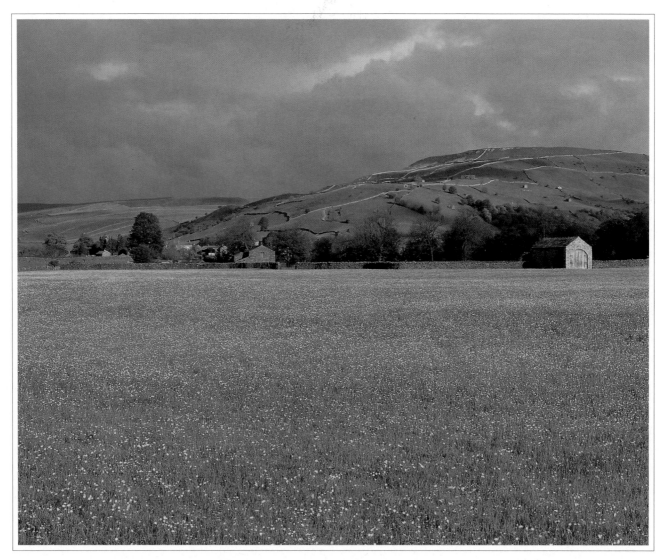

DALES CLASSIC – BUTTERCUP MEADOW NEAR MUKER

have made an early entrance to the Dales, at the end of the Ice Age in around 10,000 BC (relics from this period have been found in Victoria Cave at Langcliffe in Ribblesdale). Farming probably arrived with the first few Neolithic settlers in around 3000 BC. Bronze- and Iron-Age settlements followed, leaving fairly plentiful remains in Wensleydale and Wharfedale and in the hillfort at Ingleborough – the hillfort is a rarity for Yorkshire but, at 2,373ft (723m), it is one of the highest in Britain. The Iron-Age Brigantes tribe are said to have defended it successfully against the Romans, though their victory seems to have been less than complete. The Romans kept a garrison in Wensleydale, Swaledale's larger neighbour, for more than three centuries.

The settlement patterns of the upper dales, however, were not established until much later. The clues are in the placenames. Angles and Danes settled the broader, gentler, lower river valleys from the seventh century, and left their imprint on villages suffixed with *-by*, *-ley*, *-thorpe*, *-ton* and *-ham*. Up here where the wind blows hardest, however, it was the Norsemen who made their mark. They came via Ireland and the Lake District in the tenth century,

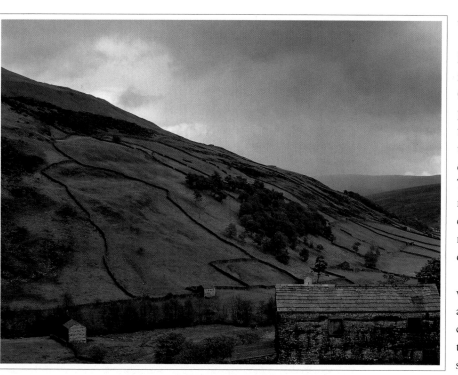

THE VIEW FROM THWAITE TOWARDS MUKER

bringing with them a tradition of pastoral farming and finding in the wildness of places like upper Swaledale a raw echo of their native Scandinavia. A whole litany of local names and terms survives as their memorial: *beck*, *clint*, *crag*, *fell*, *foss*, *gill*, *mere*, *scar*, *tarn*. The dale to the left of the panorama conceals the village of Thwaite – a Norse word, common also as a suffix, which means 'clearing'. The

word 'dale' itself is Norse for 'valley'.

For the Normans, the dales meant hunting country. For the monastic foundations – Augustinians and Cistercians – who inherited this particular corner of the earth in the twelfth century (and who kept it until the Dissolution of the Monasteries four centuries later), it meant rather more. They it was who set the agenda for much of what you see today – the endless skeins of dry-walled fields, the routes of lanes and tracks, the crystalline understanding of sheep.

In every material way, Swaledale as we now see it was fully fashioned by around the middle of the nineteenth century. Yeoman farmers had put up their stocky, stone-built farmhouses, spun hundreds of miles of walling along the lower slopes, and sprinkled the valleys with the stone field-barns that are, above all else, the defining feature of the Yorkshire Dales farmed landscape.

Their function was to provide winter shelter for young cattle, whose hay was stored in the lofts above. Many now have fallen derelict, but the Yorkshire Dales National Park Authority is offering grants for farmers to conserve them. In some places they have been converted into homes, or into bunkhouse

accommodation for visitors. The inseparable companion to the working barn was the hay meadow, of which there are still some spectacular survivals. Some of the best are at Muker, a small village hidden in the dale to the right of the panorama. Before mowing in July, they show a prodigious variety of wild flowers and grasses.

Like its neighbours, Thwaite and Gunnerside, Muker earned much of its living in the nineteenth century from the mining of lead. One of the best places to see the relics of Swaledale's industrial past is in the remote beauty of Gunnerside Gill (off the picture to the right), where you will find spoil heaps, ruined mine buildings, the entrances to old shafts – and the answer to a landscape puzzle. Most of the scarring on valley walls can be explained by glacial action, but not the strangely *vertical* gashes often seen in upper Swaledale. These are man-made – the result of repeatedly washing, or 'hushing', the hillside to uncover veins of lead.

Swaledale could once provide its own coal, too, and the pit at Tan Hill remained in production until the 1930s. Tan Hill now is chiefly known for its inn – on the Pennine Way beyond Stonesdale Moor, a four-mile hike from Keld – which is indisputably one of the remotest, and possibly the highest, in the whole of Britain.

WALLED FIELDSCAPE NEAR GUNNERSIDE VILLAGE

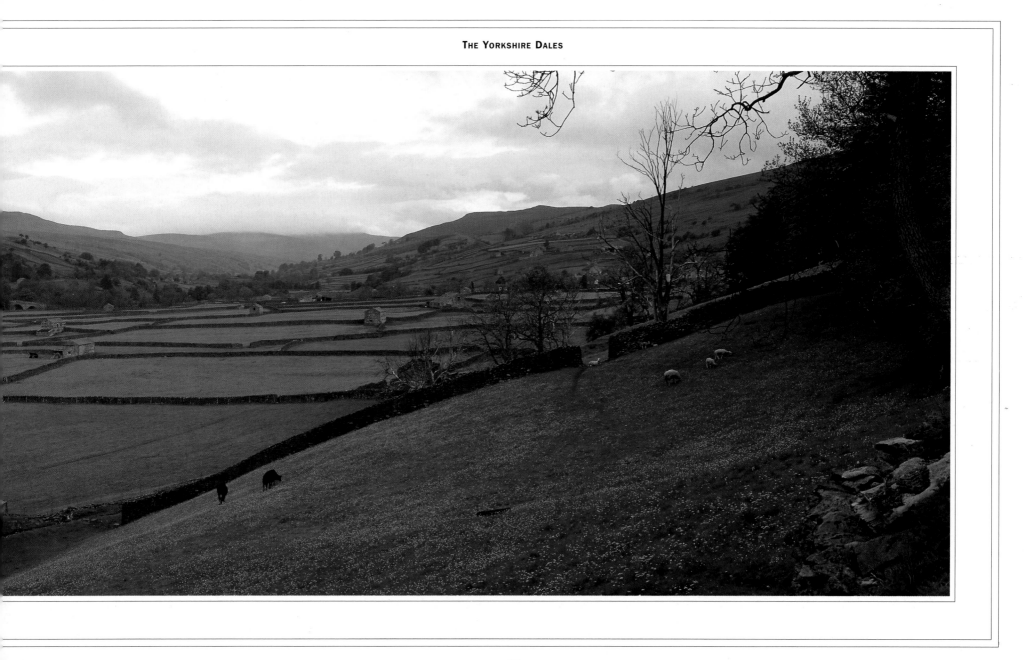

DARTMOOR
Hound Tor

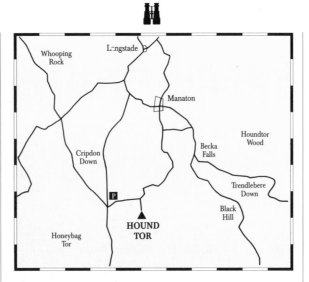

THE PANORAMIC VIEW (OVERLEAF) WAS TAKEN FROM HOUND TOR ROCKS, LOOKING NORTH-WEST. THERE IS A LARGE CAR PARK BELOW THE TOR, WHICH MAY BE APPROACHED FROM BOVEY TRACEY, WIDECOMBE OR MANATON.

DESPITE ALL THE car parks, cream teas and Uncle Tom Cobleigh, Dartmoor could never be called effete. It is, however, secretive and often miserly with its charms.

Its horizons are typically draped in mist, or in the thin rain which it seems able to call down even on days when the nearby coast is grilling under a naked sun. When Atlantic weather systems approach from the west, Dartmoor is the first high ground they hit.

For romantics it has never quite had the siren appeal of the Lakes or the bare-knuckle, knockout punch of the Highlands. And yet, when the veil is lifted and the hinted distance hardens into detail, Dartmoor provides one of the finest and most absorbing landscapes, not just in Britain but in Europe.

For all its popularity, and the 'facilities' that have attached themselves to it, any idea of tameness is dangerously misplaced. Only a century ago, the landscape in the picture was a man-killer. To the north and west, where the hills are bare, far from any road and booby-trapped with bog, it can still pass stiff judgements on those who take it lightly.

Dartmoor's origins are as violent as its hilltops are distorted. What you are standing on is an immense geological pustule, literally an eruption through the skin of the planet. Three million years ago, magma boiling up from the core of the earth pressurized the surface rock until it quaked and bulged. When the magma cooled it formed crystals of quartz, feldspar and mica – the mix we now call granite – and three thousand millennia of Dartmoor weather have done the rest. The softer over-layers have worn down until, on the high tops, the *granite* stuffing is all that's left, like springs sticking out of a broken sofa. The resulting megaliths, snagged and irreducible, have created a unique landscape which invades the imaginations of painters, writers and film-makers, in whose language the hyperbole has tended to boil over like the magma itself. The local name for these darkly suggestive spires is, appropriately enough, the Celtic one: *tor*.

From Hay Tor on a clear day you can see far out to sea. Torbay, enclosing the modern resorts of Paignton and Torquay, was first occupied by cave-dwelling men as long ago as 10,000 BC (in the spirit of the many centuries of hardship to come, they had to compete for shelter with hyenas). In the panorama overleaf you can see a long ridge called Hamel Down, along which are a line of blips like nipples on the belly of a slumbering pig. These are Bronze Age cairns, or burial mounds, which once would have contained the cremated remains of tribal elders. Inside them were found flakes of flint and, in the richest of the finds, a bronze dagger with a gold-inlaid amber handle.

This is the great contradiction of the Bronze Age people. Average temperatures in their lifetimes were perhaps two degrees centigrade higher than they are now, but still their dwelling sites on exposed windward slopes suggest an almost foolhardy

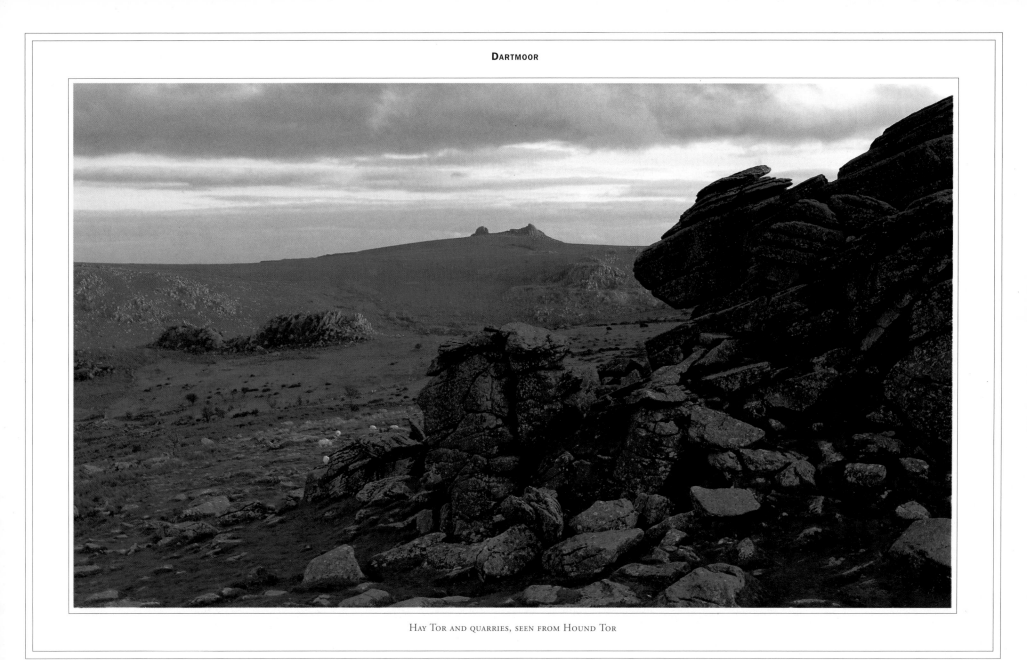

HAY TOR AND QUARRIES, SEEN FROM HOUND TOR

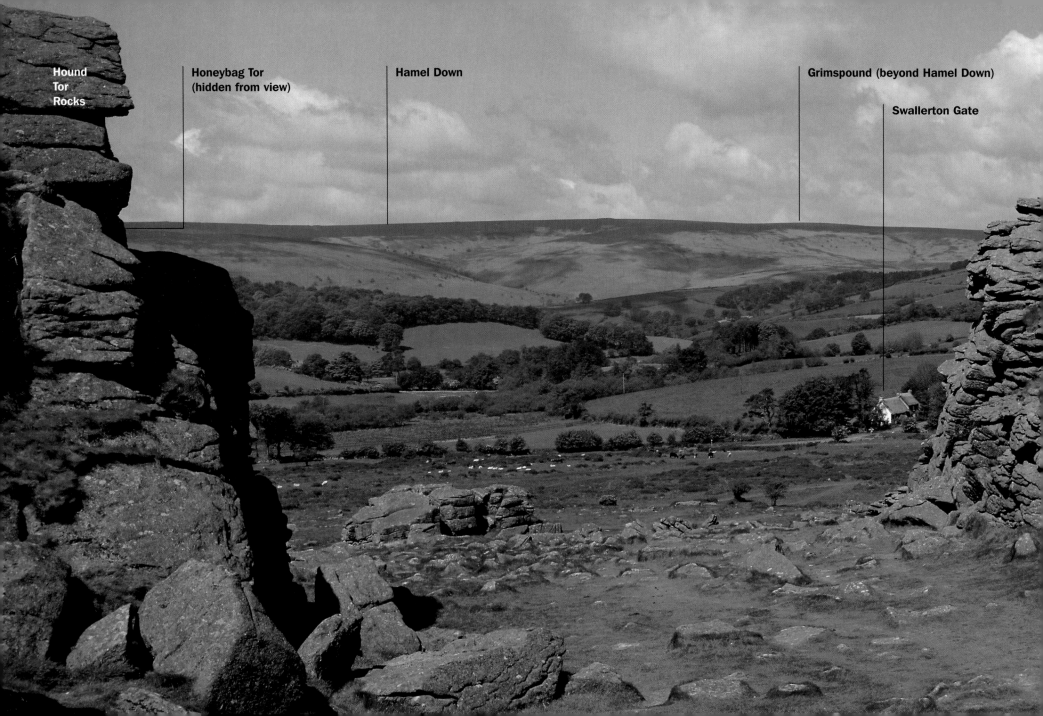

Hound
Tor
Rocks

Honeybag Tor
(hidden from view)

Hamel Down

Grimspound (beyond Hamel Down)

Swallerton Gate

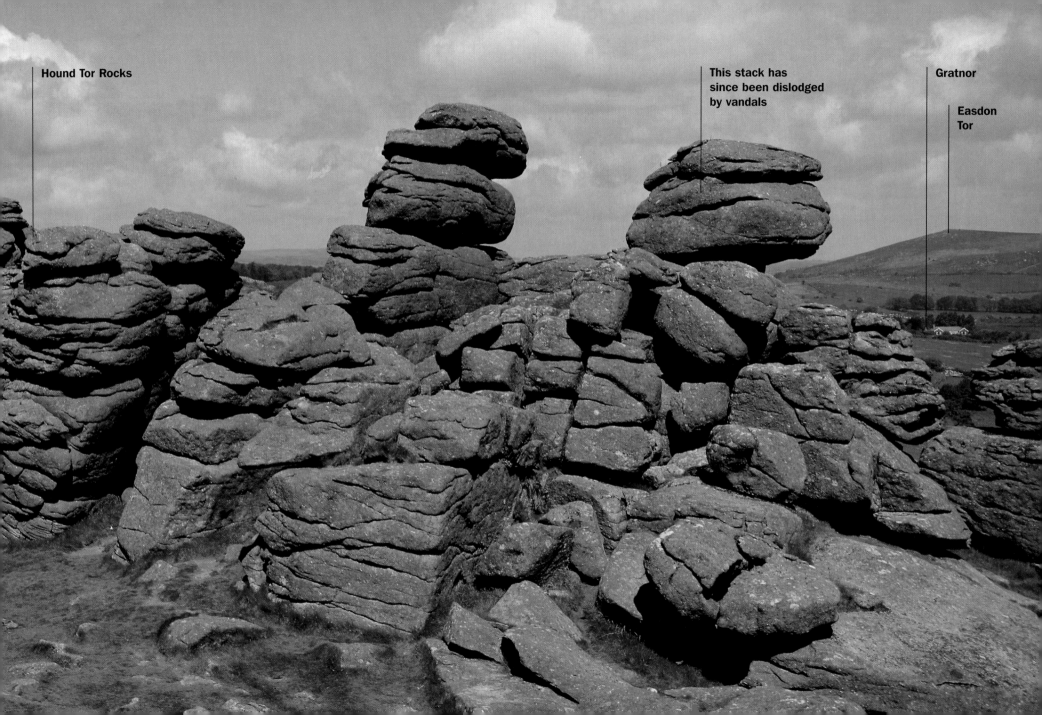

Hound Tor Rocks

This stack has since been dislodged by vandals

Gratnor

Easdon Tor

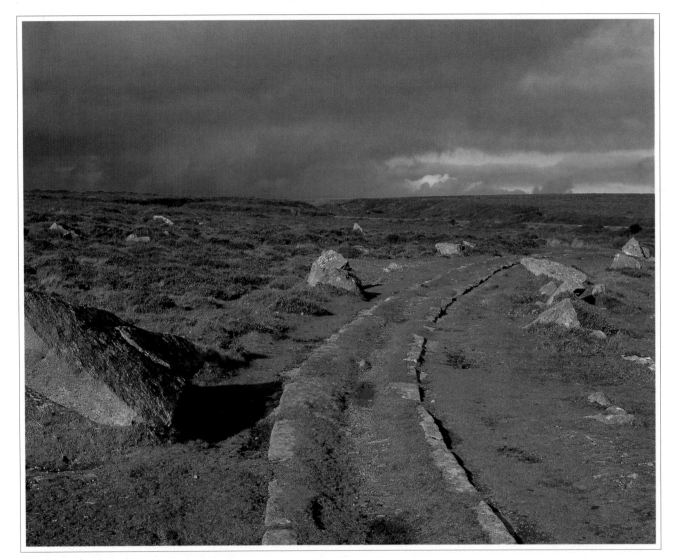

A SECTION OF THE HAY TOR GRANITE TRAMWAY

determination to endure the unendurable. And yet, for all this, they seem to have had exquisite industrial skills and an apparently sophisticated and far-reaching system of trade.

The moor is cluttered with their remains. The best and most evocative of them is a manageable walk, only a little under three miles, from Hound Tor. Just below the northern end of Hamel Down is Grimspound – a walled enclosure of some four acres, containing the stone footings of twenty-four circular huts. Inside these are hearths and cooking holes, and, in some of them, raised platforms which may have been used as sitting places or beds. Here you may lie and imagine, as your skin tightens in the cold, what the life of a Bronze Age villager might have been like.

The roof over your head would have been conical, made of thatch and turf on a branchwood frame. You would have had a fire, and you might have deflected the wind with a canopy over the porch. Beyond that, your only comforts would have been the security of the outer village wall (9 feet thick, 6 feet high), the fecundity of yourself and of your flocks, and the stream just down the hill.

Many of the Bronze Age sites on Dartmoor were so physically unwelcoming – and they became even more unwelcoming as the weather gradually worsened – that they have never been inhabited since. If the Romans ever came here they left no relics, and one can easily imagine the Emperor-to-be, Vespasian, at the head of his legion in 53 AD, perhaps reaching the crest of Haldon Hill, spying the wilderness beyond and deciding that enough was enough.

The oldest inhabited buildings on Dartmoor are the stone longhouses, dating from around the end of the fifteenth century. Originally these were single-storey buildings with human accommodation at one end and a cattle byre, or 'shippen', at the other (though in later buildings there may have been an attic at the family end for sleeping). Like all vernacular houses they have a structural simplicity which, in obedience to the natural laws of the material from which they were built, imposes a harmony of proportion, fabric and scale that no over-engineered, rule-inhibited modern design can equal. Simple, however, is not the same as easy. If you doubt the ingenuity of medieval builders, just look at the size of some of the granite rocks they managed to incorporate within the farmhouse walls.

For true devil-with-hardship romance, however, one must look, as so often, to the Victorians. In the picture opposite, taken just below Hay Tor, you will see the remains of a quarry, with the line of a roadway meeting it along a terrace. This is no mere bridlepath or tinker's trail, but the remains of one of Dartmoor's most extraordinary industrial achievements – the Haytor granite tramway. It was a perfect, functioning railway system, complete with sidings, branchlines and points, in which the rails were made of the very material they were designed to carry: granite. The line took stone on horse-drawn trucks seven miles to the Stover canal at Teigngrace, whence it found its way by barge up the Teign estuary to Teignmouth, and then by coaster to London. By this heroic route went granite for the rebuilding of London Bridge in 1825, and for parts of the National Gallery and British Museum.

The line opened in 1820 with a day of feasting and dancing on Haytor Down, but it all ended in tears in 1858 when the company spiralled into insolvency. Other local industries similarly vanished after their Victorian heyday: iron, lead, tin, silver, manganese and lignite all once lured men to take their chances in these inhospitable hills. The two industries that survive are the oldest and the newest. Sheep still run on the hills as they have always done, but increasingly the herds that count are those who flock by car and coach from all over England and beyond.

Dartmoor still offers the assurance of solitude, and very likely it always will; but more than ever it is a privilege reserved for those who have not forgotten nature's purpose in giving them legs.

OVERLEAF:
BECKA BROOK, NEAR BECKA FALLS, MANATON

Burgh Castle and How Hill

NORFOLK, PEOPLE KEEP saying, is an acquired taste. This may be so, but then fine Burgundy and Roquefort cheese are acquired tastes too. The best things always are.

Forget about flatness – or, at least, forget about it as an inhibitor of interest or pleasure in the landscape. There is as much drama in distance as there is in height, and there is the advantage that you don't have to climb too far to find a view. If you want a vantage point in the Broads, all you have to do is stand up.

It is, in many instances, a landscape of illusion: of boats sailing in the air, and of solid ground fretsawed by water into the kind of interlocking geometrical puzzle that might drive a sane man mad. Relationships, of one landmark with another, are seldom what they seem.

The photograph opposite was taken looking approximately north-west from the Roman fort of Gariannonum at Burgh Castle, just west of Great Yarmouth. This is by no means the 'prettiest', or most postcardy, part of the Broads (for that, stay north of Acle), but it is its historic essence, and its heart.

Why did the Romans build a castle here? Because in the third century Gariannonum stood in command not over marsh or grazing meadow, but over the North Sea. The flat country in the photograph then

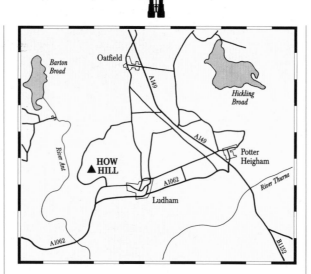

THE VIEW OF TURF FEN WINDPUMP (OVERLEAF) WAS TAKEN FROM HOW HILL, ON THE RIVER ANT, WHERE THERE IS A LARGE CAR PARK. HOW HILL IS ACCESSIBLE FROM THE A1062 (HORNING–POTTER HEIGHAM) OR A149 (POTTER HEIGHAM–STALHAM) ROADS. TO FIND THE PRECISE SPOT ON FOOT, TURN LEFT (SOUTH) ALONG THE RIVER BANK AT TOAD HOLE COTTAGE, THEN FOLLOW THE DYKE ON THE LEFT. BY BOAT, HOW HILL IS A SHORT CRUISE FROM HORNING, LUDHAM, POTTER HEIGHAM OR STALHAM.

was seabed, and contained the estuaries of three rivers – the Bure, the Yare and the Waveney. To fully appreciate the scale of the endeavour needed to transform it, you have only to look at a map. What

you see, following broad swathes inland along the courses of all three rivers, looks much like the crazed surface of an oil painting. The design may be pleasingly asymmetrical, but random it is not – for this is the pattern of drainage dykes begun in the thirteenth and fourteenth centuries to claim the land for agriculture. Everything else you can now see – every stick and stone of it – stems from this event.

What looks like dry land is kept dry only by these dykes, and to attempt a stroll through the 'meadows' is to find yourself quickly lost amid a water maze in which every field is an island. The first mistake is to suppose that the land has remained at sea level since it was drained. In fact it is *lower* than the sea, as a result of shrinkage when it dried. The classic Broadland illusion, therefore, of boats sailing above the land, is no illusion at all. The riverbanks were built up to prevent flooding, with the result that in many places the water really is higher than the marsh.

This, of course, presents a further problem, for how do you drain a dyke uphill? The answer, supplied in the seventeenth century, is the explanation for the extraordinary number of windmills that can be seen throughout the Broads – whole rows of them in some places, like Don Quixote's giants. In fact they are not mills at all but wind*pumps*, designed to turn scoop-

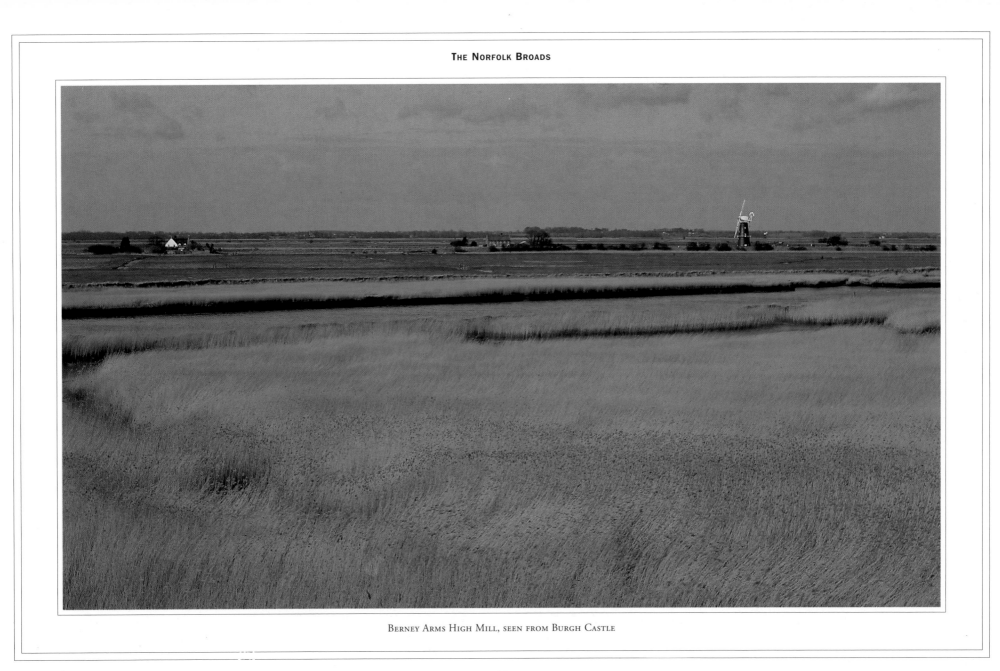

Berney Arms High Mill, seen from Burgh Castle

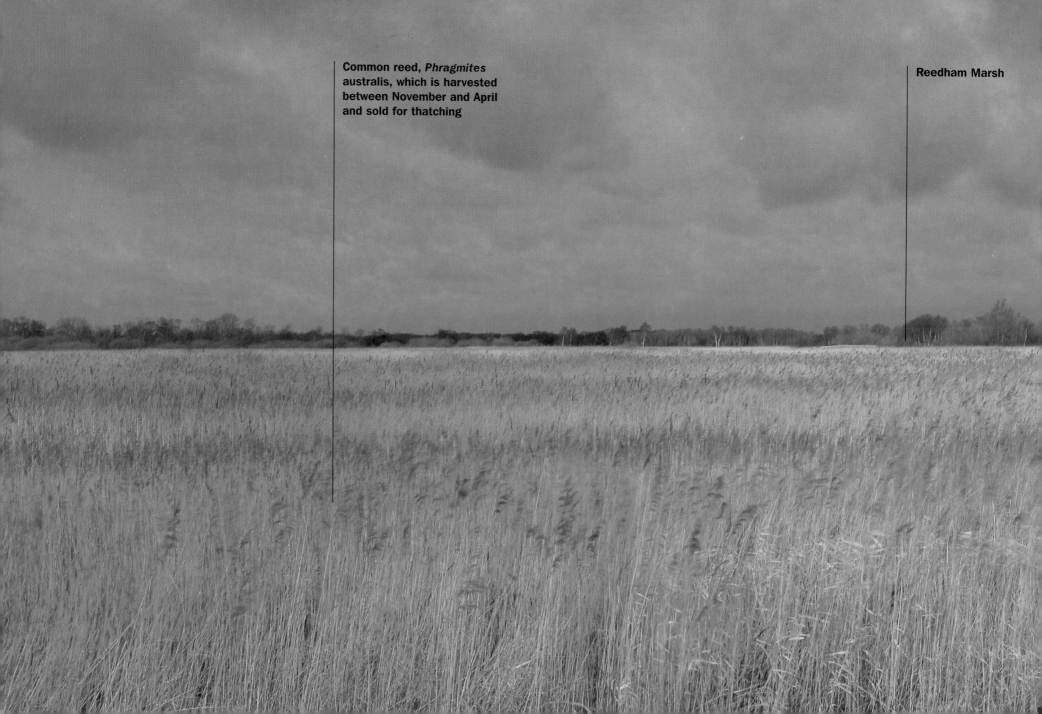

Common reed, *Phragmites australis*, which is harvested between November and April and sold for thatching

Reedham Marsh

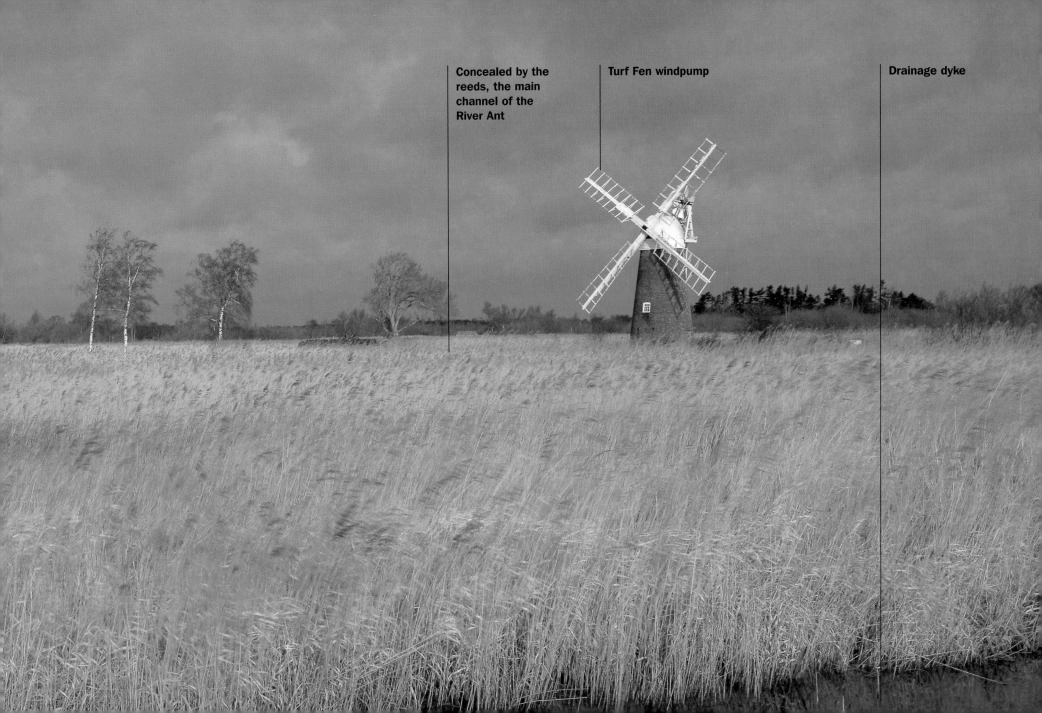

Concealed by the reeds, the main channel of the River Ant

Turf Fen windpump

Drainage dyke

wheels and lift the water from the dykes up into the rivers. The job today is done mainly by diesel or electric pumps, but many of the old ones have been handsomely restored as landmarks by the Norfolk Mills and Pumps Trust.

The example to the right of the photograph on page 27 is one of the most famous – Berney Arms High Mill – which is the tallest in Britain. Other than by boat, the easiest way to reach it is by means of another superlative, England's smallest railway station. This is Berney Arms Halt, on the Norwich-Great Yarmouth line, hidden in the picture just behind the mill.

The grazing marshes are the classic Broadland farmed landscape, supporting both sheep and suckler beef herds. Their future at one time was threatened by EC incentives for farmers to convert to cereals, but they were saved in the mid-1980s by subsidies introduced as part of a conservation scheme set up by the Broads Authority and the Ministry of Agriculture.

Their value, both as landscape history and as habitat, is incalculable. Many rare plants continue to flourish in the drainage dykes, including the bizarre, rootless bladderwort, which uses its floating bladders to trap the small insects on which it feeds. Like all

CHURCH OF ST PETER AND ST PAUL, BURGH CASTLE

wetlands, Broadland is an important habitat for insects and birds, and a large area behind the railway line, to the right of Berney Arms High Mill in the picture, is maintained by the RSPB as a nature reserve. It is one of a large number of publicly accessible reserves, including every variety of wetland habitat, within the Broadland area.

The river closest to the camera is the Waveney, which arrives from the south by way of an extravagant loop taking in the Suffolk towns of Bungay and Beccles, and feeding the seething waters of Oulton Broad at Lowestoft. Beyond it, just in front of the windpump, lies the converging River Yare, which connects Great Yarmouth westward to Norwich. Both rivers drain into Breydon Water, just off the picture to the right – the last remains of the once-great estuary which the Romans were so determined to protect.

The deeper vegetation along the riverbank is reed, which elsewhere in Broadland is still cut in winter for thatching – another ancient practice essential for the healthy maintenance of the fens. If reed and sedge are not cut, the ground soon chokes and reverts to scrub. The reedbeds also give the landscape its seasonal colour-wash: meadow-green in summer, chaff-coloured in autumn and winter, when they make an almost theatrical counterpoint to the apocalyptic, storm-filled skies.

The other classic form of Broadland vegetation is alder carr: swampy areas of alder, sallow and birch, with mud in some places deep enough to drown in. To see this, follow the Waveney south and west to

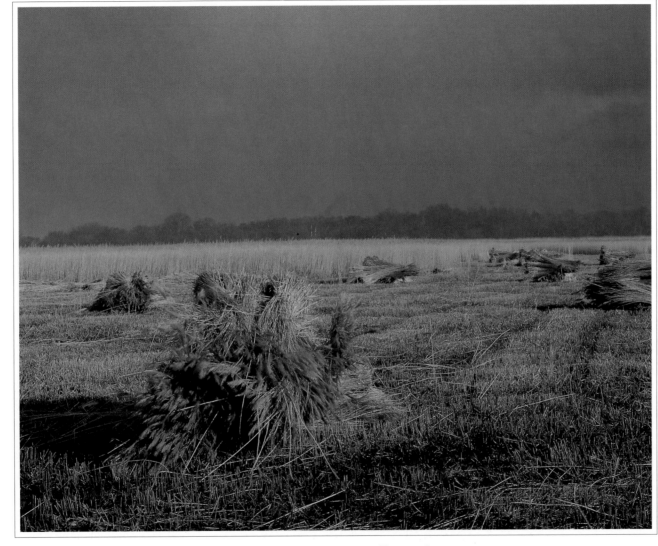

Norfolk reed cut for thatching, Hickling Broad

Beccles, or – perhaps best of all – explore the River Bure between Salhouse and Ranworth Broads. (The confluence of the Bure with the River Ant is only a couple of miles from How Hill, where the panorama was taken.)

The Broads themselves, as every schoolchild must know, are medieval peat-diggings flooded by rising sea levels and fed by a system of five rivers – the Bure, Ant, Thurne, Yare and Waveney – which drain most of Norfolk and North Suffolk. There is a total of 125 miles of navigable water, whose popularity with holidaymakers has combined with problems of pollution by sewage and agro-chemicals to land the Broads Authority, English Nature and the National Rivers Authority with an unenviable sequence of environmental headaches.

These they have tackled with courage and imagination – sucking out thousands of tons of polluted mud, clearing and reinvigorating moribund fens, reinforcing wash-damaged banks. Much remains to be done, but Broadland today – protected in all but name by National Park status – is far from the lifeless sump which, even ten years ago, many commentators were predicting.

THE RIVER ANT, NEAR HOW HILL, AT SUNSET

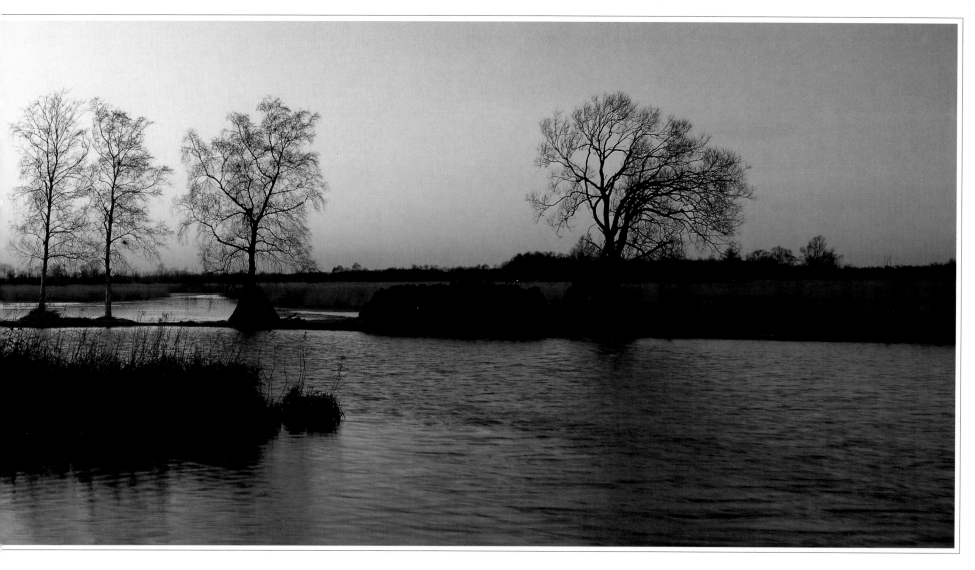

THE RIDGEWAY
Uffington White Horse

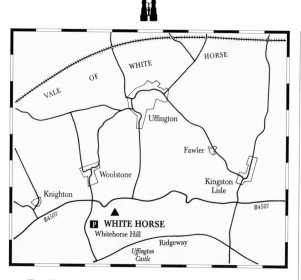

THE GIVEAWAY IS the bare chalk in the bottom right-hand corner of the panorama overleaf. Enigmatic and indecipherable though the shapes may appear, they will be unmistakable to anyone who has walked the Ridgeway National Trail in Oxfordshire.

The Uffington White Horse, whose limbs and torso these seemingly abstract slashes represent, is one of the most important and puzzling of all the chalk hill figures in southern England. Who made it? When, and why? Who was it for? (To get a satisfactory view of the entire figure, you need a helicopter.) Even its identification as a horse requires an act either of faith or of great imagination. It could just as easily be a dragon, or a cat.

Imagination, however, is in abundant supply. No one who walks, or even contemplates, the Ridgeway can fail to be stirred by its image as a kind of High Street through British antiquity. Its precise importance as a prehistoric international trading route may be open to question; what cannot be disputed is the extreme length of its pedigree. The chalk on which you stand was laid down in the Cretaceous period, the last 65 million years of the Mesozoic era, and is perhaps 70–135 million years old. As befits a landscape so rich in wild flowers (look for gentians and orchids among many others), this was

THE UFFINGTON WHITE HORSE IS ON THE OXFORDSHIRE RIDGEWAY ABOVE THE VILLAGE OF UFFINGTON. WALKERS MAY APPROACH FROM EITHER DIRECTION ALONG THE RIDGEWAY PATH; MOTORISTS MAY APPROACH VIA THE B4507. THERE IS A CAR PARK NEAR BY.

the very same period during which flowering plants made their first appearance.

Imagine what it might have looked like in the early Stone Age. In the absence of modern field drains (the invisible architects of much of the fertile landscape you can see in the background), the valley bottom, draining into the Thames, would have been very much wetter than it is now, though the fact would have been well hidden from you by the density of the forest.

It seems reasonable to assume that a Stone Age hunter following his prey (wild pig, deer) would have sought a route where the vegetation was thinnest and the going easiest – that is, along the tops of the hills. Hilaire Belloc, in *The Old Road*, seemed almost to believe that the Ridgeway had been handed down intact, as a gift. 'Nature herself,' he said, 'laid down the platform of a perfectly defined ridge, from which a man going west could hardly deviate, even if there were no path to guide him.'

Man's self-image as something distinct from, and by implication 'higher' than, the rest of nature must have been well implanted by the time the first Neolithic farmers arrived here wielding their flints some six thousand years ago. In archaeology textbooks their culture is named after their 'causewayed camp' at Windmill Hill, not far from the Ridgeway north of Avebury. The relics left by the Windmill Hill people are among the most evocative and awe-inspiring that British prehistory can offer.

If you walk west a little over a mile along the Ridgeway from the Uffington White Horse, you will come to Wayland's Smithy – a chambered long

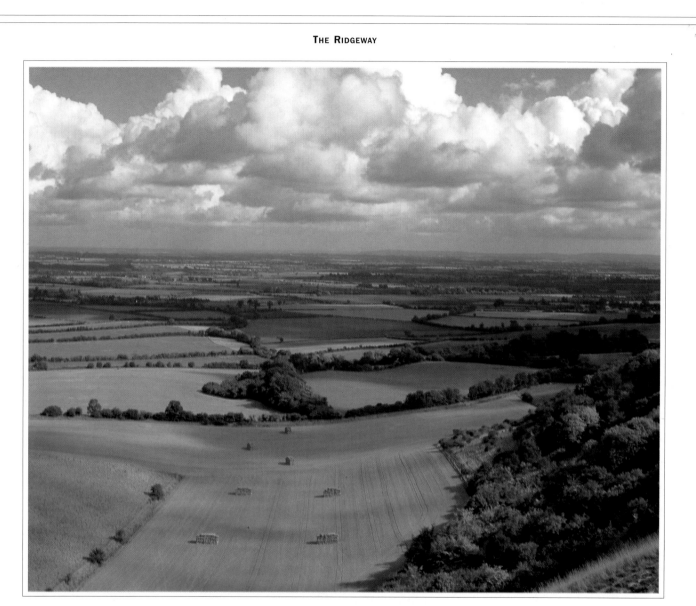

THE VIEW NORTH-EAST FROM UFFINGTON WHITE HORSE

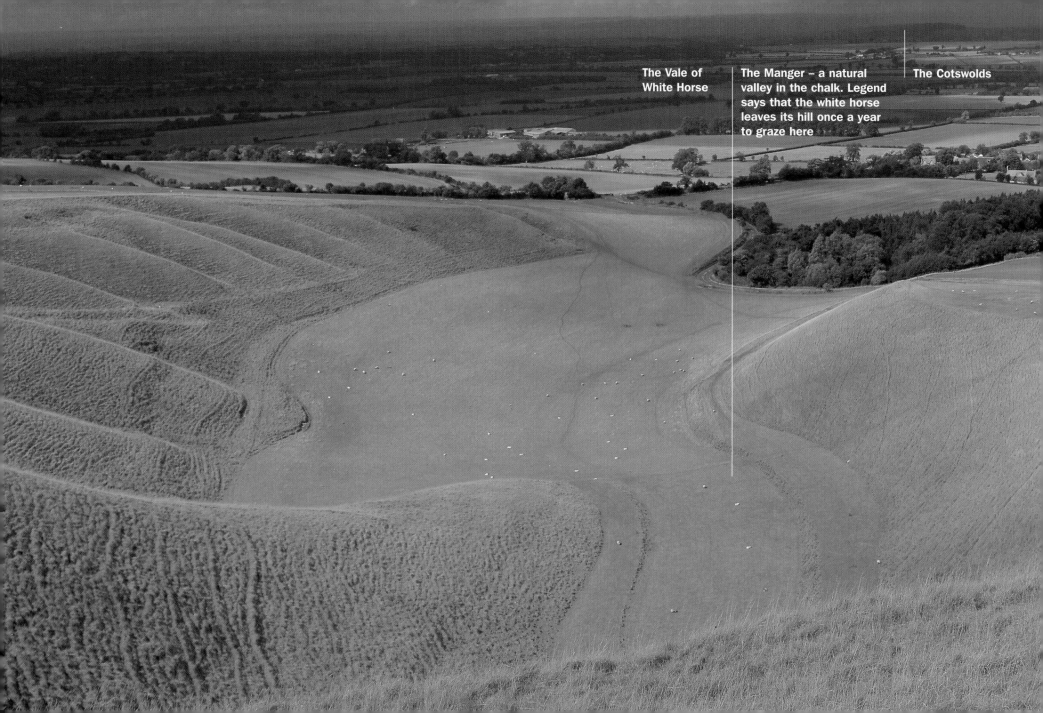

The Vale of White Horse

The Manger – a natural valley in the chalk. Legend says that the white horse leaves its hill once a year to graze here

The Cotswolds

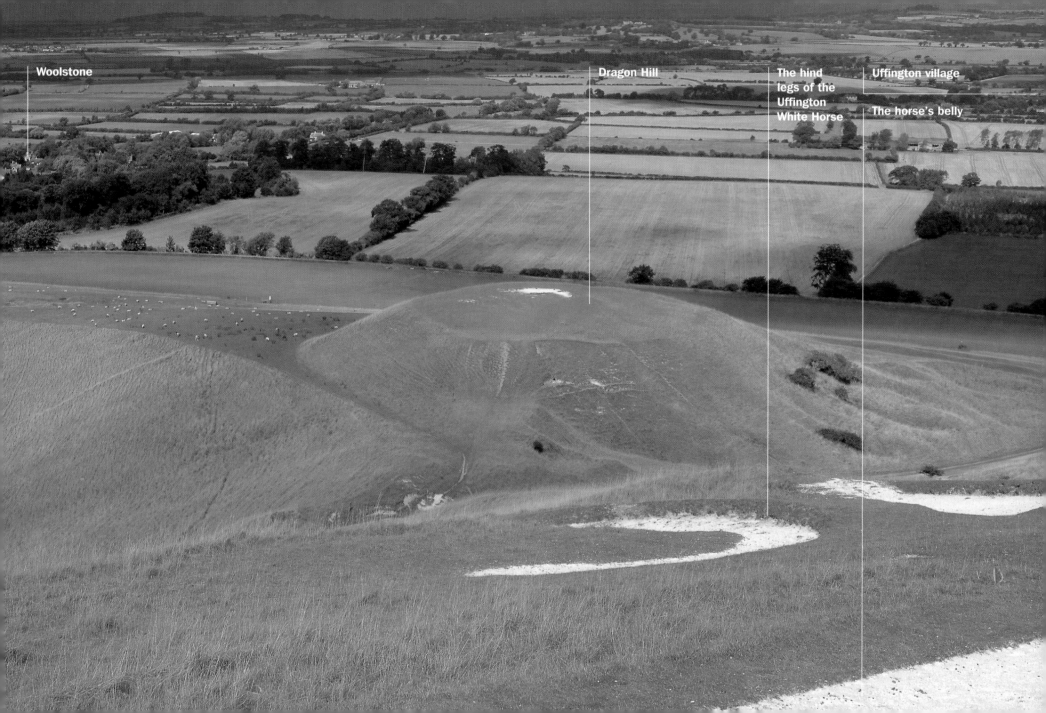

Woolstone

Dragon Hill

The hind
legs of the
Uffington
White Horse

Uffington village

The horse's belly

barrow standing in a classic chalkland beech grove. Here, as in the similarly important tomb at West Kennett, the Windmill Hill people buried their noble (or holy) dead. They also began the great henge monument at Avebury; nearby Silbury Hill – the largest man-made prehistoric mound in Europe (Jacquetta Hawkes calculated that it would have taken five hundred men ten years to build); and the oldest part of Stonehenge.

The greater part of their legacy, however, is made invisible by its very ubiquity – the farmed landscape. With fire and axe, and helped by their foraging pigs, they began the clearances later continued by their Bronze and Iron Age successors which evolved into the pattern of agriculture we see today. The introduction of sheep, and the growing of corn, accelerated the forest clearance at such a rate that by the middle of the first century BC the hills would have looked remarkably similar to the way they look today. Sheep, with their close-cropping teeth, are highly efficient sward-managers whose impact on the chalk hills is like that of landscape architect and groundsman combined.

On either side of the Ridgeway, overlaid by modern agriculture, lie thousands of acres of prehistoric fields within a complex warren of trackways. It is argued by some that the Ridgeway was *the* major arterial route for the trading of (among

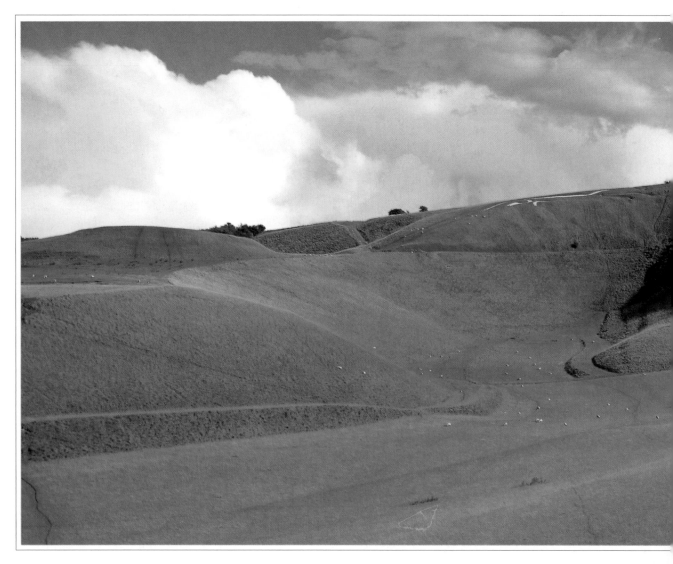

LOOKING ACROSS THE MANGER TOWARDS THE WHITE HORSE

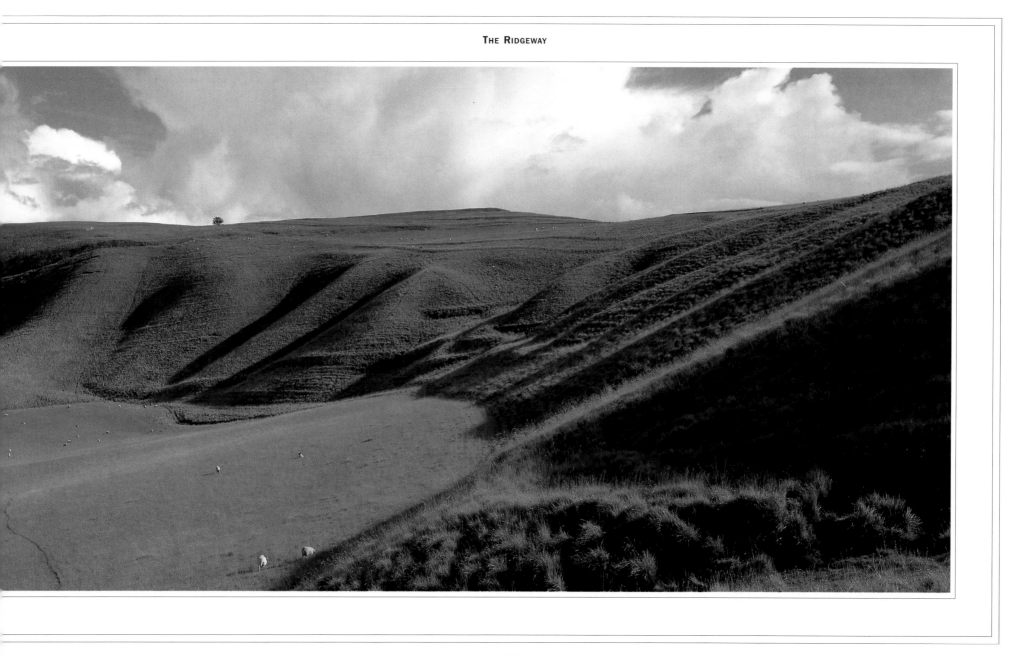

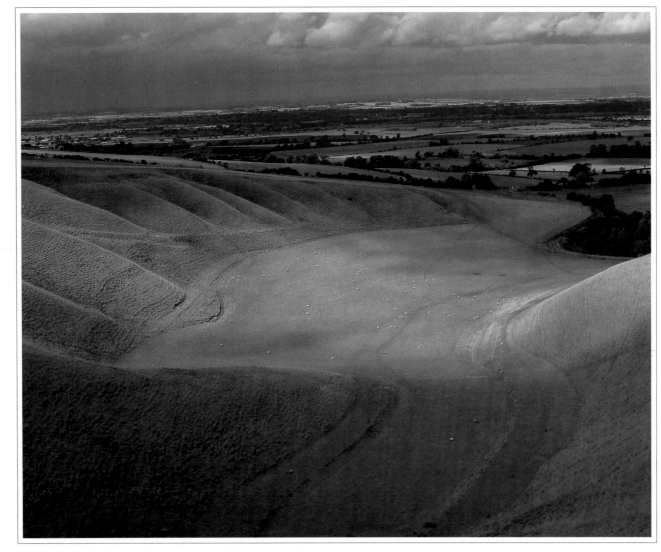

THE MANGER, WHERE ONCE A YEAR THE WHITE HORSE IS SAID TO GRAZE

other things) flint, jet and tin; by others that it was merely one route among many. To the modern visitor, such arguments scarcely seem to matter. The essence of this landscape is pre-Roman, beyond recall of written history, and it is scarcely to be wondered at that conjecture so often flirts with fantasy.

The flat-topped, pudding-shaped hill to the right of the panorama is natural in origin but betrays human intervention in its symmetry. Legend says that this was the place where St George fought the good fight, and that the bald patch on top of the hill shows where the vanquished dragon spilled its poisonous blood. It was also believed that leaving a coin by Wayland's Smithy was enough to get your horse re-shod overnight by a Saxon god.

Behind the photographer, clipped by the Ridgeway itself, stands the more solid outline of Uffington Castle – a castle so-called, but in truth an Iron Age hillfort built, like others in the area, in around 500 BC, presumably to mount guard over the Thames valley. Its inner bank seems to have been reinforced with sarsen stones and palisades – though whether it was ever called upon to prove its defensive worth is another of the Ridgeway's enduring mysteries. It seems improbable that the Ridgeway forts saw action against the Romans, or that they were of any use at all during the Roman occupation,

ESSENCE OF ENGLISHNESS – A HOUSE AT WOOLSTONE VILLAGE

though they seem to have been pressed into service hundreds of years later against the Saxons. (The Romano-British defenders are known to have suffered defeat by the invaders at Barbury Castle, on the edge of Marlborough Downs below the Ridgeway, in 556.)

The Ridgeway later also figured as a defensive line against the Danes, and it is King Alfred's victory over them at Ashdown in 871 that some people believe inspired the cutting of the Uffington horse. Others have attributed it to the Anglo-Saxon warlord Hengist, while the strongest body of opinion favours

the Iron Age. Schematic horses, very similar in design to the one in the turf, appeared on Iron Age coins, and it is suggested that it might have been an emblem of the local Atrabates or Dobunni tribes. Given the skyward-looking aspect of the figure, it is entirely believable that it was designed to meet the eye of gods rather than men. As is the way with chalkhill figures, there is a precise spot – in this case the horse's eye – where you must sit to earn good luck.

You may simply feel that being here on a clear day, with chalkhill butterflies fluttering between wind-frayed flowers and the view misting to a blue infinity that might contain the whole of England, is luck enough. The romance of the place might not have been obvious to the drovers who harried their London-bound herds and flocks through here in the eighteenth century, and yet – even as utility gives way to recreation – there is continuity. In modern man's rediscovery of the Ridgeway as a place of retreat and spiritual refreshment, there is a sense of something shared, not only with each other but with the flint axemen and henge-builders of our most ancient and mysterious past.

OVERLEAF:
THE MANGER FILLS WITH MIST

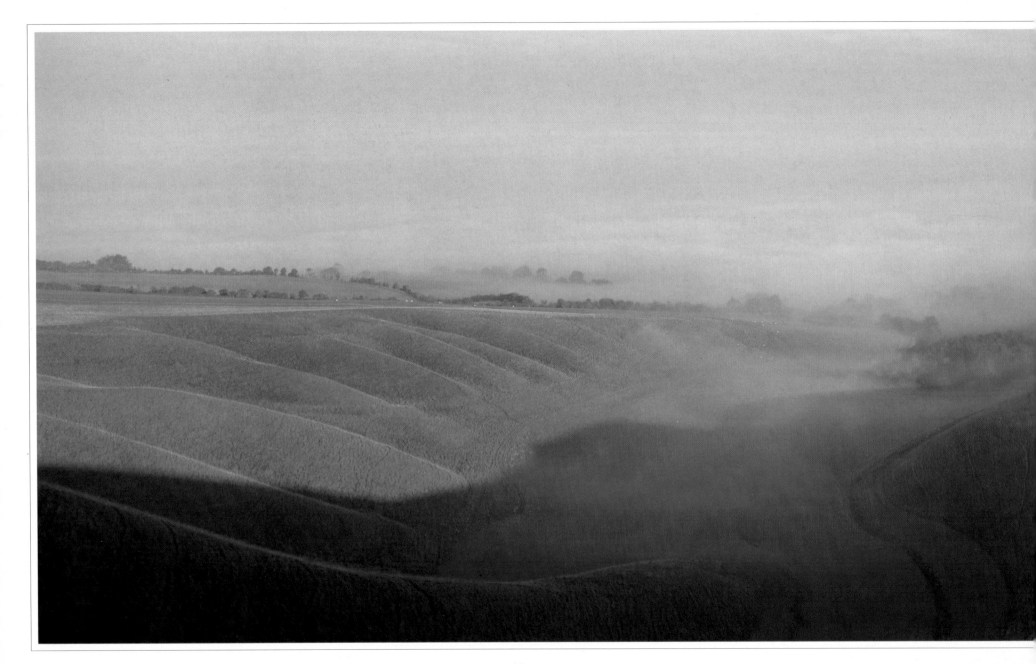

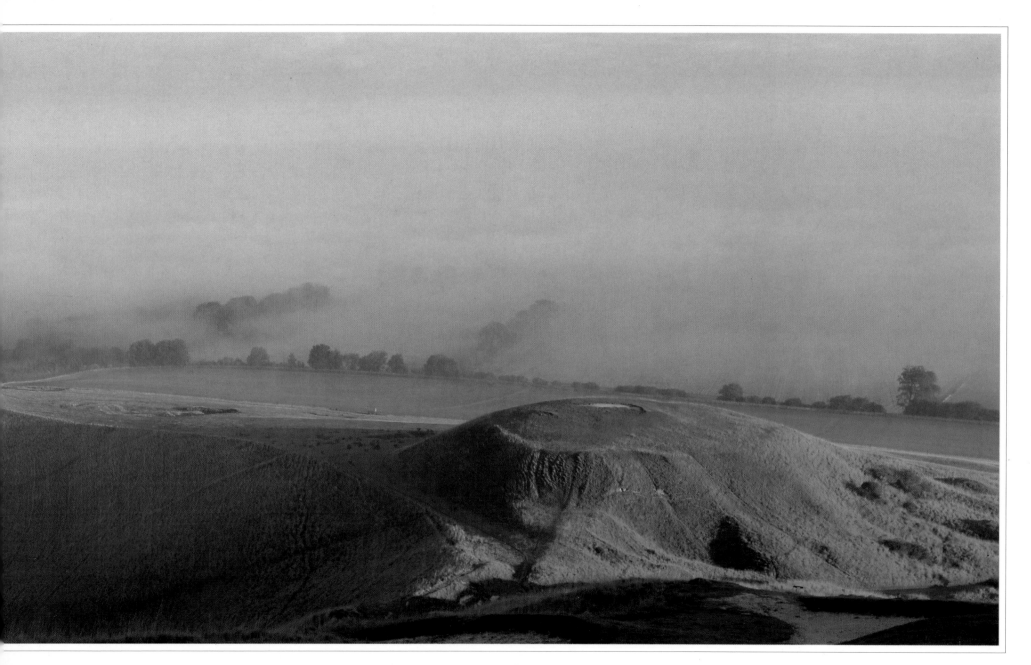

SNOWDONIA
Llyn Gwynant and the Llanberis Pass

IT WAS ONCE believed that the mountains of *Eryri*, as the Welsh have it – Snowdonia to the English – was a hellish cauldron within which devils boiled clouds for the torment of sailors at sea. Legends always abound in mountains: the closer to the elements men live, the nearer the demons that control them.

Mythology to the ancient Celts was theology, geology and physics all rolled into one: it explained everything from the death of a cow to the profile of a lake. This view south-west across Llyn Gwynant (opposite) finds the mountain Moel Hebog in its familiar form – barely visible, lost in the weather, just like the devil himself. It might have looked very similar in the days of Owain Glyndwr, but it would have had a very different resonance. They had worse goblins then than the TV weatherman.

Further along the valley, hidden in the folds below Yr Aran, is a sister lake, Llyn Dinas, haunted by the spirits of Vortigern and Arthur. Beyond it, at the conjunction of the valleys between Moel Hebog and Moel y Dyniewyd, is the village of Beddgelert. Just west of it, by Moel yr Ogof, is a low cave into which the outlaw hero Glyndwr himself – impudent scourge of England's Henry IV – is said to have crawled after his defeat. Like King Arthur and his knights, whom legend has put to sleep in caves, the spirit of Glyndwr

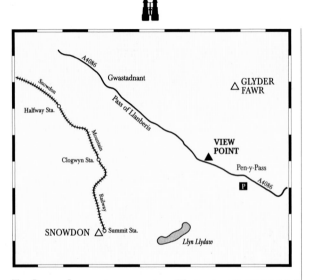

THE PASS OF LLANBERIS IS ON THE A4086 ROAD WHICH CONNECTS CAERNARFON WITH BETWS-Y-COED. THE PANORAMIC VIEWPOINT (OVERLEAF) WILL BE FOUND A SHORT DISTANCE FROM THE CAR PARK AT THE SOUTH-EASTERN END OF THE PASS, BETWEEN THE PEAKS OF GLYDER FAWR AND SNOWDON. FROM THE CAR PARK, FOLLOW THE ROAD IN THE DIRECTION OF LLANBERIS.

awaits history's call, to rise up again and lead the Welsh to victory. Over whom that victory would be won is not a question it would be sensible for anyone from east of Offa's Dyke to ask.

If empires were founded on the grandeur of the landscape, then Beddgelert would be a capital city.

From the north-east, the road to it skirts the southern shore of Llyn Gwynant (left in the picture), carves its way liked a cheesewire through the Nantgwynant pass, then rims the northern edge of Llyn Dinas. The village itself adds its grain to the mighty tonnage of Snowdonian folklore. Its name translates into English as Gelert's Grave. Who was Gelert? An heroic dog, of unknown breed, which saved its master Prince Llywelyn's son from death in the jaws of a wolf. Llywelyn, not a major contender for Brain of Wales, somehow lost the plot, falsely accused the dog of killing the boy, and hacked it to death. The story is now attributed to a nineteenth-century landlord who was alert to the commercial potential of the myths-and-legends trade, and who provided a grave by the river for the convenience of dog-loving pilgrims. Blarney would be a Welsh word if the Irish hadn't got to it first.

Snowdonia's geology, which takes some explaining, is similar to that of the Lake District. That the peak of Snowdon contains fossilized marine shells is a good measure of the upheaval that went on here. The rocks are a mixture of volcanic lava, which it seems must have poured out from numerous but now unidentifiable vents, solidified ash from a range of active volcanoes, and marine sediments mixed with

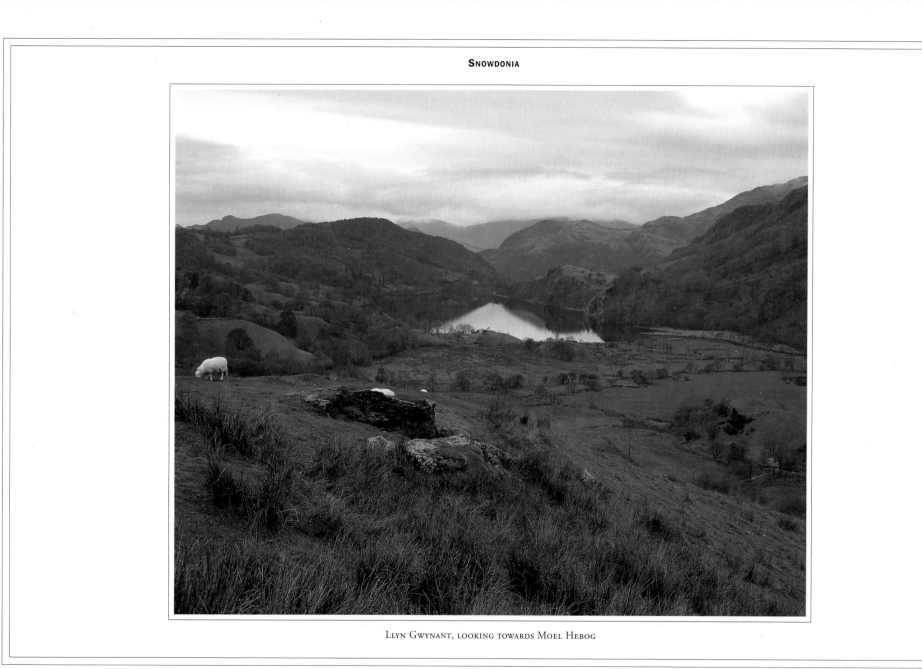

LLYN GWYNANT, LOOKING TOWARDS MOEL HEBOG

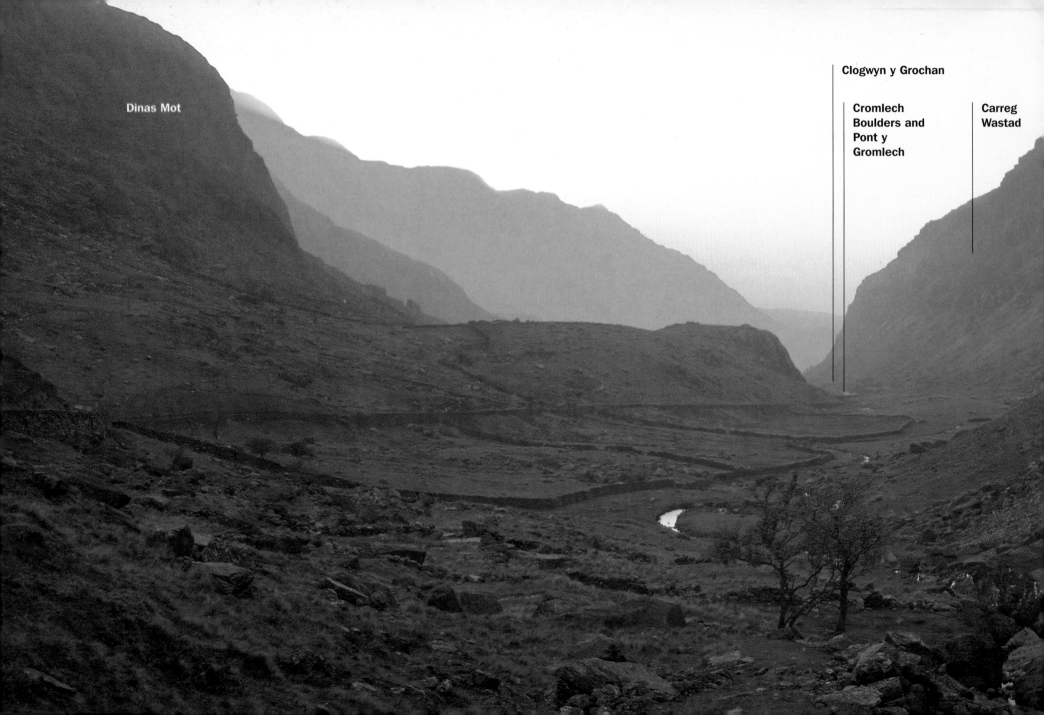

Dinas Mot

Clogwyn y Grochan

Cromlech
Boulders and
Pont y
Gromlech

Carreg
Wastad

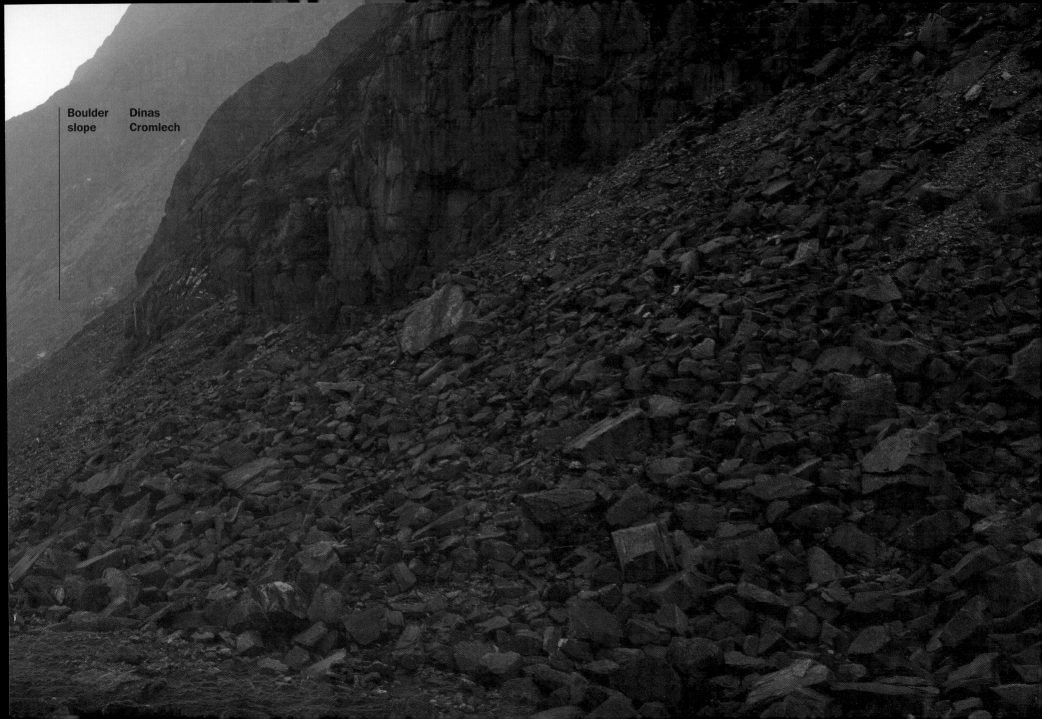

Boulder
slope

Dinas
Cromlech

igneous rocks forced into them by long periods of volcanic activity. Snowdon's summit is made of volcanic ash laid on the sea bottom in the Ordovician period, 500–435 million years ago. The whole lot was forced upwards during the Devonian period, 395–345 million years ago, and erosion and glaciation have done the rest. Cutaway diagrams show wave-like folds in which Snowdon itself is part of a syncline, or downfold, indicating that its neighbours to north and south, before wind and weather had their way with them, were once considerably higher.

Geography students will recognize in the U-shaped profiles of the Gwynant valley and nearby Llanberis pass (shown in the panorama on pages 46–7) the unmistakable hallmarks of retreating ice. Snowdonia is *the* classic glaciated landscape: hanging valleys, glacial scratch marks and moraines (masses of debris carried and dumped by the ice), all in textbook order. Most of the twenty or so tarns, or mountain pools, visible from the top of Snowdon are the result of natural dams formed by moraines.

The land in the foreground of the picture on page 45 belongs to a farm named Hafod Rhisgl. The Welsh word *Hafod*, meaning in English 'summer dwelling', is all the clue you need to understand the agriculture here. Welsh black cattle and, especially, Welsh

ARCHITECT AT WORK – WATERFALL ABOVE LLYN DINAS
OVERLEAF:
SLATE QUARRY BY LLYN PERIS

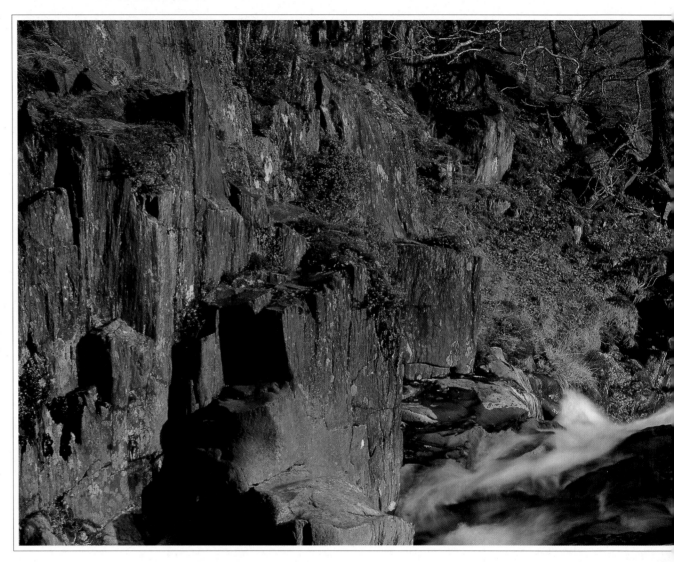

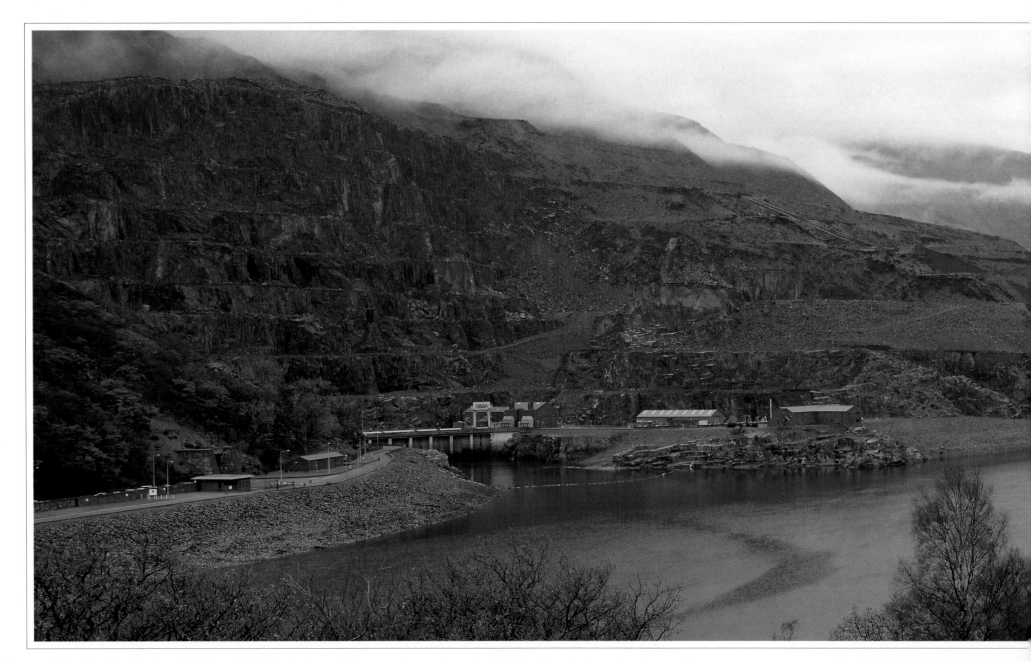

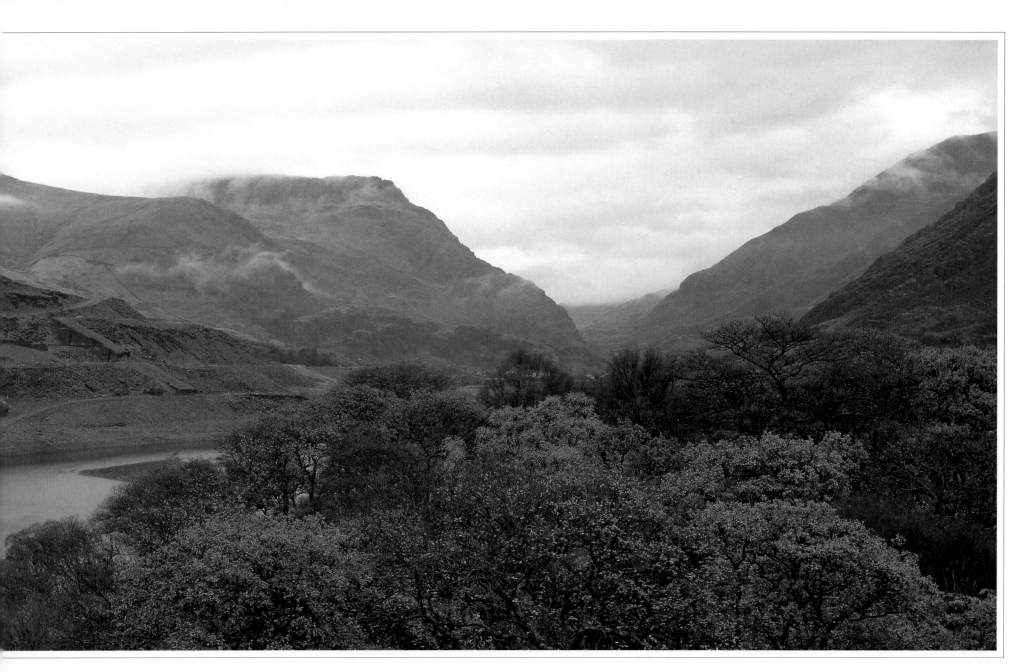

Mountain sheep, are the hardy breeds that sustain the hill farmers of *Eryri*. It is to farmstead or *hafod* that the flocks are brought down in high summer for shearing – not transhumance exactly, but still a great, two-way migration of men and animals that owes as much to the tenacity of the shepherds as it does to the extraordinary stamina of the ewes.

In the mists of Moel Hebog and its northerly neighbour Moel yr Ogof you will find the other great cash crops of present and past alike. Footpaths duck in and out of Beddgelert Forest, one of many green splashes on the map which indicate the strong local presence of the Forestry Commission, and emerge on bare tops littered with abandoned quarries and mines. The Moel Hebog copper mine (find it on the map between Moel Hebog and Moel yr Ogof) perhaps offers some clue to the presence on the same slope of settlements from the Bronze Age. It is probable that more fortunes were lost than gained in trying to wrest mineral wealth from Snowdonia's miserly slopes, notwithstanding (or perhaps because of) the three Victorian goldrushes in 1852, 1862 and 1887. The gold was real, but so were the greed and the gullibility that are the inseparable companions of easy wealth. Moel Hebog was not the only copper mine suddenly to offer traces of gold just before its owners put it up for sale.

Elsewhere in the mountains you will find traces of

AUTUMN COLOUR NEAR LLYN DINAS

iron, lead and slate – an industry that still survives, though only as the smallest relic of its late-nineteenth-century peak.

Snowdonian rock now is more a thing of recreation than of industrial endeavour. Llyn Gwynant is popular with canoeists, who like to cool off in hot weather by jumping from Penmaenbrith ('Elephant Rock' to the English – visible above the lake in the centre of the picture on page 45). Most other accessible outcrops in Snowdonia, including almost every cliff and boulder of Llanberis Pass, are the province of climbers, who you will see everywhere

like spiders in their webs of rope. The increasingly competitive nature of rock-climbing is the latest development in a process which began in the late eighteenth century with the Georgian Romantics, who were the first to celebrate landscape in terms of beauty rather than utility.

Today tourism is the most visible local industry. More than half a million people reach the 3560ft (1085m) summit of Snowdon every year (there are six routes to the top, three of them from points near Beddgelert, two from the head of Llanberis Pass and one – the easiest – which follows the route of the Snowdon Mountain Railway from Llanberis village), and millions more tramp, scramble and dangle their way across the scenic playground of the National Park. There are no eagles any more (though the name *Eryri* means exactly what it suggests), but you will have as good a chance as anywhere in Britain of spotting a peregrine, a raven or a chough. Arctic char survive in some of the glacial lakes, including Llyn Cwellyn beneath Snowdon's western flank just north of Beddgelert. Elsewhere you may have to make do with trout.

Owain Glyndwr, Vortigern and Arthur – accompanied, perhaps, by the entire cast of the Mabinogion – may, as legend predicts, rise up one day and repel the invader. More likely, knowing which way the wind really blows, they'll open a guesthouse.

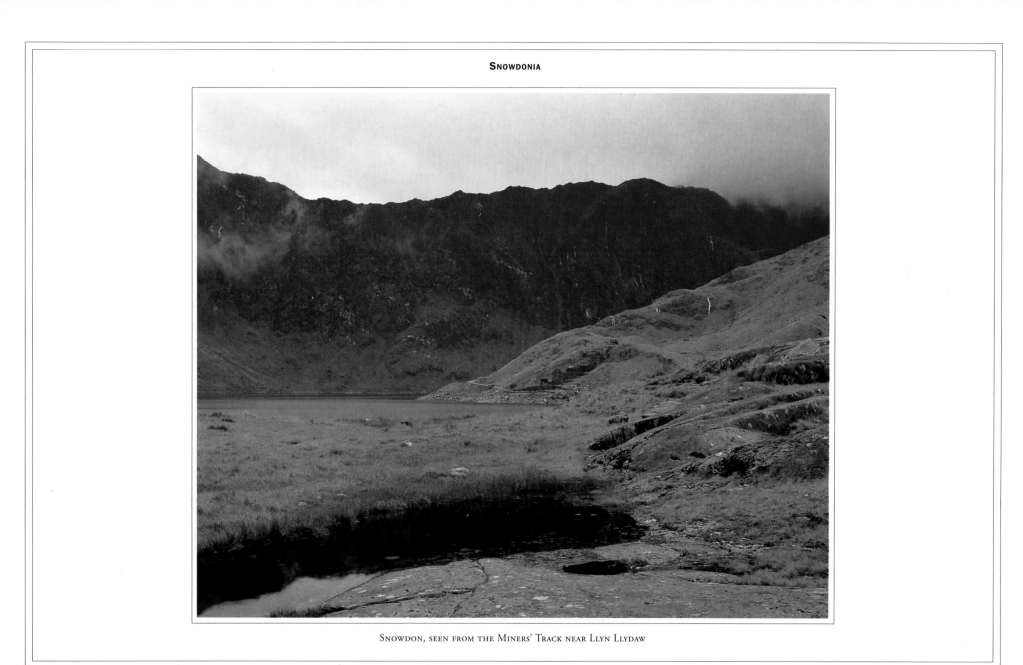

SNOWDON, SEEN FROM THE MINERS' TRACK NEAR LLYN LLYDAW

THE PEAK DISTRICT
Mam Tor

LIKE CID OFFICERS, the Peak District comes in two distinct modes: hard, and harder still. The hard bit is the so-called White Peak – farmable, mineral-rich limestone country, maggoty with caves and mineshafts. Harder still the millstone grit of the Dark Peak – high, bleak and hobnailed, with a permanent aversion to nonsense. You mess with it, you lose.

The point from which the panorama was taken, at Mam Tor, is the point at which the two modes meet. 'Collide' might be a better word, for Mam Tor could hardly be less stable if it had been hit by a bomb. Its beds of hard gritstone are interleaved with soft shales that have been on the move ever since the end of the last ice age, when meltwater caused mudslides to exaggerate the slopes and set the hill up as a defenceless victim to the forces of erosion and gravity.

At 1695ft (516m) it's not a major-league mountain, and not remote in the sense of being far removed from human habitation (Castleton lies just below to the south-east, and the village of Edale is clearly visible in the opposite direction), but it offers both heady views and the possibility of a sharp lesson if you stray on to the shifting shales that account for its alternative name – Shivering Mountain. Earlier victims of its instability included the A625 trunk road from Sheffield, which disappeared into a void reminiscent

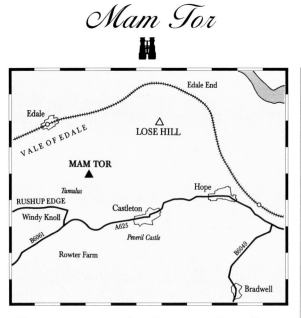

THE PANORAMIC VIEW OF LOSE HILL AND THE VALE OF EDALE (OVERLEAF) WAS TAKEN FROM MAM TOR, ABOVE CASTLETON.

of a San Francisco earthquake.

The pictures opposite and overleaf look approximately north-east along the ridge towards Lose Hill. The farmed valley beyond the ridge is the Vale of Edale, where the enclosed fields and stone walls offer the most obvious evidence of human intervention in what otherwise might appear to be virgin wilderness. In fact the character of the Dark Peak itself, even at its most wild and pitiless, is nature's

riposte to man's frail ingenuity. The blanket of sphagnum bog that covers the uplands would not be there if early settlers nine thousand years ago had not removed the trees.

It is suggested that the very earliest hominids to leave a footprint on the Peaks were Neanderthals, during the glaciation between 80,000 and 30,000 BC, but it was only in the Upper Paleolithic, around 10,000 BC, that the joys of cave-life became fully apparent and the area became busier. By 7000 BC the settlers had realized the value of slash-and-burn as a technique for pasturing deer, and by 3000 BC they were into farming proper, both as cereal growers and herdsmen. As you can see from the evidence all around you, they are still at it: dairying and sheep on the White Peak limestone; more sheep on the Dark Peak grit. (Look for the local breeds – the spotty-faced Derbyshire Gritstone and the aquiline White-faced Woodland.)

The burial mounds that clutter the hilltops are of the Bronze Age, as is the hillfort on Mam Tor itself. This is the largest hillfort in Derbyshire, and also seemingly the earliest, with a radio-carbon date of 1180 BC. In its original form it seems to have had a wooden palisade enclosing a group of circular huts and a pair of burial mounds.

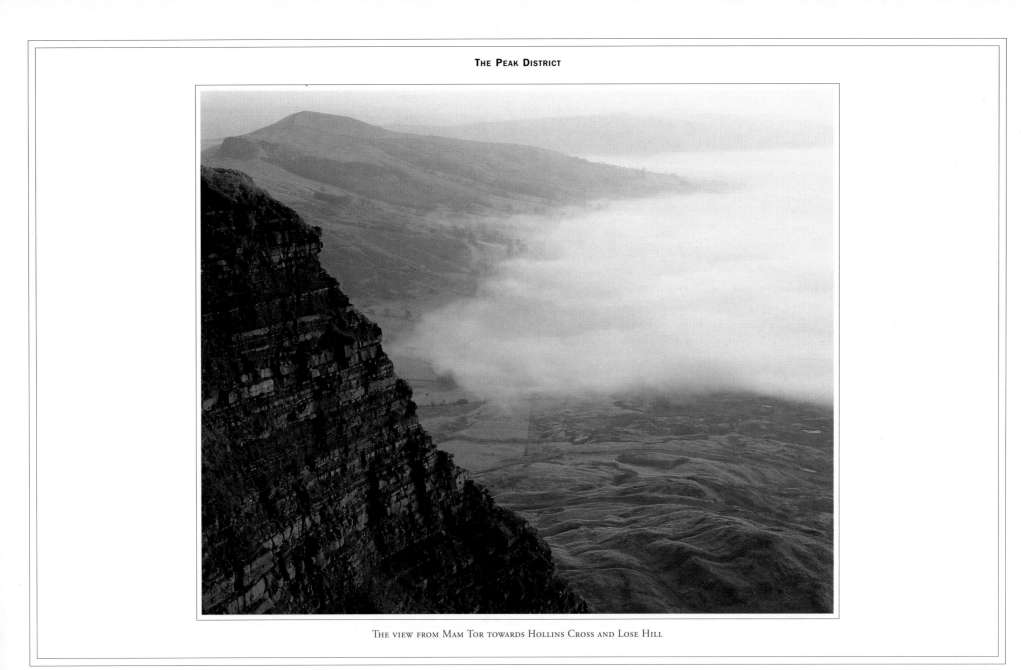

THE VIEW FROM MAM TOR TOWARDS HOLLINS CROSS AND LOSE HILL

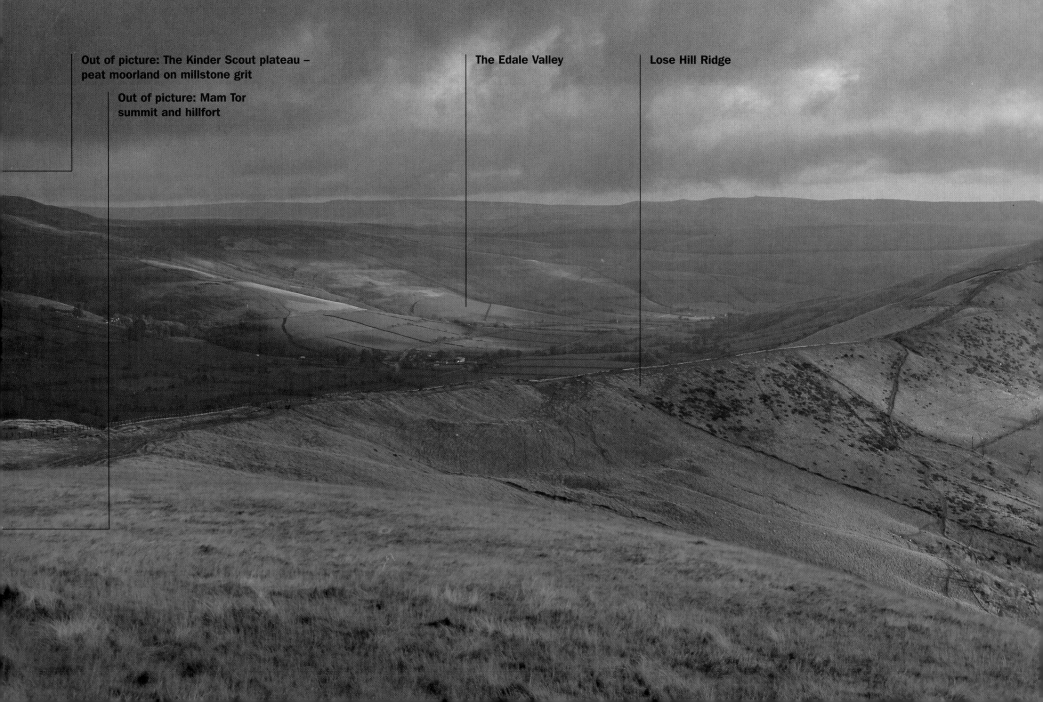

Out of picture: The Kinder Scout plateau – peat moorland on millstone grit

Out of picture: Mam Tor summit and hillfort

The Edale Valley

Lose Hill Ridge

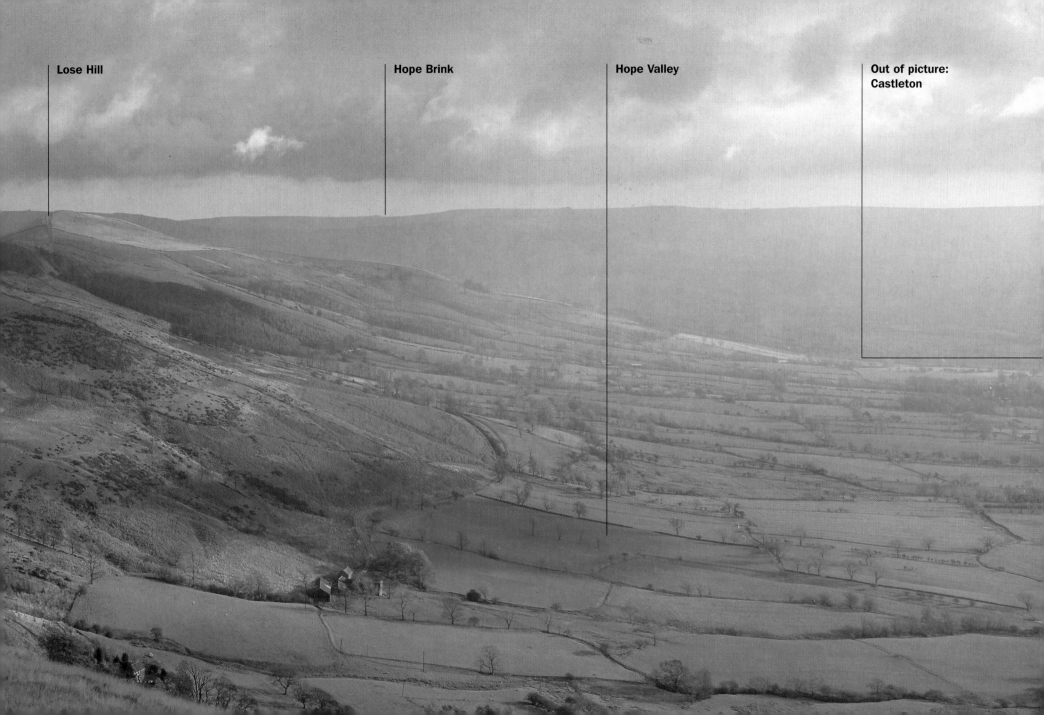

Lose Hill

Hope Brink

Hope Valley

Out of picture:
Castleton

The ridge which shuts off the horizon in the panorama is Hope Brink, a kind of geological superhighway which, it is no surprise to find, is traversed by a Roman road. The reason the Romans came here will already be obvious if your way of approach to Mam Tor has been by way of Castleton village, or if you have glanced at a map. The bait was lead. The limestone of the White Peak is laced with it, like veins in a cheese, and for 1800 years or so, until the industry collapsed under foreign competition in the latter half of the nineteenth century, generations of miners nibbled away at it like burrowing mice.

On the White Peak (Castleton) side of Mam Tor, you will find the slopes littered with their relics. The most eloquent of these is the ruin of Odin Mine, whose name is traceable to the thirteenth century and whose origins may be Saxon. Here you can find a classic example of an old vein working, or 'rake', which the miners worked at with their picks. Very often in open landscape the line of a rake is defined by planted trees, the purpose of which was to shade out the undergrowth and save grazing animals from the perils of lead-contaminated grass.

Also at Odin you should spot the mouth of a sough (pronounced *suff*) – a stone-lined drainage tunnel dug to reduce the water table and extend the range of the mine. Even in the eighteenth century these could cost tens of thousands of pounds to build,

WINTER IN EDALE – FROM STANAGE EDGE

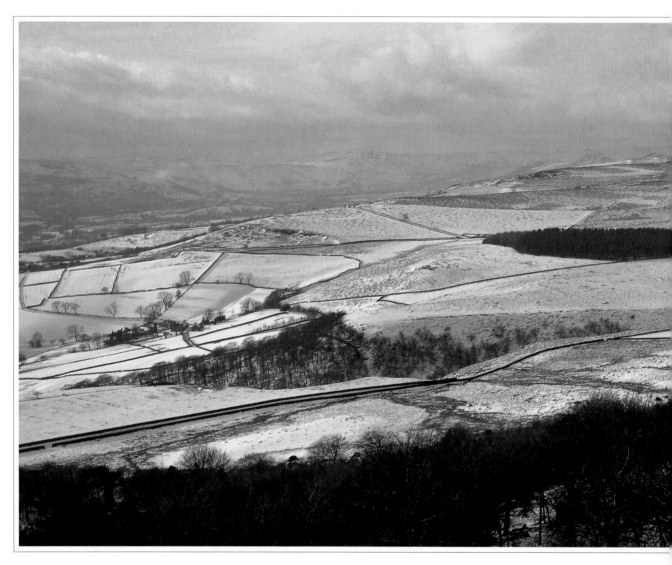

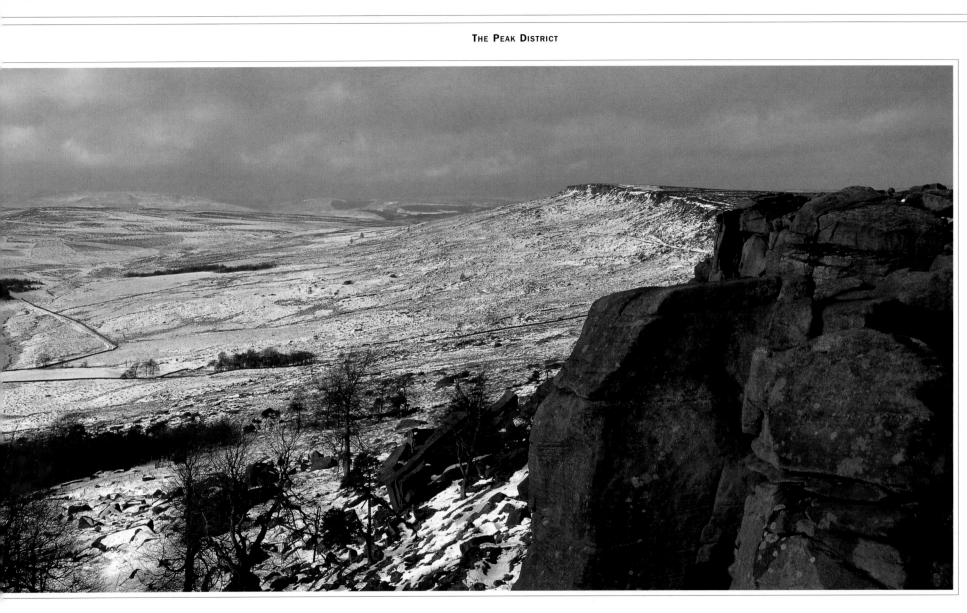

and sometimes reached a length of several miles (this one, made between 1816 and 1822, finishes 800 feet inside Mam Tor). The best of Odin's relics, however, is the nineteenth-century ore-crusher – a man-high gritstone wheel which was worked by a horse around a circular iron track.

It is not whimsy that makes the Peak National Park Authority choose for its emblem a millstone. After sheep these were the commonest products of the gritstone uplands, and there are places in the park where you may see dozens of them, abandoned where they were cut and never used.

At the head of the Hope Valley, Castleton lives as if on bended knee beneath the ruins of Peveril, the Norman castle within which Henry II took the surrender from Malcolm of Scotland in 1157. When it comes to the inspiration of awe, however, the castle plays a distant second fiddle to its neighbour, Peak Cavern. This huge gash in the rocks – at 50 feet high and 100 feet wide, the largest cave opening in Britain – once contained an entire village of ropemakers. It is the first in a sequence of four caves – all open to the public, and all displaying the classic stalactite formations of limestone cave systems – that you will meet on your way up to the tor.

The others are Speedwell Cavern, in which you may descend to a boat that will carry you half a mile along an underground canal to an old lead-working face; then, as you near the tor, Treak Cliff Cavern and Blue John Cavern. In addition to lead, both these

EDALE VILLAGE, WITH MAM TOR AND RUSHUP EDGE BEHIND

were famous for producing another local speciality, the banded fluorspar Blue John, which is used in ornaments and jewellery. Treak Cliff still yields half a ton a year – enough to have a significant impact on the cufflink market, but forty times less than Castleton produced in its heyday.

The Vale of Edale, on the other side of Mam Tor, may lack the prettiness and intimate (if sometimes overcrowded) charms of the better-known and more romantically inclined Dovedale, but leaves it for dead in terms of history. From the tor you will see the village of Edale just over a mile away, roughly northward at the head of the valley. Behind it, knuckling the sky, is perhaps the most symbolic lump of landscape in the whole of Britain – Kinder Scout.

It was here on April 24, 1932, that a procession of four hundred ramblers, most of them young, organized by the Manchester area committee of the British Workers' Sports Federation, committed the famous Mass Trespass. Their targets were the grouse-shooting landlords and the nineteenth-century Enclosure Acts that ring-fenced their fiefdoms; their aim, to establish the right of ordinary people to share the freedom of the high open spaces. In the short term, it could be said that they lost. Six young men were arrested on various charges including riotous assembly, breach of the peace and assault (a gamekeeper was hurt in a scuffle), and five were sent to prison. The judge at Derby Assizes made much of the fact that one of the defendants had owned a book by Lenin.

The last laugh, however, has been as sweet as mountain spring water. In 1951 the access movement scored its greatest ever victory when the Peak District became Britain's first National Park. The first designated long-distance footpath, the incomparable Pennine Way, begins (or ends) at the Nag's Head in Edale and almost immediately clips the high (2,088ft/636m) plateau of Kinder Scout, by way of the Peak's highest waterfall, Kinder Downfall.

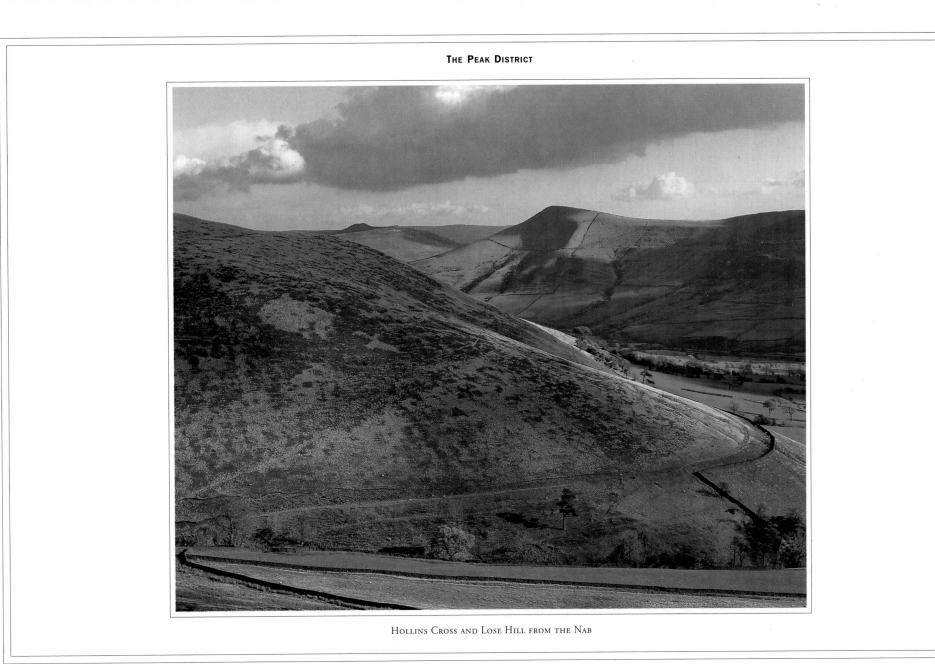

HOLLINS CROSS AND LOSE HILL FROM THE NAB

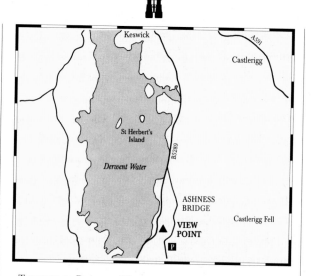

YOU ARE NEVER far from a superlative in the Lake District. They come in both empirical form (England's tallest peak, deepest lake, highest number of mountain rescues) and subjective (most beautiful view of the highest mountain, loveliest dale, sublimest walk, etc.). For all the subjective categories the Lakes themselves offer a multiplicity of candidates, and fixing on a single view as in any sense 'the best' is to invite catcalls.

We could have chosen Thirlmere, under Helvellyn; the view of Great Gable across Wast Water; Langdale Pikes from Tarn Hows; Helvellyn from Ullswater; the Troutbeck valley; downwards or upwards from any point of the compass, any peak or contour. All would have qualified quite comfortably as among England's best. What we have chosen (because we had to choose *something*) is Derwent Water. Again we could have shown it from almost any angle or perspective – distantly, from Skiddaw; intimately, from Friar's Crag; dizzyingly, from Lady's Rake. In our panorama (overleaf), however, we see it from a point near the head (southern tip) of the lake, above the Lodore landing stage on the eastern shore.

You are looking approximately north-west, towards Bassenthwaite Lake, which can be seen in the distance. To the right (east) of Bassenthwaite the land

THE VIEW OF DERWENT WATER OVERLEAF, FROM A POINT NEAR ASHNESS BRIDGE, IS KNOWN LOCALLY AS SURPRISE VIEW.
TO FIND IT, FOLLOW THE B5289 SOUTHWARD ALONG THE EASTERN SHORE OF DERWENT WATER FROM KESWICK. TAKE THE NARROW ROAD TOWARDS ASHNESS BRIDGE AND WATENDLATH.
A CATTLE GRID IS FOLLOWED BY A VERY NARROW BRIDGE AND THEN A PARKING AREA IN THE WOODS.
THE VIEW IS THROUGH AN OPENING IN THE TREES.

rises towards Skiddaw. The fan of alluvium to the left of the picture is where the River Derwent enters from Borrowdale. It disappears when the water level rises in winter. The forested ridge at the top of the picture will lead your eye south to Grisedale Pike and Hopegill

Head. Beyond it lies the old market town of Cockermouth, at the confluence of the Derwent and Cocker rivers.

When it comes to superlatives, Derwent Water figures more highly among the subjective kind (many good judges have made it their choice for 'most beautiful lake') than among the empirical. It is the first of the large lakes to freeze, if only because it is one of the shallowest – 72 feet at its deepest point, against Wast Water's 250 feet. It is one of only two lakes (Bassenthwaite is the other) to provide a home for the Cumberland vendace, *Coregonus gracilior*, one of Britain's rarest freshwater fish. The woods of mixed oak at the southern end of the western shore (Brandelhow Park, on the lakeside towards the left of the panorama) were one of the earliest acquisitions of the National Trust, in 1902. Borrowdale, to which the lake connects, is a favourite contender for the title of Wettest Place in England – Seathwaite, at its head, gets more than 130 inches of rain a year.

What you will particularly notice at Derwent Water is the contrast in mountain scenery between the areas roughly north and south of the lake. The mountains to the north and west are smooth green humps (fox-coloured when the bracken turns in autumn) that might almost have been cast from

By the Lodore landing stage, Derwent Water

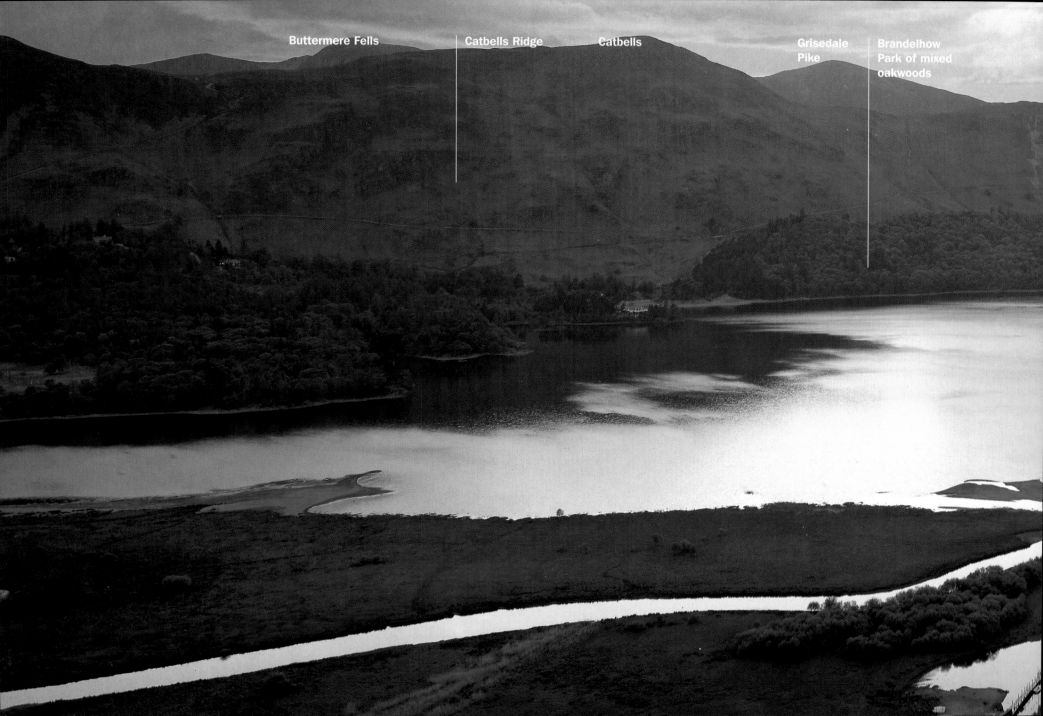

Buttermere Fells

Catbells Ridge

Catbells

Grisedale Pike

Brandelhow Park of mixed oakwoods

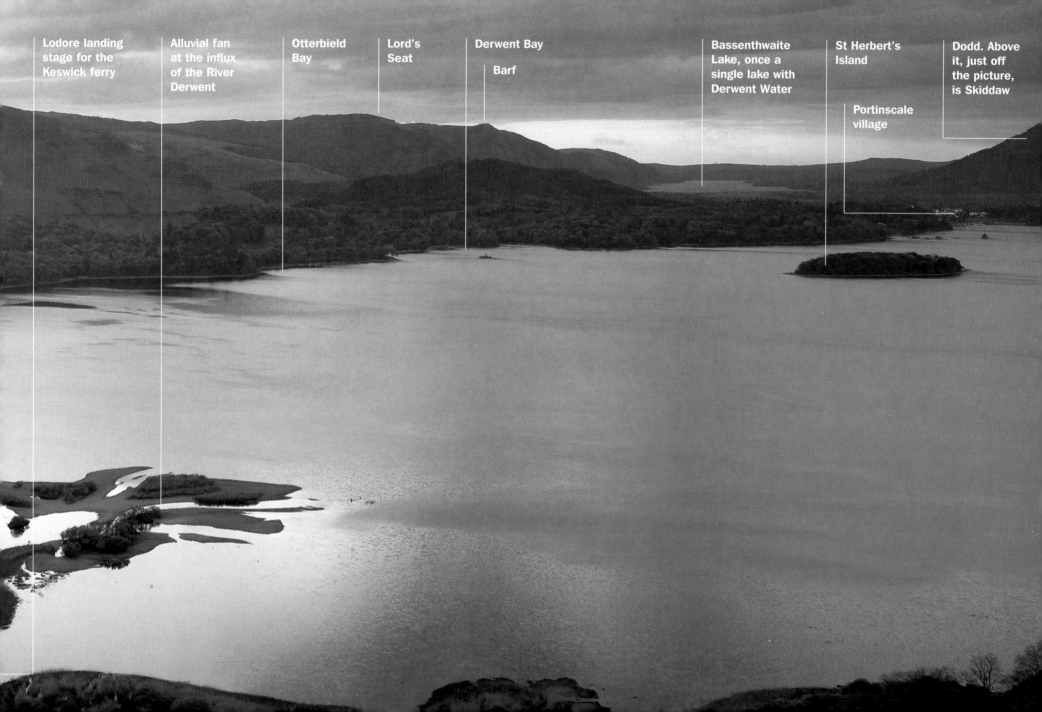

Lodore landing
stage for the
Keswick ferry

Alluvial fan
at the influx
of the River
Derwent

Otterbield
Bay

Lord's
Seat

Derwent Bay

Barf

Bassenthwaite
Lake, once a
single lake with
Derwent Water

St Herbert's
Island

Portinscale
village

Dodd. Above
it, just off
the picture,
is Skiddaw

moulds. Those to the south and east are anything but smooth – great shards of geological shrapnel whose shattered crags are the natural habitat of raven, peregrine falcon and the Gortexed hordes of human thrill-seekers.

Our vantage point is close to the junction between these two scenic bands. The smooth, bracken-clad humps to the north – including, most famously, the great mound of Skiddaw behind the lakeside town of Keswick – are made of slate whose earliest antecedents are unguessable to any but geologists and geographers. Improbable though it may seem, these hills all began life as muddy or sandy deposits on the bed of a shallow sea. The great earth movements in the Mid-Tertiary period simultaneously compressed the layers into slate and pushed them upwards, causing them to split. The brittleness of slate, its tendency to crumble through weathering, is what gives Skiddaw and its neighbours their characteristic, nursery-book outline.

The mountains of Borrowdale, and the Lakeland rock-climbing apparatus of Scafell, Helvellyn, Great Gable and the Langdale Pikes are a different matter altogether – a fact you will see immediately in the crags of Lodore near the point from which the photograph was taken. These are the rocks of the so-called Borrowdale Volcanic Series – mountains

DERWENT WATER, FROM CASTLERIGG FELL

formed from lava, dust, ash and concrete-like agglomerates thrown up by a chain of erupting volcanoes; then milled by glaciers and chiselled by millions of years of wind and rain. One's imagination, however, must be held in check. The peaks themselves are not extinct volcanoes; they do not even mark the positions of former volcanoes (these remain unknown). The high peaks stand proud of neighbouring slopes only because they are made of harder rock and are eroding more slowly.

Because the geology is so frank in what it reveals, there is a temptation to imagine that this and other Lakeland views are exactly what nature made them – a primeval landscape unaltered since the passing of the ice. In fact the very assertiveness of the rocks and peaks is evidence to the contrary. Left to nature, the lakes themselves would be drowned in a sea of forest – oak on the lower slopes, as at Brandelhow; pine and birch higher up, stifling the views of dales and fells. If you climbed to a point of sufficient eminence from which to see them – the top of Helvellyn, say – only the highest peaks would be bare of trees.

As an individual you may with good reason feel tiny and vulnerable on the raw and dangerous flanks of the high fells. But it would be a mistake to underestimate the power of man to bend a landscape to his purposes. The farmers of the Late Stone Age (Neolithic) began it when they discovered a vein of tufa (rock formed from solidified volcanic dust), so hard that they could split and sharpen it like flint. They used it in the form of axes to make clearings for their animals to graze, thus beginning a process of deforestation which continued right through into the modern age. Theirs in a sense therefore is the greatest monument of all, though each of the great periods of English civilization has left its mark: the Bronze Age stone circle at Castlerigg; the Iron Age hillforts; the Roman

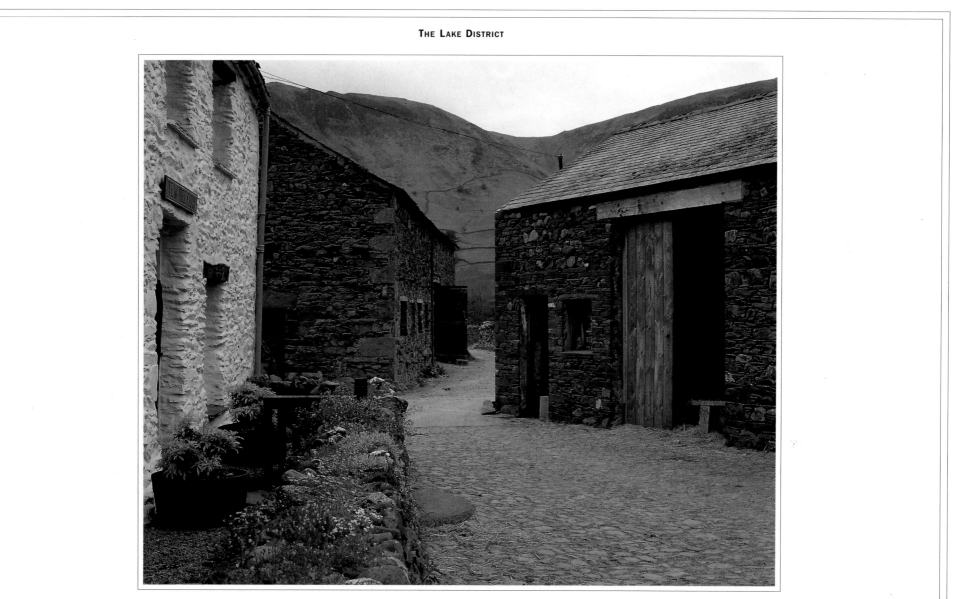

YEW TREE FARMYARD, AT ROSTHWAITE IN BORROWDALE

roads; the Anglian farmers and Norsemen remembered in their placenames (-*ton*, -*ham*, and -*ington* for the Anglians; -*thwaite*, -*fell*, -*gill*, -*booth* and -*beck* for the Norsemen); the Normans who cleared the fells for their sheep; the farmers of the seventeenth, eighteenth and nineteenth centuries whose legacies are the solid stone farmhouses and hillsides veined with drystone walls.

All this – not just the brooding face of unquiet nature – inspired the 'romantic' view of landscape which found its expression here, and which fired the pens of Dorothy and William Wordsworth and their friends Coleridge, Southey (who versified about Derwent Water's Lodore Falls) and the opium addict de Quincey. Walter Scott came to write in the Lakes. So did Keats, Hugh Walpole, Matthew Arnold, Tennyson, Arthur Ransome and Beatrix Potter. Many of them in their poems and stories described precise locations which can be traced with book in hand – powerful attestation, lest you should need it, of the strange thralldom which Lakeland exerts on all who dabble with it. The urge to take a photograph, or write a postcard, is much like the urge to paint a picture or write a sonnet. If you don't feel it in Lakeland, you'll never feel it anywhere.

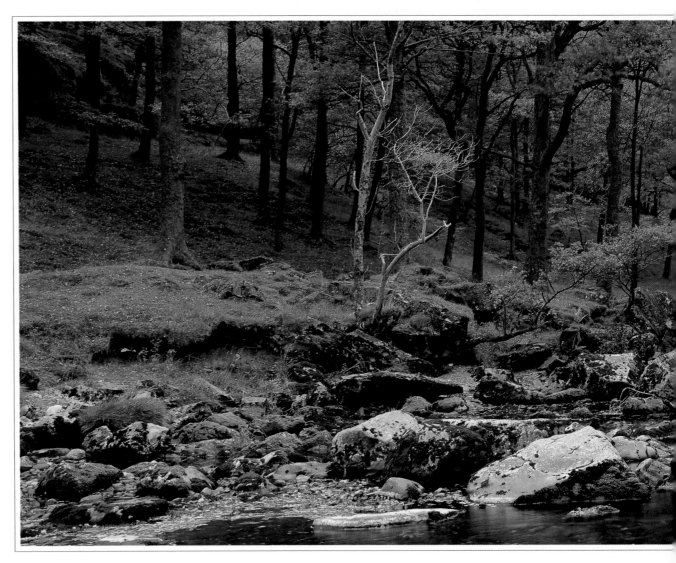

THE RIVER DERWENT IN BORROWDALE
OVERLEAF:
A HARD ROAD – WINTER NEAR WATENDLATH

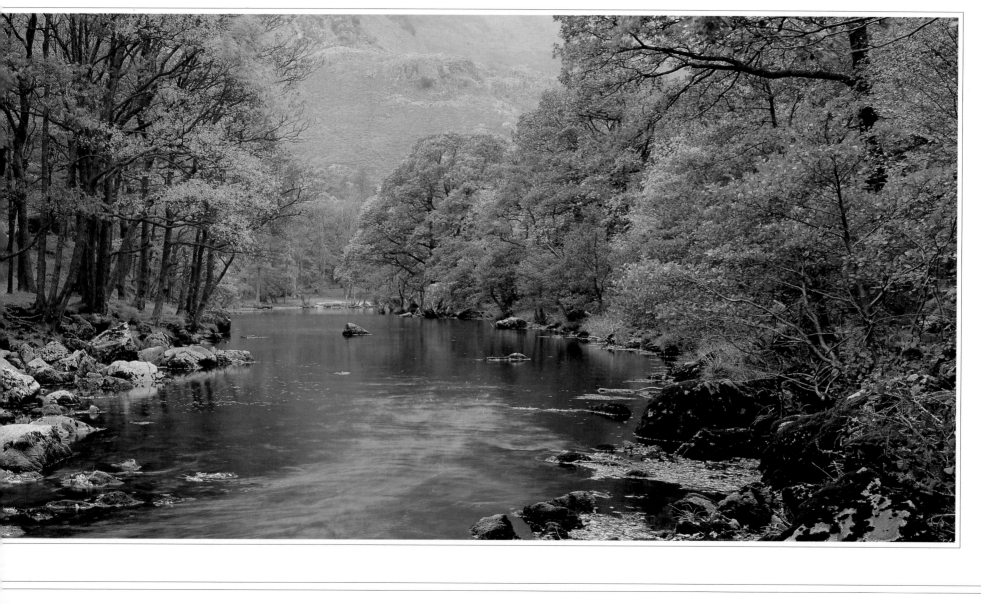

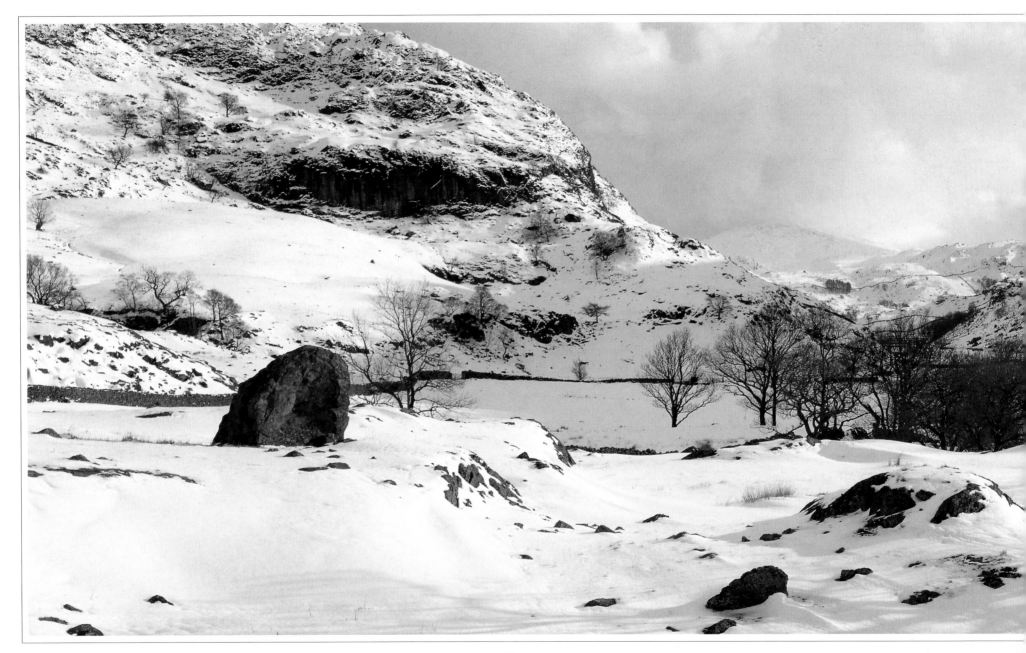

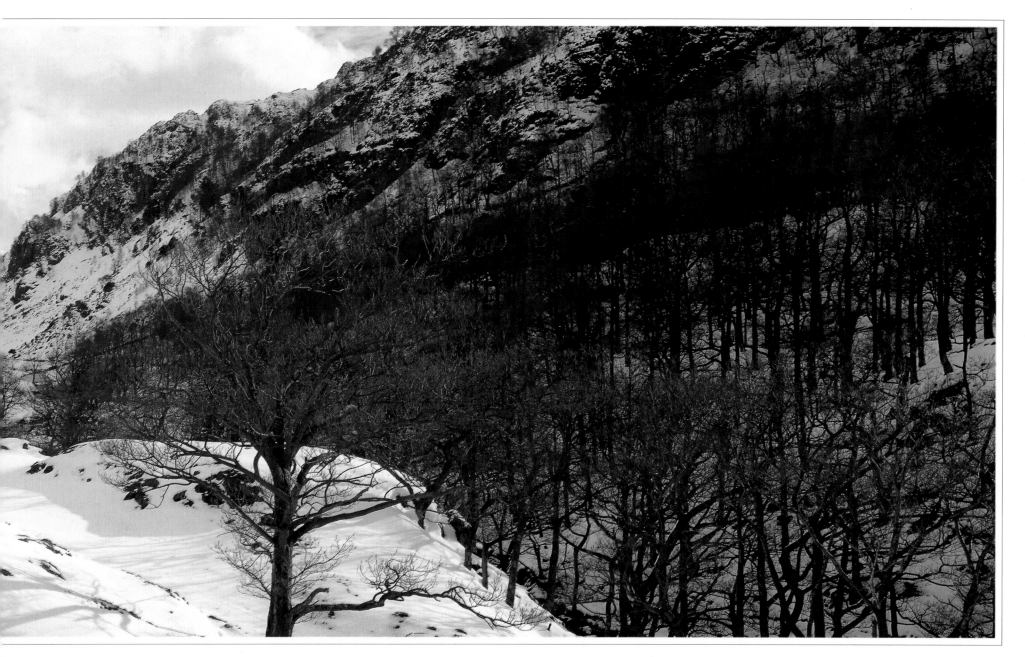

THE NORTHUMBRIAN COAST
Lindisfarne and Bamburgh Castle

LINDISFARNE IS ONE of those places that can make your hair stand on end. There is no silence. When the gale abates, it is only for one wall of sound to be replaced by another – the fractured choirs of seabirds whose every scream sounds like a tiny, distant death. If you could be in no other place, however, you could be in almost any time. It was in 635 AD that St Aidan came from Iona to Lindisfarne, the almost-isle whose prosaic modern name – Holy Island – precisely defines its role in British history.

Aidan's community on Lindisfarne was one of the most powerful and magnetic forces in the whole of Western Christendom, a place of pilgrimage and a focus of the seventh-century 'Northumberland Renaissance', whose products made the island as much a world centre of art as of spirituality. The beautifully illustrated Lindisfarne Gospels, now in the British Museum, are one of the greatest surviving treasures of the Golden Age of the English Church – an epoch which, even in this new golden age of cynicism and bottom-line accountancy, still seizes the imaginations of the visiting hordes who stream across the causeway from Beal. It is one of those places, like a stone circle or an ancient temple, which stirs something deeper and older than human memory – something which doesn't wait to be thought about,

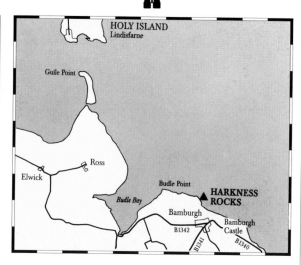

THE PANORAMIC VIEW (OVERLEAF) WAS TAKEN FROM HARKESS ROCKS, ON THE BEACH NEAR BAMBURGH, LOOKING APPROXIMATELY SOUTH-EAST TOWARDS BAMBURGH CASTLE. IN THE OPPOSITE DIRECTION IS HOLY ISLAND.

but which injects itself straight into the blood.

Not all visitors to Lindisfarne have been of devout, or even benign, intent. Its riches being also of the material kind, it was an obvious target for the Vikings. In their first raid on England to which a definite date can be attached – June 8, 793 – Norwegians sacked the monastery and either butchered the monks or forced them into slavery abroad.

It is not true to say that the island would have looked the same to Aidan or to his disciple and successor, the shepherd-boy saint Cuthbert (whose followers tramped Northumbria with his remains after the Viking raids). Its outstanding landmark, Lindisfarne Castle, is the legacy of a patron whose relationship with the Almighty was considerably more volatile. Henry VIII had it built in the 1550s, using stone from the already ruined priory, to keep the harbour safe from plundering Scots. Despite the reek of antiquity, however, even he might be hard-pressed to recognize it today. Having been stripped of its guns in 1819 (the only action it had ever seen was a short-lived Jacobite occupation in 1725), it fell into serious disrepair. Its saviour was the founder of *Country Life*, Edward Hudson, who in the early 1900s commissioned the architect Sir Edwin Lutyens to rebuild it for him as a home. Sir Edward de Stein bought it from Hudson in 1921 and presented it in 1944 to its current owners, the National Trust.

The remains of the priory itself are at Holy Island village, beyond the harbour west of the castle. This is not Aidan's monastery, or Cuthbert's, which must have been plainer and bleaker than a jail. The roofless sandstone arches result from the refoundation of the priory by Benedictines in the eleventh century. The

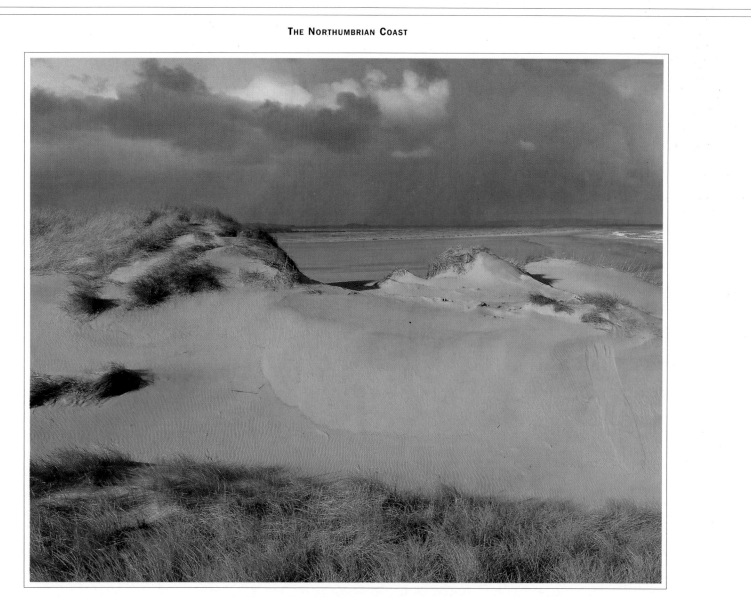

DUNES IN BUDLE BAY, SEEN FROM BUDLE POINT

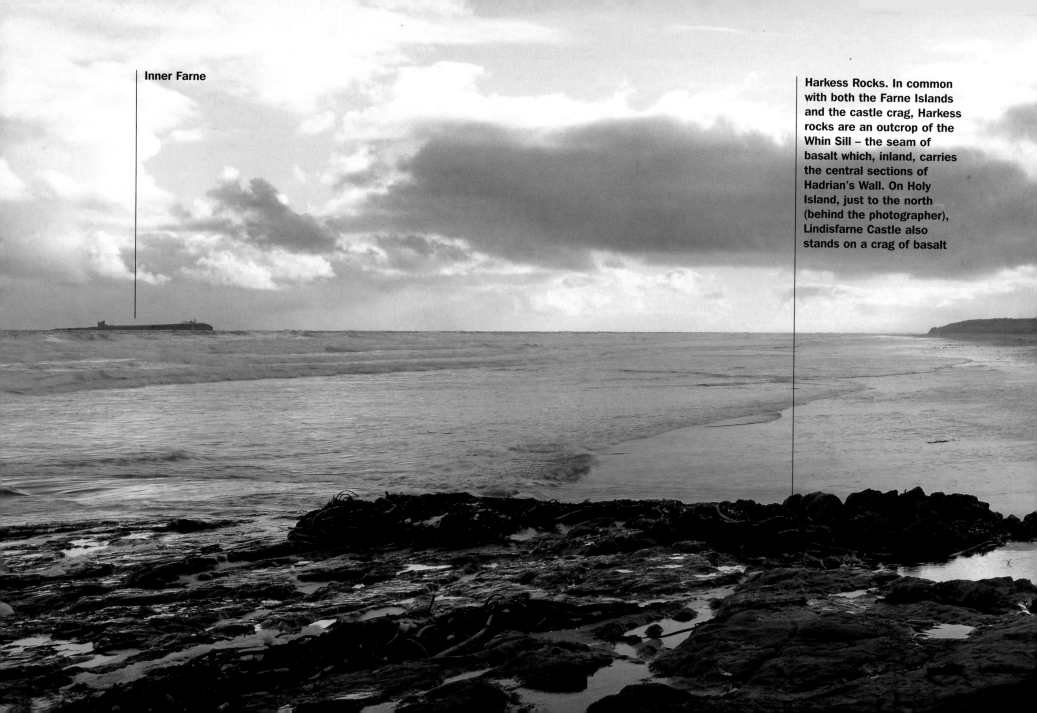

Inner Farne

Harkess Rocks. In common with both the Farne Islands and the castle crag, Harkess rocks are an outcrop of the Whin Sill – the seam of basalt which, inland, carries the central sections of Hadrian's Wall. On Holy Island, just to the north (behind the photographer), Lindisfarne Castle also stands on a crag of basalt

sun here can be as strong, and as pitiless, as the politics of the medieval church. Even on winter days, the sea framed by the arches catches the light and flares in the empty windows like crystal glass.

Holy Island is true to the second part of its name only twice a day when the tide covers the causeway. The ridge on which the castle stands, Beblowe Crag, is whinstone, a vertical slab or 'dyke' of coarse-grained basalt which is an offshoot of the Whin Sill – a craggy scarp which, inland, carries and reinforces the central sections of Hadrian's Wall. Most of the rest of Holy Island is tidal mudflat (important for waders, geese and other wildfowl), sand dunes (a National Nature Reserve containing several rare species of plant) and outcrops of limestone which were once quarried for lime. The stone was burnt in kilns below the castle.

The Whin Sill proper meets the coast just south of Holy Island, at Bamburgh, and has its last visible fling about a mile and a half out to sea in the Farne Islands. This is where St Cuthbert first lived as a hermit, in 676 to 684, and where he returned to die in 687. A fourteenth-century chapel dedicated to him now contains a memorial to the local heroine Grace Darling, the Longstone lighthousekeeper's daughter who famously rowed to the rescue of a wrecked passenger steamer off the Farnes in 1838.

The Farnes, which also belong to the National

A WAY OF LIFE – TOOLS OF THE TRADE ON HOLY ISLAND

Trust, are an internationally important breeding site for seabirds (eider, puffin, guillemot, fulmar, cormorant, kittiwake) and grey seals. Two of the islands – Inner Farne and Staple – may be visited by boat from Seahouses.

The Whin Sill basalt, or dolerite, is an igneous rock that was injected between beds of Carboniferous limestone about 300 million years ago. Its uncountable vertical joints give it a craggy, columnar structure like the basalt of the Giant's Causeway.

Nearby Bamburgh Castle grows almost seamlessly out of a cliff of it, and dominates the coastline for miles in each direction. Bamburgh has had at least three incarnations: a Norman castle replaced an earlier Saxon one, and was itself rebuilt in fine Victorian medieval style in the 1890s and early 1900s by the arms manufacturer Lord Armstrong. The impact is astonishing – like some Hollywood fantasist's blueprint for Camelot.

Northumbria has fortifications like East Anglia has windmills: every view seems to have a castle in it. The reason is a history of cross-border hostility with the Scots, for which the Romans set the agenda when they built Hadrian's Wall. Northumbria for centuries afterwards was the front line in a running territorial war, and cross-border horse- and cattle-thieving vied with crop-burning as the favourite Borderer's sport. When the Scots won at Bannockburn in 1314, Northumberland responded with a rash of castle-building that made it the most heavily fortified county in England. The sniping continued right up until the late sixteenth century and it was not until 1603, when the two thrones were united under James I, that Northumbrians could look to the border without suspicion.

OVERLEAF:
HOLY ISLAND VILLAGE AND THE PRIORY

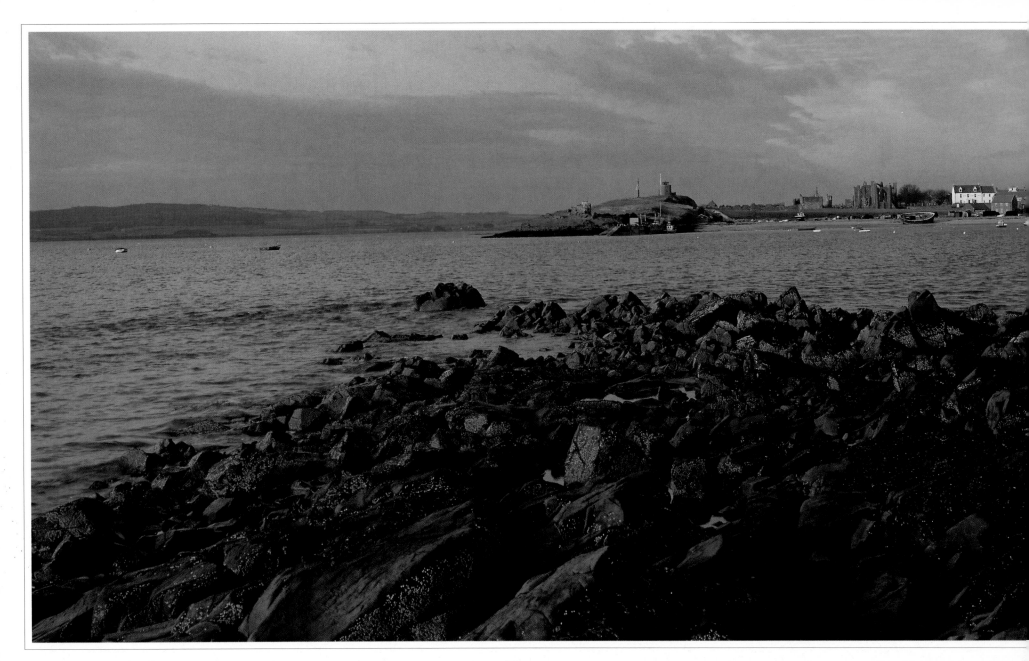

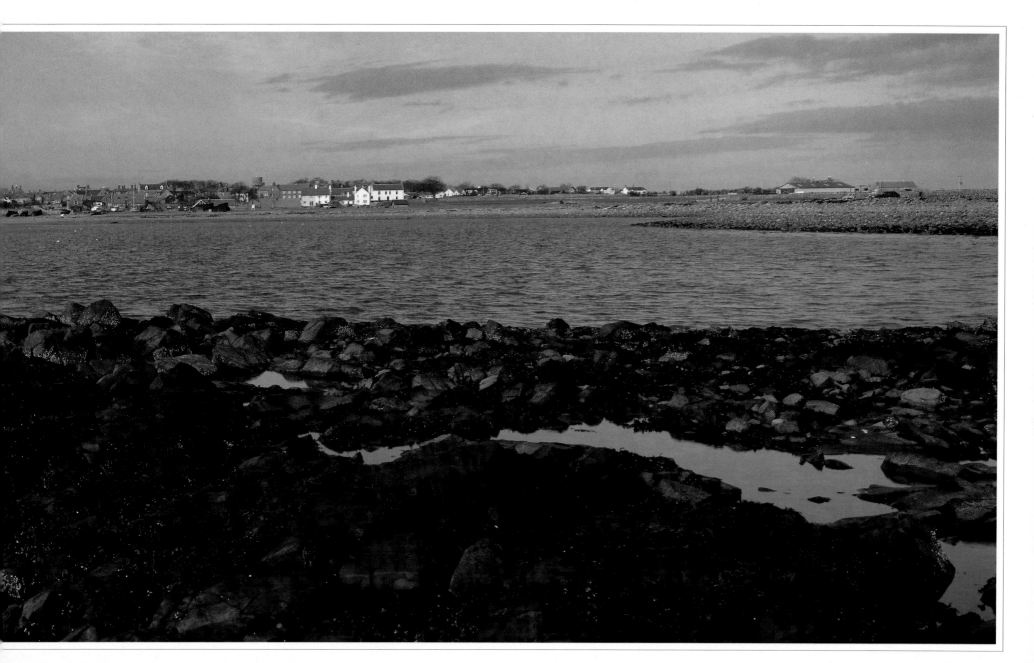

THE NORTH CORNISH COAST
Trencrom Hill and St Ives town

CORNWALL. IT IS one of those names, like Sahara or Alaska, that immediately conjures an image in the minds of people who have never seen it. When an American thinks of England, likely as not he pictures Cornwall.

It is, unsurpassably, the kingdom of the sea – a pagan kingdom that seeks or needs no other god. On all but the calmest days when the Atlantic is vitreous in its depth and stillness, the entire Cornish peninsula sits like a slab of cake on a white lace doily. On wild days, curling cliffs of water hurl themselves, and anything within their grasp, with shocking force against the fists and fingers of rock. No community could live with such a neighbour and not be shaped by it.

Cornwall's notion of itself as a place apart is nourished by this fearful proximity, by the sense of belonging more to the Atlantic than to the tenuously connected landmass to the east. No place in Cornwall is more than 15 miles from the sea, and from the hilltops, where the view stretches to both north and south coasts, the horizons are more ocean than land. The photograph opposite was taken from the summit of Trencrom Hill, south-east of St Ives on the north Cornish coast, with the camera pointing approximately north-west, across St Ives Bay to

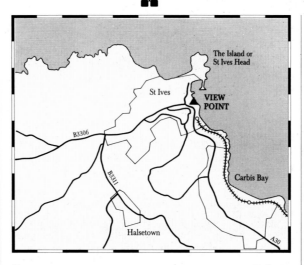

THERE ARE MANY POINTS WHICH AFFORD GOOD VIEWS OF ST IVES. THE PHOTOGRAPH OVERLEAF, LOOKING TOWARDS THE ISLAND ACROSS HARBOUR BEACH, WAS TAKEN FROM THE BUS DEPOT.

Godrevy Island and Navax Point.

The view in the opposite direction is another classic – a patchwork of meadows and arable fields which has no sooner assembled itself into a pattern than it plunges over the lip into Mount's Bay on the south coast. Everything – the angular grid of hedgerows, the curve of the bay, the southern horizon slicked with cloud – is composed into a frame for one

of England's most iconic seascapes: the distant view of St Michael's Mount.

The rocks in the foreground of the picture are exactly what they appear to be – granite. This is the eastern edge of the most westerly of the Cornish granite masses, marked by a wide depression, running north–south between St Ives and Mount's Bays, which was once a strait (when it was younger, the land stood 400 feet lower than it does today). After the sea, it is the stone that lends most to Cornwall's character. The shape of the western tip of the county is defined by the outline of the granite mass, which stands up to the sea more stubbornly than the neighbouring slates. The sweep of Mount's Bay, for example, is precisely chiselled to the profile of the granite rim. Elsewhere the process is still continuing. On the north-west coast between Cape Cornwall and St Ives there are places where the waves biting through the greenstones (slates and dark green igneous rocks) have not yet broken their teeth on the granite and are still eating towards the core.

Cornwall builds its houses of granite. It has fought an ultimately losing battle to wring tin from its grasp – a battle commemorated in the landscape of Penwith, around Zennor to the west of St Ives, by the abandoned hulks of chimneys and engine houses.

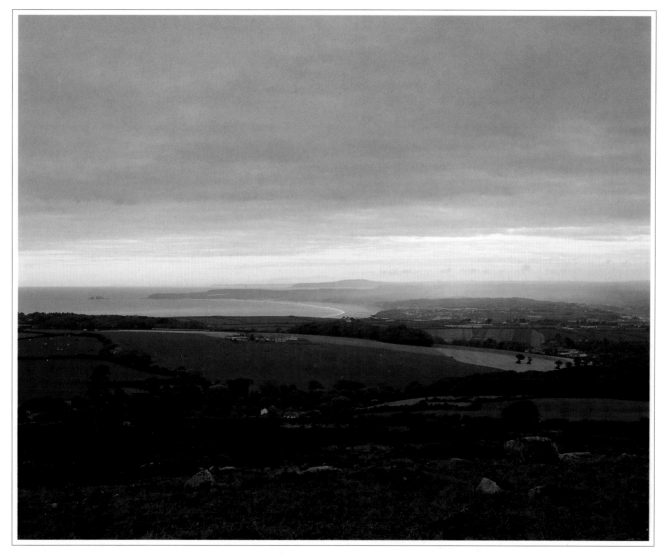

St Ives Bay from Trencrom Hill, looking towards Navax Point

St Ives parish church, dedicated to St Ia, said to have floated on an ivy leaf from Ireland to Cornwall

Hidden behind the isthmus is Porthmeor beach, popular with surfers. It is overlooked by the Tate Gallery

The lifeboat station

At the neck of the isthmus is the old fishermen's quarter a warren of cobbled lanes, steps, artists houses and old pilchard cellars

West Pier

St Nicholas
chapel

The Island, or St Ives Head, joined
to the town by the isthmus

Smeaton's Pier
and lighthouse

Harbour
beach

The cottages here stand on Crab Rocks,
their footings almost in the sea

In its decayed, or 'kaolinized', form the rock conveniently transforms itself into another of Cornwall's traditional cash crops, china clay. Among the adder-haunted bracken and heather of Trencrom Hill, however, the granite is as raw as the day it cooled and hardened.

In human terms, too, the hill is ancient history. Trencrom is the site of a Celtic (Iron Age) hillfort, where at least seventeen circular huts stood within a stone wall enclosing approximately an acre of land. Pottery found here suggests a date around the second century BC. It was two centuries earlier that the Celtic people first arrived in Cornwall – an event which has bequeathed to the county its rich seam of folklore.

Being much taller than the earlier Neolithic and Bronze Age peoples, the newcomers were seen as giants. The lofty Celts for their part looked down upon the smaller, swarthier natives as dwarves. Hence, alas, the wretched giants and 'piskies' which have become as inescapable a part of Cornwall's marketed image as that other devalued relic of an heroic past, the pasty. Once it was a meal fit for a man to go to work on. Now, with a few noble exceptions, it is a machine-made travesty that defies analysis.

The town of St Ives, in the panorama on the previous pages, is the accredited record-holder for what was once the linchpin of the Cornish economy, pilchards. It is claimed that, in 1834, thirty million

FISHER'S DELIGHT – SUNSET AT ZENNOR HEAD

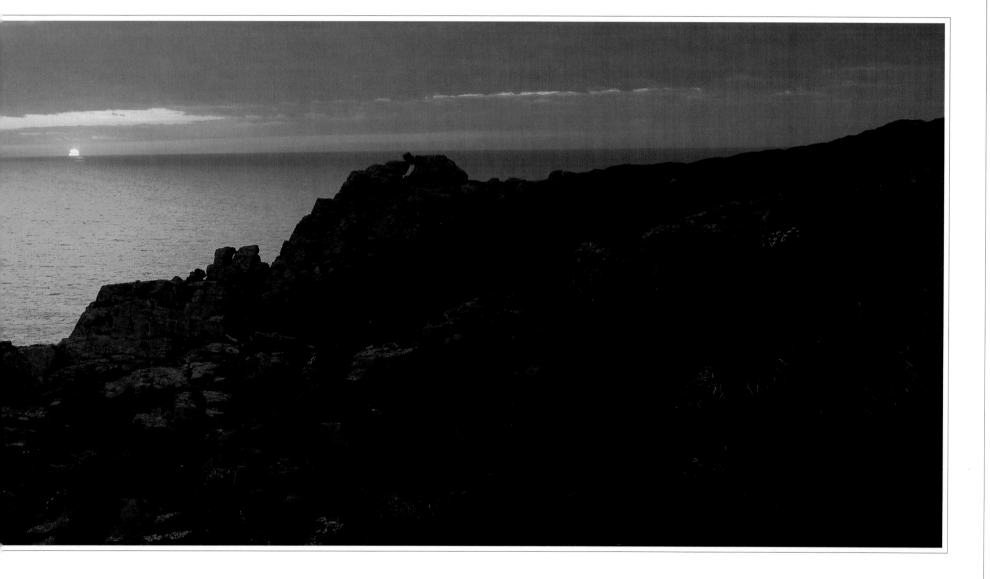

of them were landed here in a single hour, though the name of the man who counted them is not recorded. A combination of over-exploitation and changed water conditions have sent the pilchard the way of Cornish tin, though the fishermen have fared rather better than the miners in its wake. Life is hard, but the sea still yields up a serviceable trawl of other species, and the yo-ho-ho Cornish fisherman, one of the most robust of English stereotypes, at least has his sea boots solidly planted in reality.

The stench of pilchards' blood might not have been much to the taste of modern tourists, but it did nothing to deter the painters who have feasted on the intense Italianate light of St Ives ever since Turner paid a visit here in the 1880s. He was followed by Sickert and Whistler, and later by a celebrated twentieth-century school whose members have included Ben Nicholson, Barbara Hepworth and Patrick Heron. The importance of St Ives to British twentieth-century art was in no way exaggerated by the opening there in 1993 of a brand new gallery, overlooking Porthmeor Beach, to display the Tate Gallery's collection of modern Cornish pictures.

WHERE IT ALL BEGAN – ANCIENT FIELDS NEAR ZENNOR

Further around the bay, to the east, is Hayle. From Trencrom Hill, cradled in the sands, it looks sleepy and bland. In fact in the last century it was the crucible of Cornish industry, a sweltering smokescape of foundries which blackened the air like a transplant from the industrial north. Its products were steam engines, machinery and boilers for the mines – not an

easy thing to visualize on a broiling summer's day with a cone of good Cornish ice cream in your hand.

It was further round the bay again, overlooking Godrevy lighthouse, that Virginia Woolf enjoyed – or perhaps endured – the childhood picnics that made the background for *To the Lighthouse*. As an adult she returned to rent a cottage on the Penwith peninsula near Zennor, which had earlier been used by both Katherine Mansfield and D. H. Lawrence, who wrote *Women in Love* here. It was Lawrence's misfortune during the First World War to have a German wife, Frieda, and to be careless with flickering lights in his window. In the minds of the locals, *zwei und zwei* made *vier* and he was hounded out of the county as a spy.

If Cornwall has a soul, then Zennor is perhaps the place you would dig for it. The irregular, stone-walled field boundaries seem to run across the tamed moorland landscape like paint dribbling to the sea. They date from the Celtic Iron Age – the age of the giants – but follow a pattern laid down in prehistory. It would be a pisky indeed, a dwarf of the spirit, who could come to such a place and not feel uplifted by a sense of man and nature in rare and enduring harmony.

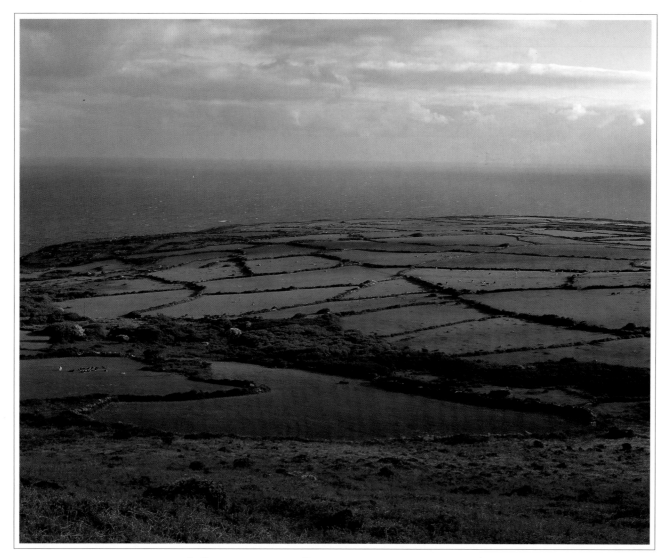

'IF CORNWALL HAS A SOUL, ZENNOR IS WHERE YOU WOULD DIG FOR IT'

CHESIL BEACH IS easy on the eye, hard on the feet and impossible to explain. One theory is that the Fleet, the narrow stretch of tidal water on the landward side of the beach, is a bay which has been stoppered by an offshore bar forced landward by the tide. Most geologists, however, believe it is the result of wave action on the beach itself.

Waves driven by the prevailing wind hit the shore at an angle, but the backwash – in obedience to gravity rather than wind – sucks the water, and anything being carried by it, straight back down the beach by the shortest route towards the sea. Sand and gravel swept up by the incoming waves thus are disgorged each time a little further downwind, so that the whole beach is perpetually on the move. It is a process which geologists call 'longshore drift'.

As it stretched south-east towards the Isle of Portland, so the theory goes, the bank kept to its line of advance and simply cut off the body of water behind it. So far, so straightforward. The great shingle bank extends in total 15 miles from Bridport to Portland, the last eight of them (shown in the panorama overleaf) enclosing the Fleet. It rises up to 50 feet above sea level and is 600 feet wide – a formidable barrier which generates a vicious undertow and is a danger to swimmers throughout its length.

THE VIEW OF CHESIL BEACH (OVERLEAF) WAS TAKEN FROM WEARS HILL. BY CAR, TAKE THE B3157 OUT OF ABBOTSBURY TOWARDS SWYRE. AT THE TOP OF THE HILL, PULL INTO THE LAYBY AND LOOK BEHIND YOU.

Many ships, too, have gone to the bottom here. A storm of historic violence in 1824 swallowed an East Indiaman and all its crew, drove another ship clean across the shingle into the Fleet, and wrecked the village of East Fleet, scene of Meade Falkner's novel *Moonfleet*. Whales have been washed up here. So too, apparently, have sharks, wreckage from Spanish galleons and Roman coins. What makes Chesil Beach unique, however, is not the sheer size or danger of it so much as the extraordinary arrangement of the stones.

Wherever along the bank you look, the pebbles as far as you can see appear to be of exactly uniform size. Revisit it at intervals along its length, however, and a very different story begins to emerge. As you head east, the stones gradually get bigger. Near Bridport they are scarcely larger than peas. By the time you reach Portland they have grown to the size of large potatoes, or even bigger. It is as if they have been sieved, or arranged by a librarian. Some fishermen have claimed they can tell whereabouts they are simply by listening to the changing note of the waves along the shingle.

The cliffs of Portland are in effect a gigantic natural groyne which prevents the extension of the bank any further to the east. The stones of Chesil Beach – mostly rounded flints from the local chalk and quartzite from sandstone – do not find their way around Portland Bill into Weymouth Bay, where the shingle is made of the limestone for which Portland's quarries have made it famous. By some accounts, however, the flow of pebbles from Chesil Beach turns back on itself in deeper water where the process of grading is repeated *in reverse*, now increasing in size towards Bridport.

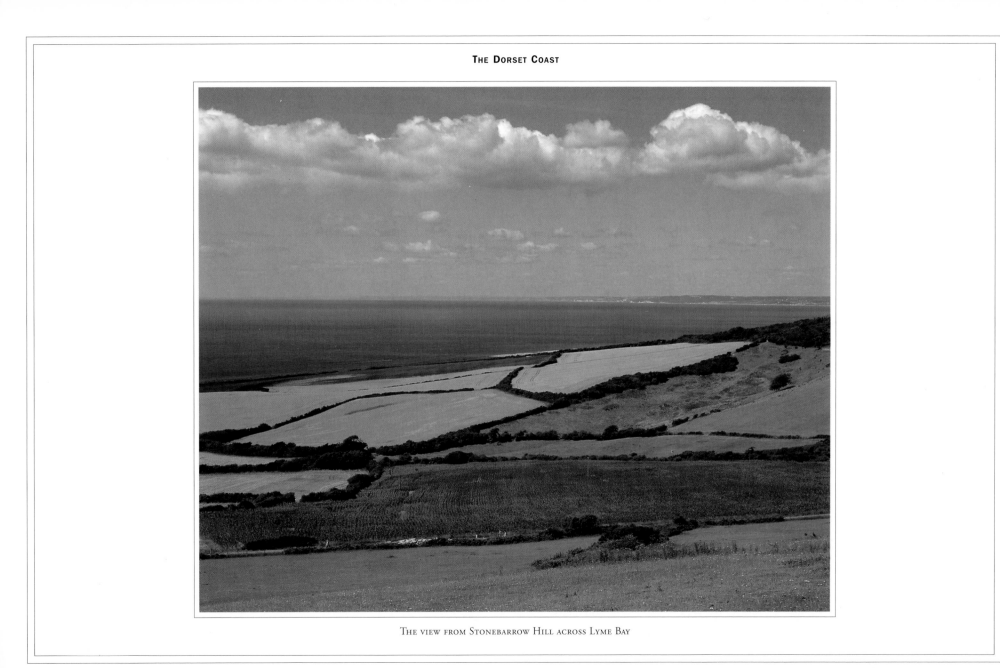

THE VIEW FROM STONEBARROW HILL ACROSS LYME BAY

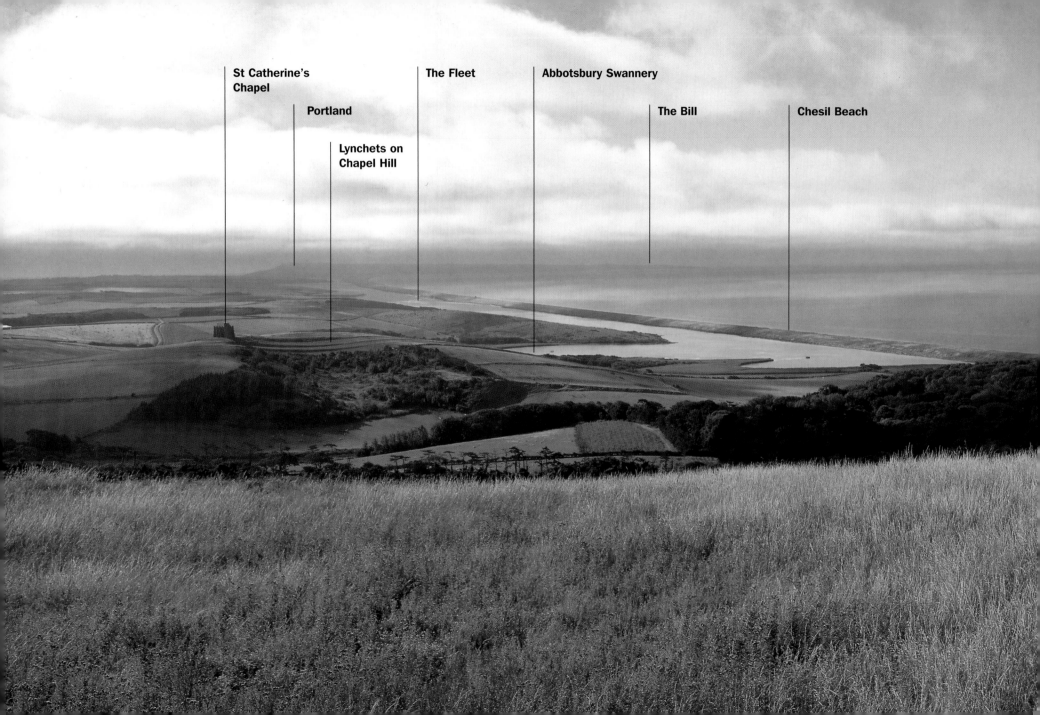

St Catherine's
Chapel

Portland

Lynchets on
Chapel Hill

The Fleet

Abbotsbury Swannery

The Bill

Chesil Beach

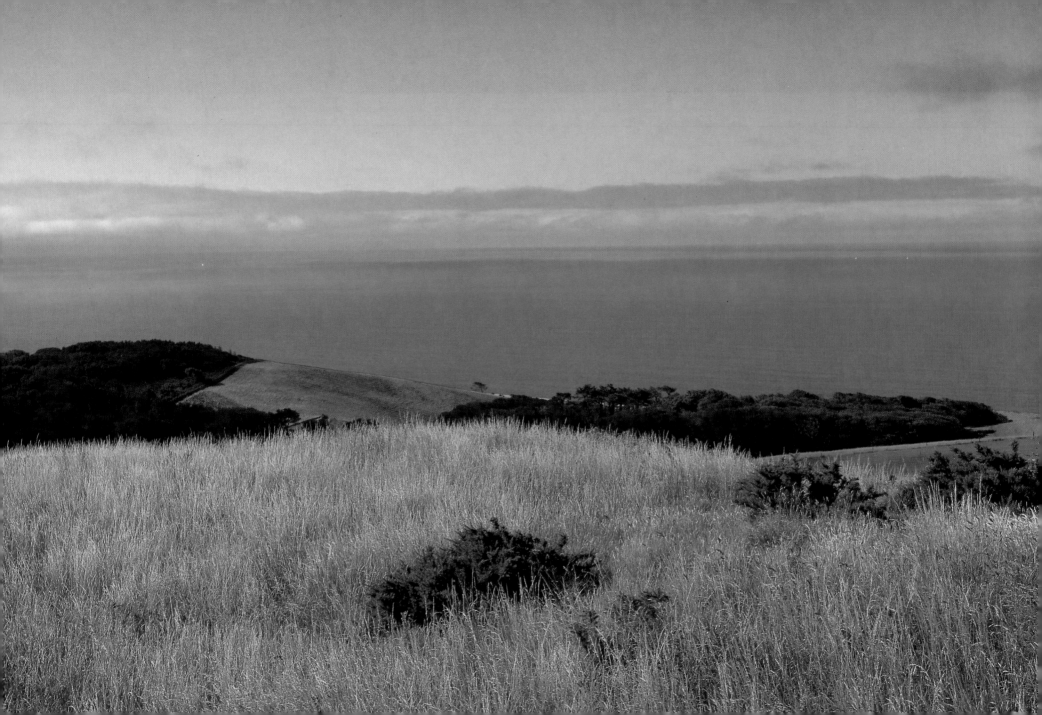

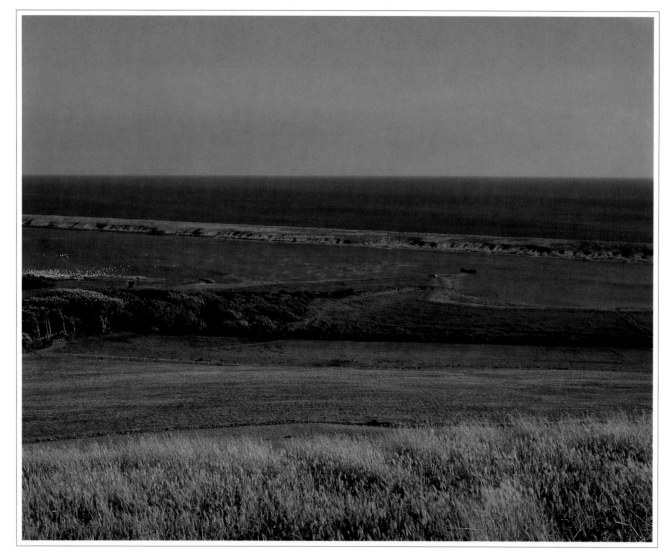

CHESIL BEACH, THE FLEET AND ABBOTSBURY SWANNERY

The Bill itself is a view more comfortably admired from onshore vantage points than from the sea. For sailors, the eddies around Portland are a beckoning graveyard. The six-mile peninsula's disruption of the tidal flow, exacerbated by the Shambles – a huge underwater bank of stones and shell fragments – stirs the sea into a pinnacled maelstrom with an insatiable appetite for boats. For a yacht skipper the sensation is like being hit by a whirling complex of garden walls.

Few people would call Portland beautiful. Hardy's name for it, the Isle of Slingers (after the inhabitants' reputed talent for hurling stones), hardly suggests a fondness. It is a lump of raw geology, a tapering mass of limestone pitted with quarries, which scarcely supports a tree. Its villages bear the marks of the three most visible local employers – the Royal Navy, the prison service and the quarries themselves – and are most politely described as 'austere', like gritty, wind-scoured chunks of northern England that have become attached to Dorset by mistake. Yet from its hard heart has been hewn a catalogue of architectural and sculptural masterpieces by the likes of Sir Christopher Wren, who used Portland stone for his rebuilding of

HALL OF PLENTY – THATCHED BARN NEAR ABBOTSBURY

St Paul's Cathedral, and the sculptor Henry Moore. There is beauty, but you have to dig for it.

Birds are perhaps the most contented of residents and the most numerous and varied visitors. An observatory in an old lighthouse keeps watch on the whirling flocks of migrants, often including rare exotics, which gather here in spring and autumn.

The panoramic photograph was taken from Wears Hill, near Abbotsbury, looking south-east along Chesil Beach and the Fleet, with the Isle of Portland filling the horizon. The hill in the centre is Chapel Hill, with early cultivation strips or lynchets clearly etched in the sunlight. The building on the crest is a fourteenth-century seaman's chapel dedicated to St Catherine – its value to mariners as much navigational landmark as spiritual refuge (the turret is a lighthouse). With walls four feet thick, however, it is a worthy monument to terrestrial solidity. Even the roof is built of stone.

In Dorset as elsewhere the Reformation put paid to many of the finest medieval monastic buildings. Abbeys and their churches were used as self-service builders' yards, their fabric plundered and carted off stone by stone. Disproportionately large blocks set in the walls of otherwise modestly proportioned houses are strong circumstantial evidence of the culprits' identity. Abbotsbury lost just about every vestige of its eleventh-century Benedictine abbey save a ruined cloister, a vast and magnificent fourteenth-century tithe barn and the famous swannery, which survives on the West Fleet just below Chapel Hill.

The number of mute swans here varies but is usually put at around five hundred. They have swum here since the days of the Plantagenet kings.

Eel grass is what the swans like to eat. Eels, too, are in abundance and help make the Fleet as popular with fishermen as it is with waterfowl and walkers. A word of warning, however. Unless you are in the mood for hard exercise, do not be tempted to accept what, from the hill, may look like a clear invitation to explore the Fleet's southern shore by way of the beach. There are few surfaces more exhausting underfoot than deep, shifting shingle. Keep to the northern side and follow the South West Coast Path instead.

ABOVE: NEAR ABBOTSBURY
RIGHT: THE VIEW FROM PORTLAND HEIGHTS

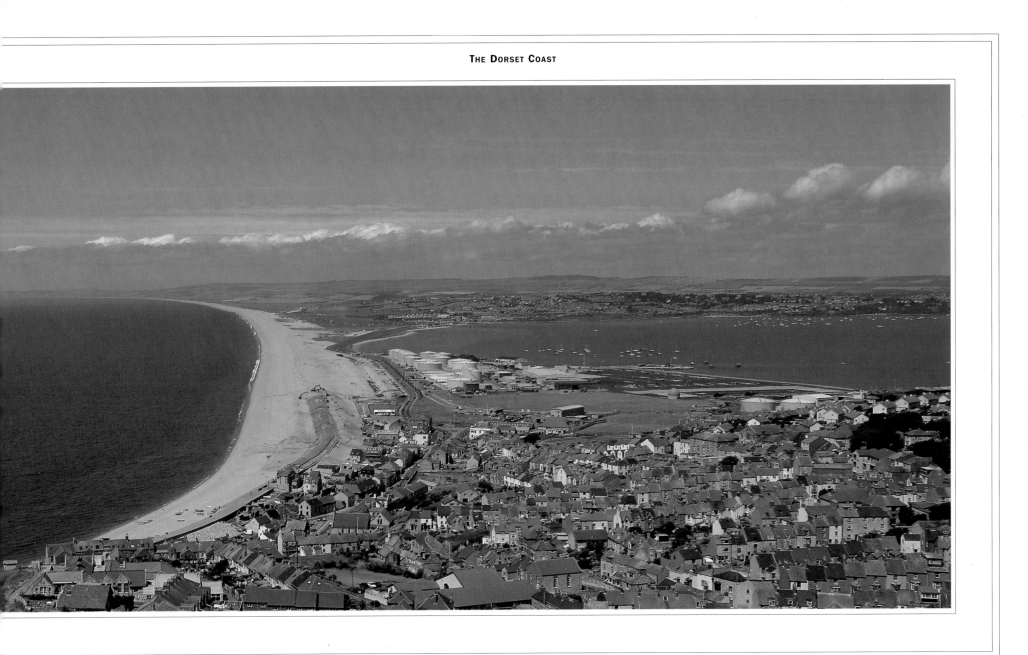

THE SOUTH DOWNS
Devil's Dyke and Ditchling Beacon

MORE THINGS THAN you might imagine have had a hand in making the South Downs look the way they do. Earthquakes, ice, farmers from every known period of human civilization; sheep, rabbits, agribusiness, wars and myxomatosis.

Its roller-coaster profile, with huge views both landward and over the sea, make it the signature landscape of southern Britain, rivalled only by Southend as London's favourite weekend escape. The one thing everybody knows about the South Downs is what they are made of. With the Chilterns and the North Downs they make up a trio of chalk ridges extending eastward from Salisbury Plain, climaxing in a *coup de theatre* at Beachy Head, where England's most dramatic, romantic and, all too often, tragic chalk cliff falls more than 500 feet sheer to the sea.

It is the sea, of course, to which the chalk owes its existence. Over millions of years a thick sheet of marine debris – small shells and crushed fragments of larger ones – accumulated on the floor of what would then have been a clear ocean. It was shoved up and folded by the same sequence of movements in the Miocene epoch that created the Alps, making an initially dome-shaped mass (in geological terms, an anticline) which over the next several million years was stripped of its crest through erosion. The original,

THE PANORAMA (OVERLEAF) WAS TAKEN FROM THE SOUTH DOWNS WAY, JUST WEST OF DITCHLING BEACON, LOOKING ALMOST DUE NORTH. ACCESS BY CAR IS FROM THE B2116 FROM EITHER DITCHLING VILLAGE OR LEWES.

pudding-shaped profile of the chalk may be imagined (though still on a much reduced scale) if you picture the outer, seaward dip slope as a smooth curve extending inland to fill the space behind the landward scarp. It is into this space, carved by wind and water, that the camera is looking in the panorama overleaf.

The photograph was taken from the South Downs Way near Ditchling Beacon – at 813ft (248m) the

highest point in East Sussex – looking due north towards Haywards Heath and the distant High Weald. The word 'weald' is an Old English relative of the German *wald*, meaning 'forest' – which is an exact description of what nature meant to happen here. Before the Channel made Britain an island, hazel, oak and possibly beech (some researchers now think beech was introduced later) would have spread this way from continental Europe. The oak settled happily into the heavier clay of the weald itself while beech – which remains the characteristic species of the Downs – was perfect for the chalk.

The logic of all this can be read in what you see, though it does nothing to solve the word-puzzle. How is it that, in defiance of gravitational logic, one finds oneself 'up' on the Downs? The answer is in the Old English word for hill – *dun*.

In the Middle Stone Age (the Mesolithic period), hunters scoured the hills and valleys for deer and pig. But it was in the New Stone Age (the Neolithic), some six thousand years ago, that farmers began seriously to attack the trees and to establish the first permanent settlements. They found the thin soils of the chalk ridge relatively easy to clear, and there was an inexhaustible supply of flints for their axes.

Bronze Age farmsteads came next, then the great

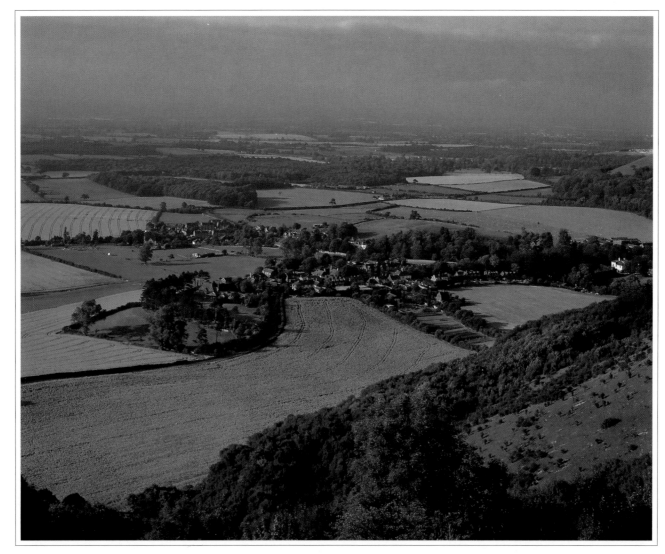

THE VIEW NORTH FROM DEVIL'S DYKE ACROSS POYNINGS VILLAGE

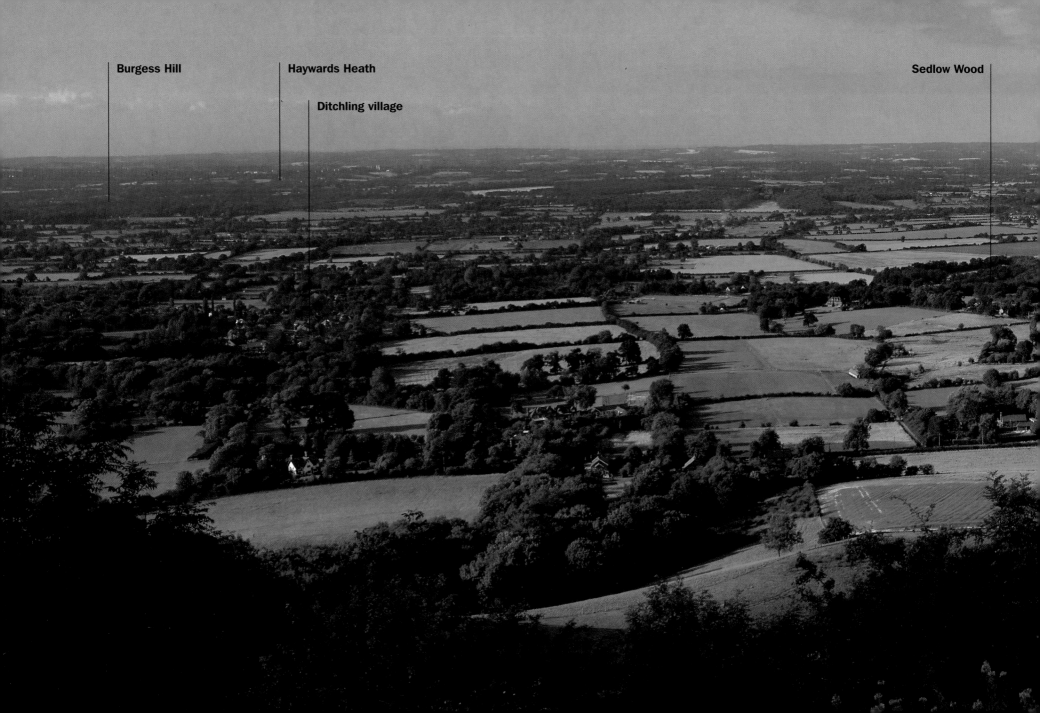

Burgess Hill

Haywards Heath

Ditchling village

Sedlow Wood

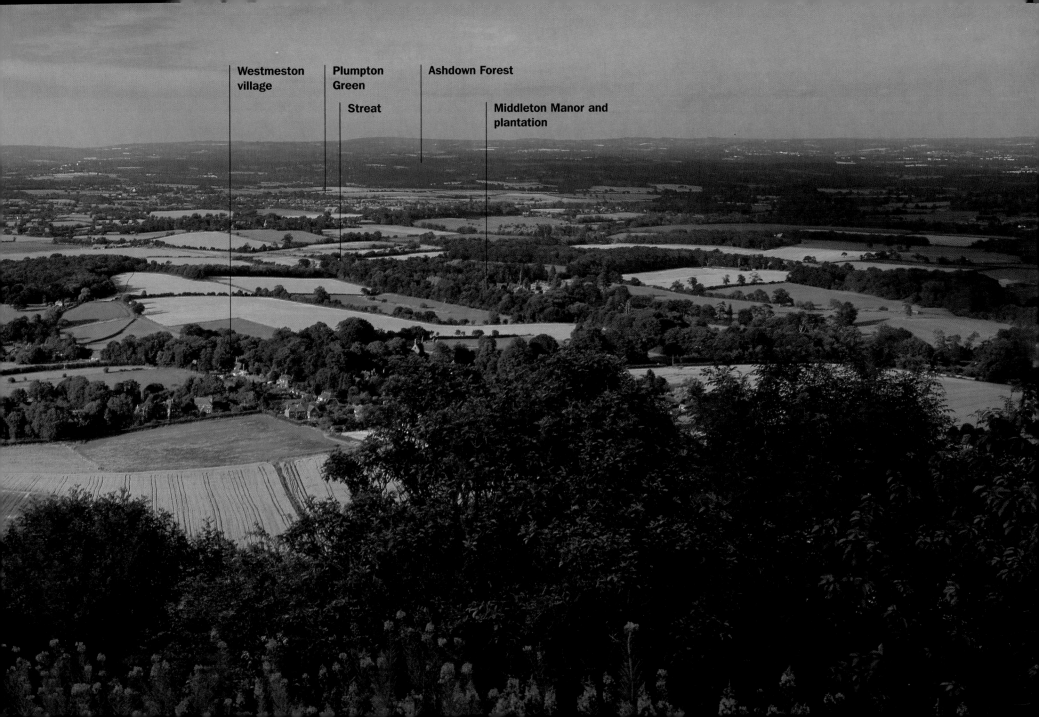

Westmeston
village

Plumpton
Green

Streat

Ashdown Forest

Middleton Manor and
plantation

civil and military engineers of the Iron Age. Ditchling Beacon is the site of one of their many embanked and palisaded hillforts. So too, more famously, is Chanctonbury Ring, a short distance along the chalk ridge to the west. Chanctonbury is a smallish fort, roughly pear-shaped, which contains a clump of beeches (planted in 1760, during his boyhood, by Charles Goring of nearby Wiston House) that were one of Sussex's most prominent landmarks until they were hit by the great storms of 1987 and 1990. The atmosphere here is discomfiting to some, and there are numerous legends of witches, ghosts and other manifestations of the Sussex underworld. To come face to face with the Devil himself, it is said, you need do no more than run seven times around Chanctonbury Ring. Small wonder, therefore, that – especially on pagan red-letter days like the Winter Solstice – it maintains an active appeal to *al fresco* devil-worshippers and/or pranksters, or that post-solstice debris cleared away by conservation workers has included bagfuls of headless chickens.

Sheep flocks were already being run on the lower slopes during the Roman occupation, though the big money crop then was wheat. Saxon, Norman and medieval farmers in turn kept up the process of agricultural intensification, with small farmsteads continuing to pin their faith on a combination of

DIABOLICAL BEAUTY – LOOKING THROUGH DEVIL'S DYKE

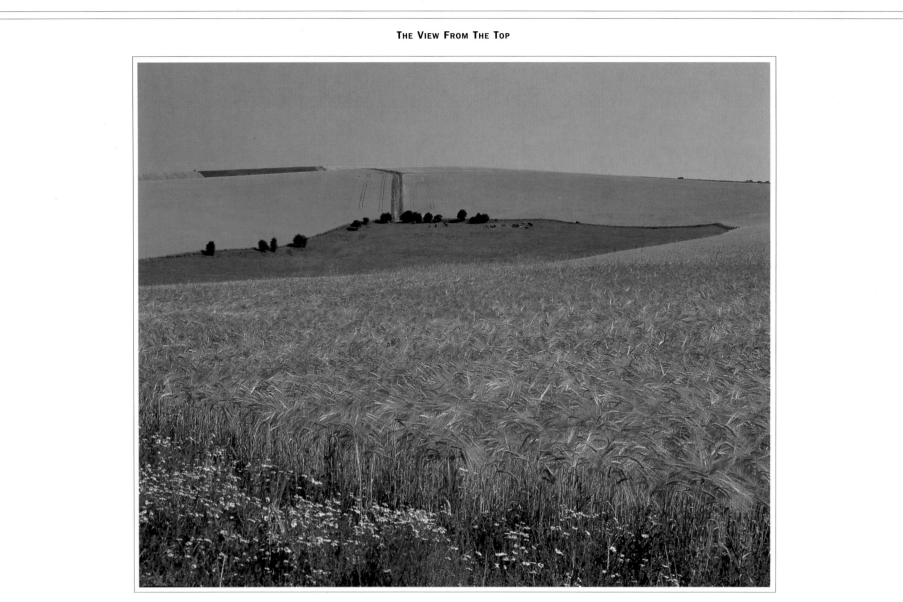

KING BARLEY – LOOKING NORTH FROM HEATHY BROW

sheep and corn. By the late fifteenth century, an important change had taken place – a change which leaves as its legacy the very shape and texture of the Downs as we now see them. The contest for dominance of the agricultural landscape between crops and flocks had been decisively won by the sheep. Thousands upon thousands of them chewed their way up and down the hillsides, with machine-like efficiency converting the last remaining vestiges of 'weald' into sward.

A seething population of rabbits later added their weight to the process, shifting greenstuff as rapidly as they reproduced their own kind. No seedling survived to become a sapling; no sapling became a tree.

Much of this is still evident in the landscape we see: it is still well barbered, still as remote from true 'weald' as it is possible for a living landscape to be. But something else, something vital, has now gone missing from it too – the sheep themselves.

The reasons for this are both historical and economic. Historical because the Second World War (like the Napoleonic wars before it) raised the banner of national self-sufficiency and brought huge tracts of Downland pasture back under the plough. Economic because post-war developments in agricultural machinery and chemicals, combined with major changes in European and world markets, have altered

THE DOWNS – DUE EAST FROM DITCHLING BEACON

the agricultural landscape quite beyond the recognition of anyone who knew it before the war. Where mutton once ruled, barley now is king, and oilseed rape the prince. Many people dislike the 'alien' intrusion of rape (and equally of blue flax, or linseed), but others find the dense, wax-crayon yellow an almost painterly touch among the early summer greens. Van Gogh, one feels, would have been drawn to it like a butterfly – though even he might not have cared too much for its stick-in-the-nose, sickly smell.

The South Downs Way was opened in 1972 and still remains the only National Trail which is designated as a bridleway. It runs for a hundred miles, from Eastbourne to Winchester, and conducts the walker, cyclist or horse-rider through a sequence of archaeological and historical cameos that propels them as much across time as through distance. Neolithic, Bronze and Iron Age people lived, farmed and buried their dead here. A signal fire on Ditchling Beacon warned of the Spanish Armada in 1588; William Cobbett got a drenching on the ridge in 1823. There are legends, ghosts, echoes of a past which, though not long dead, might anywhere else seem as remote – and as remarkable – as the geological era when the weald stretched all the way to France.

Here, however, it is different. You may be more likely to meet a hang-glider than a Southdown sheep (such sheep as remain are modern, low-fat hybrids), but still the South Downs cling to their identity, and to their history, as stubbornly and as unyieldingly as the sea they overlook.

OVERLEAF:
FROM STANMER DOWN TOWARDS SEVEN SISTERS

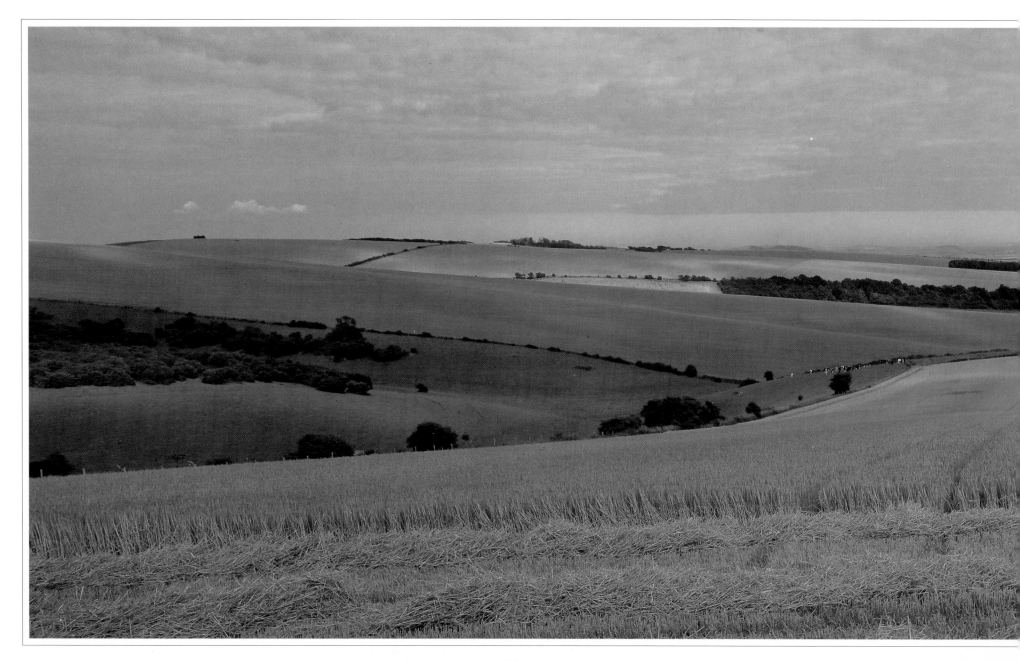

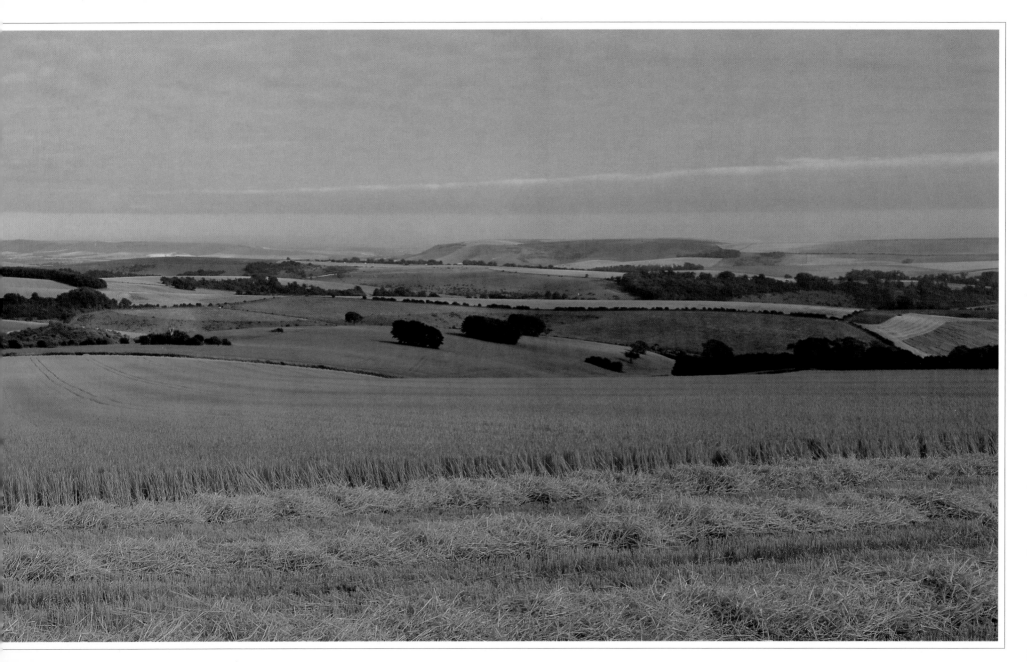

THE HIGHLANDS OF SCOTLAND
Loch Morlich and Cairn Gorm

SOME SUBJECTIVE JUDGEMENTS are so widely shared, and so rarely challenged, that they might as well be regarded as empirical truths.

One such judgement is reflected in these pictures. The Highlands of Scotland, together with its islands and coastline, is not only the grandest, most dauntingly beautiful landscape in Britain. It is also, beyond all reasoned argument, one of the finest in the world. Even to call it 'a landscape' is to seriously undersell its importance and scale. Geologically it is deep, ancient and vast. Historically it is monumental. Scenically it is beyond the range of all but the most extravagant of superlatives. Through any eyes, and in any language, it is unique.

Within the Highlands – on the north-west mainland and in the Outer Hebrides – are the oldest rocks in the British Isles, with 1000-million-year-old sandstones crowning even older gneiss. The assault by internal forces on the earth's crust was nowhere more brutal than here. The shunting of land masses some 400 million years ago forced up a mountain chain of Himalayan scale which stretched from here to Northern Ireland, Cumbria and Snowdonia. The Great Glen, a hundred-mile-long wrench fault which splits Scotland like the blow of an axe from north-east to south-west, was formed at this time – a cleft into

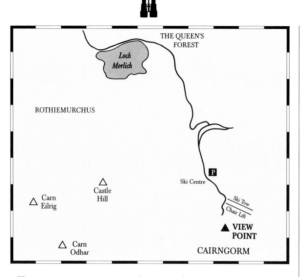

THE PANORAMIC VIEWPOINT (OVERLEAF) IS APPROACHED FROM AVIEMORE BY WAY OF THE ROAD TO THE SKI CENTRE, WHERE THERE IS A LARGE CAR PARK. THE VIEW IS FROM THE NORTHERN CORRIES, SOUTH-WEST OF THE SKI TOW, LOOKING NORTH OVER LOCH MORLICH. THE WALK FROM THE CAR PARK IS QUITE STRENUOUS.

which nature later tipped the peaty depths of Loch Ness, and through which the engineering genius Thomas Telford threaded the Caledonian Canal in the early nineteenth century. He intended it to lubricate trade and create employment – and it still does, though most of the jobs now are in tourism.

Much of the rock, including that of the Cairngorms where the photographs were taken, is granite. The area, eroded to a stump of the original, was uplifted again about 500 million years ago, then more recently gripped and stirred by ice. There have been many 'ice ages' during the past 100 million years – perhaps as many as twenty – with the depth and range of the ice reaching its maximum about 18,000 years ago. The summit of the ice-cap then probably topped 5000 feet – well above the mountain peaks frozen inside, and about 1500 feet higher than the point from which the panorama overleaf was taken. The weight of it was so enormous that it actually reduced the height of the ground through compression. The freezing and thawing of the ice, the movement of the glaciers, carved the valleys and scooped out the characteristic corries – gouged hollows – at their head. The ice retreated for the last time some ten thousand years ago – two thousand years before the arrival of man in the Highlands – leaving behind it the rough maquette of the landscape we know today, with its shattered peaks, rutted valleys and deep, silent lochs.

This is not to say that the landscape has looked the same for ten thousand years. It hasn't. The climate following the meltdown of the ice would have been

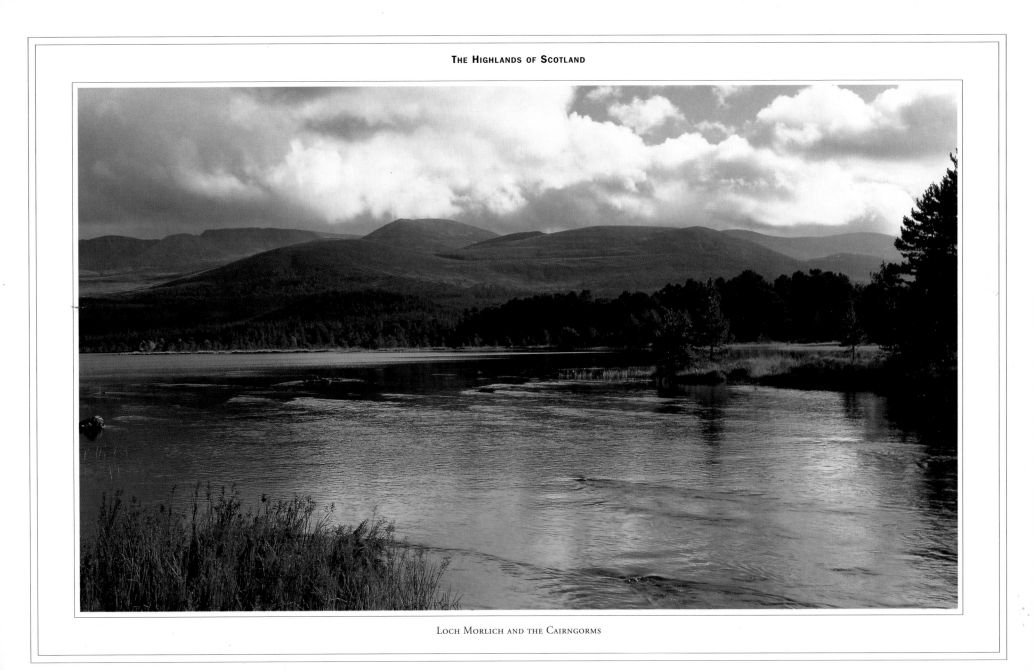

LOCH MORLICH AND THE CAIRNGORMS

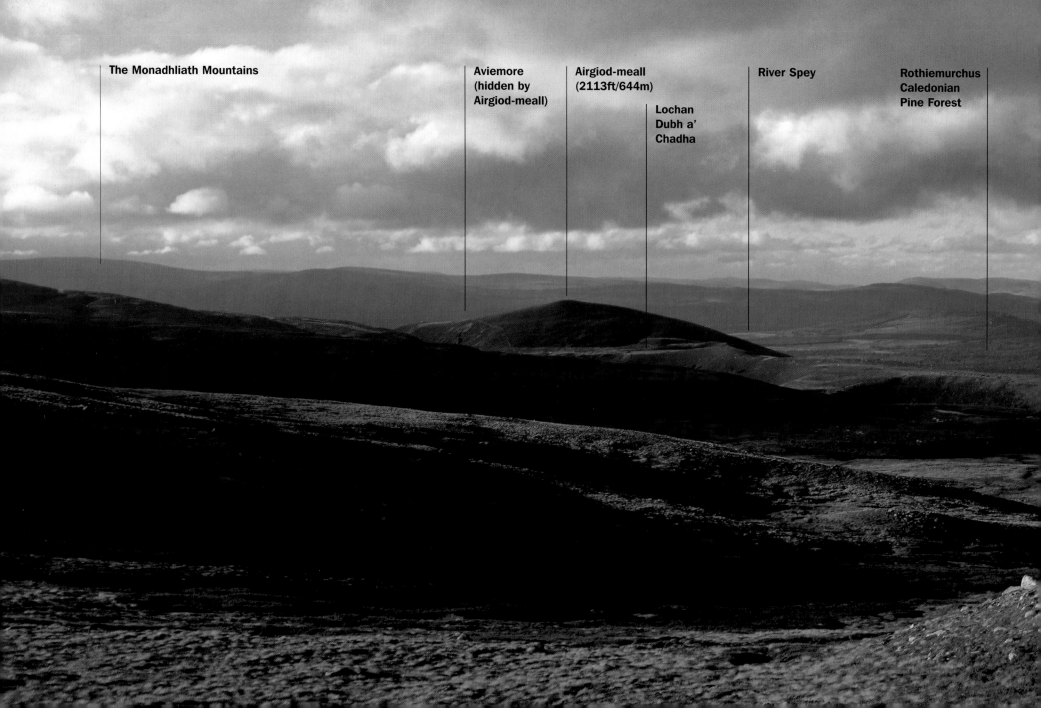

The Monadhliath Mountains

Aviemore
(hidden by
Airgiod-meall)

Airgiod-meall
(2113ft/644m)

Lochan
Dubh a'
Chadha

River Spey

Rothiemurchus
Caledonian
Pine Forest

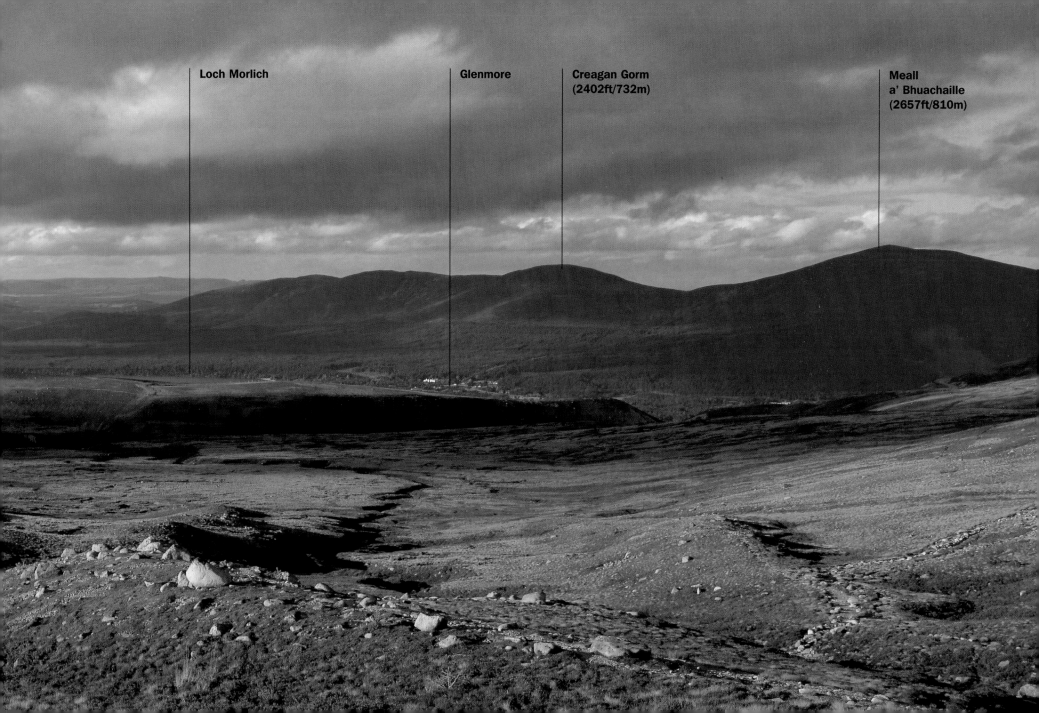

Loch Morlich

Glenmore

Creagan Gorm
(2402ft/732m)

Meall
a' Bhuachaille
(2657ft/810m)

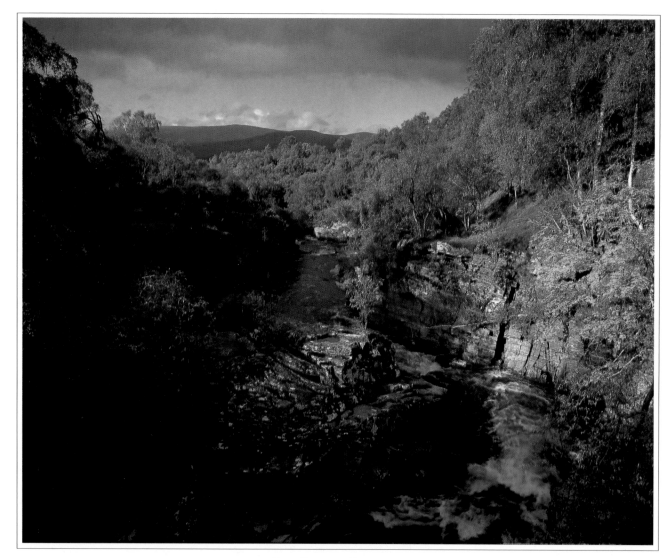

RIVER TROMIE AT DRUMGUISH

sub-arctic, much like that of modern Scandinavia, and with vegetation to match. Small, stunted trees – birch and willow – would have colonized the thin gravelly soil with other classic plants of the arctic tundra, including mosses and juniper. In time, and with further mellowing of the climate, this burgeoned into a full-scale forest that was dominated by Scots pine – the so-called Forest of Caledon, or Great Wood. By the time the first hunter-gatherers put in an appearance about eight thousand years ago, the trees had extended to cover all but the highest mountaintops.

At its peak, the pine forest covered more than three million acres and supported significant populations of brown bears, lynx, elk, wild boar and wolves. Where, then, did it all go? The first major blows were struck by the Vikings in the west, where they began to burn the forest and fell timber for their ships. The brown bears, deprived of solitude and habitat, were gone by the tenth century. The damage was increased by later clan chiefs, who cut and sold timber to English iron-smelters, and by the eighteenth century the great forest was all but reduced to moorland. Even the wolf – the most tenacious of the larger forest animals – gave up the struggle. The last one was killed in Inverness-shire in 1743, three years before the Scots' attempt to win the British crown for their own lone

IN THE AUTUMN OF ITS YEARS – HOUSE AT WHITEWELL

wolf – Prince Charles Edward Stuart, 'Bonnie Prince Charlie' – came to grief at Culloden.

This was the age of the Highland clearances, when the great landowners decided they had better things to do with their property than let smallholders grow potatoes on it. Instead of a Jacobite king, the Highlands got sheep. The sheep needed land, and the pace of forest clearance accelerated, with grazing animals putting paid to any new tree seedlings that pushed their heads above the soot-blackened earth.

Worse was to come. After the sheep came the great Victorian sporting estates, and with them that ultimate destroyer of growing timber, the red deer.

The needs of two world wars and the bad old days of the Forestry Commission, when anything that grew straight and tall was rendered into telegraph poles or railway sleepers, reduced the Great Wood to a number of tiny remnants – at Rannoch, Glen Affric and elsewhere – like half-forgotten scraps in the national attic. Nowadays, attempts are being made to conserve what remains – even, in some places, to regenerate it – but it cannot be imagined that the Highland landscape, its thin soils eroded through deforestation, will ever recover its original, primeval character. Nor, it must be admitted, would many of its visitors now want it to.

The irony is the same as with all the great upland wilderness areas. What we most value and admire for its 'naturalness' is, in the form in which it meets the eye, an accidental by-product of human hunger, competitiveness and greed.

The panoramic photograph is taken from the Northern Corries, on the western slopes of Cairn Gorm itself, looking approximately north-east towards the Glenmore Forest Park and Loch Morlich. The small mountain in the middle ground is Airgiod-meall (2113ft/644m) with the Lochan Dubh a' Chadha

at its foot. In winter this is skiing country. Beyond Loch Morlich, on the banks of the River Spey, stands Aviemore, Scotland's principal ski resort. A short distance from where the photographer stands, to the north-west, are the ski-tows and chairlifts of the ski centre, which in the season bring skiers right up to the Ptarmigan Restaurant – at 3,600 feet, only 484 feet below the Cairn Gorm summit (4084ft/1245m).

Looming to the south is the 3400ft (1309m) hulk of Ben Macdui, Britain's second highest mountain. Its only superior, Ben Nevis (4406ft/1343m), stands, a magnet for cloud, at the head of the Great Glen to the west.

The trees which can be seen around Loch Morlich are within the Forestry Commission's Glenmore Forest Park – mostly commercial conifers, but with a surviving, and now gradually spreading, fragment of the Great Wood. There is a car park and visitor centre on the north shore of the loch, which is heavily used for watersports. The entire area is well supplied with footpaths, both at the loch and around the ski centre and Cairn Gorm summit.

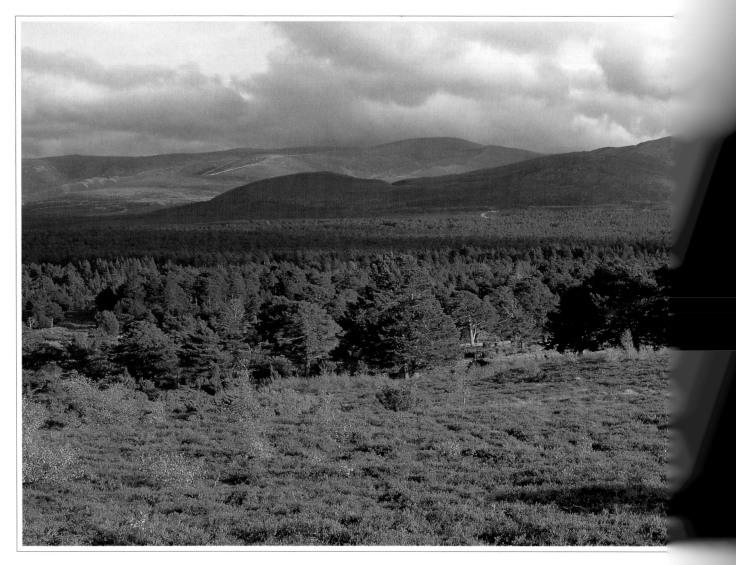

FROM WHITEWELL TOWARDS CARN EILRIG

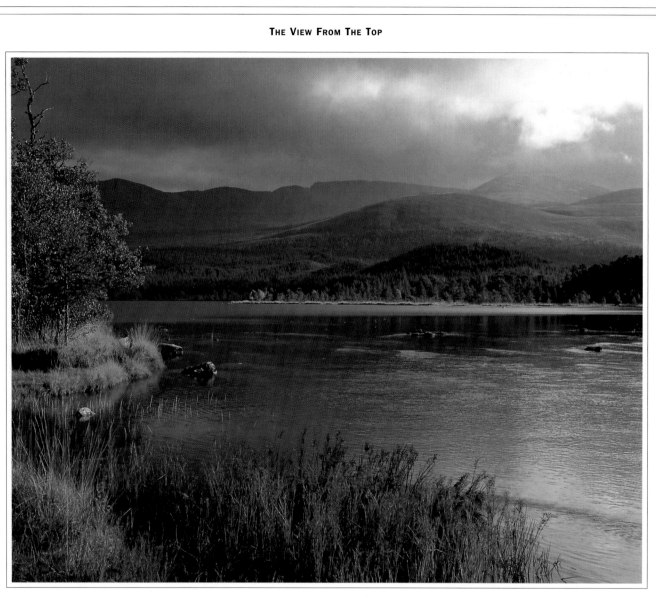

THE FOREST AROUND LOCH MORLICH CONTAINS A FRAGMENT OF THE GREAT WOOD

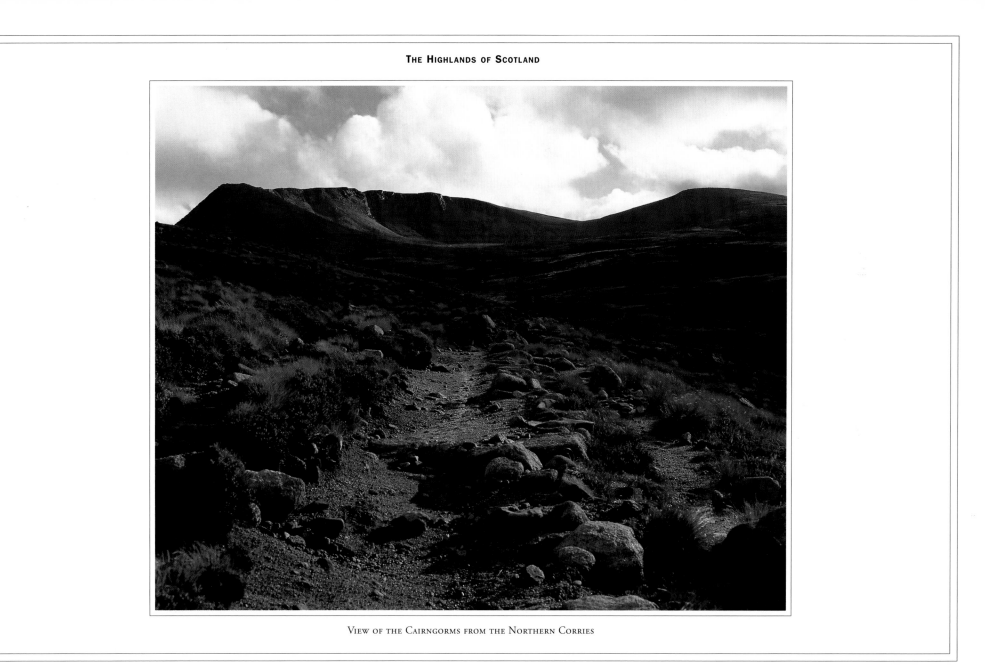

VIEW OF THE CAIRNGORMS FROM THE NORTHERN CORRIES

THE ISLE OF SKYE
Elgol and the Black Cuillins

S KYE EXISTS AS a kind of world centre of Scottishness. It is, indeed, from all over the world that Macleods and Macdonalds – descendants of feuding clansmen dispossessed by the Highland clearances – return with their Australian, New Zealand or American accents to inquire for their Jacobite roots.

What they find is infinitely closer to the world of their forefathers than it is to the lands of their birth. Gaelic is still spoken here, and not only by the elderly. Whisky is distilled, the Sabbath observed and sins condemned. The pleasures, and the perils, are elemental.

Skye's origins are every bit as violent as its history. To get here, assuming you have approached by way of the Scottish mainland and not 'over the sea' from the Outer Hebrides (which is what the song means), you have already crossed one of the classics of the geology textbooks, the Moine Thrust. This line, which bites off the south-easternmost tip of the island and extends across the north-west corner of the mainland to Loch Eriboll just east of Cape Wrath, represents the edge of an enormous chunk of the earth's crust which has been driven bodily upward over another.

It puzzled geologists until late in the nineteenth century. Why was it that the rock formations along

THE HAMLET OF ELGOL IS ON THE EASTERN SIDE OF LOCH SCAVAIG, APPROACHED BY THE A881 FROM BROADFORD (ABOUT 15 MILES). THE PANORAMIC VIEW (OVERLEAF) IS FROM THE SHORE BELOW THE HAMLET, LOOKING APPROXIMATELY NORTH-WEST TOWARDS THE CUILLINS.

this line appeared to be upside down, with the oldest strata on top instead of at the bottom? It was in resolving this anomaly that they first identified a phenomenon which is now one of the staples of structural geology, the 'thrust fault'. Like a collision between juggernauts, the impact is so enormous that the very skin of the earth is bent back on itself.

Immediately to the west of the Moine Thrust, where sandstone peaks rise from ice-scarred gneiss, lies the oldest landscape in the British Isles, while to the east, composing the bulk of the northern mainland, are mountains made up of what was once merely sand or mud, metamorphosed by heat and pressure into flaky schists. The south-eastern tip of the Isle of Skye, adjacent to the fault, is ancient sandstone. The rest of the island, however, is something else.

You get a hint of it almost immediately. On the long, hilly A881 (B8083 on older maps) from Broadford to Elgol – a drive no sensible visitor to the island will deny himself – the landscape shifts almost kaleidoscopically, rearranging itself with every bend in the road. As you approach Loch Slapin you confront what you could easily believe must be the most majestic view on the island, the sharkfin ridge of Bla Bheinn (in English guidebooks often called Blaven), Garbh Bheinn and Sgurr nan Each. It whirls behind you, vanishes, comes again – and then, this . . .

Symbolically and appropriately, the road goes no further than the village of Elgol, on the eastern shore of Loch Scavaig, where there appears across the water this immense spectacle of the distant Cuillin Hills. The photograph is taken from a point just north of the village, looking north-north-west to the peak of

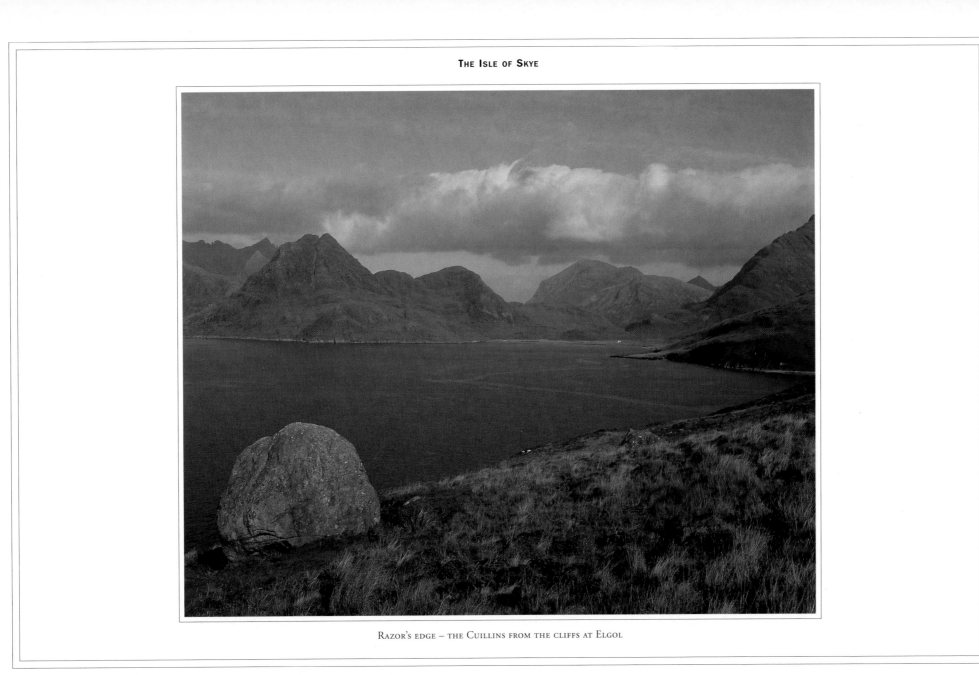

RAZOR'S EDGE – THE CUILLINS FROM THE CLIFFS AT ELGOL

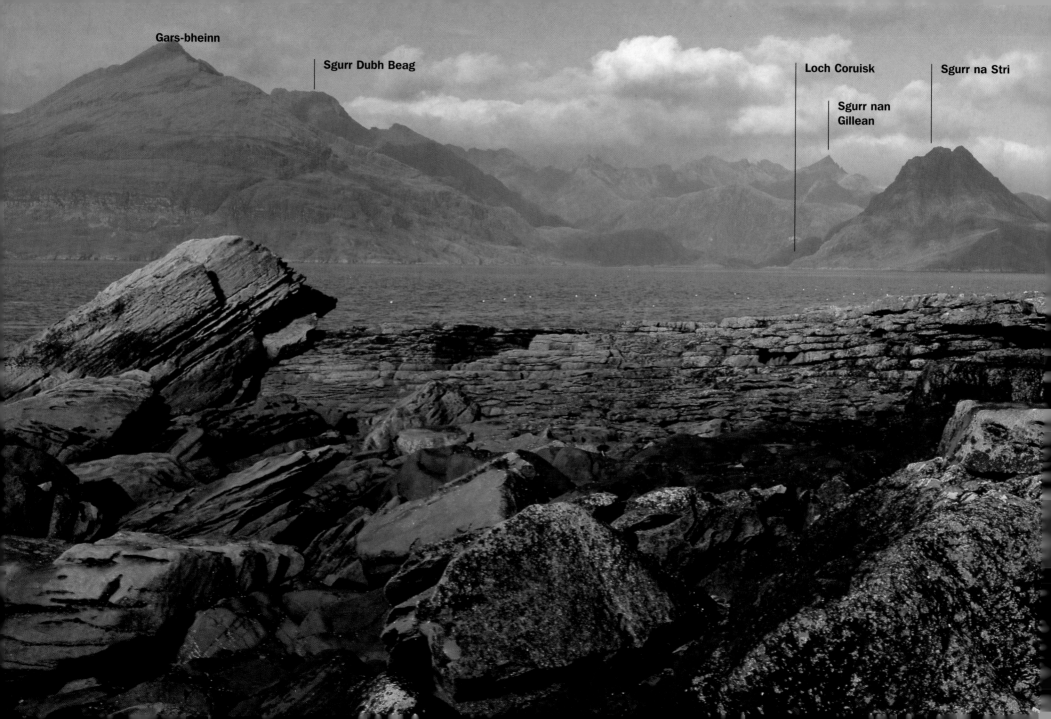

Gars-bheinn

Sgurr Dubh Beag

Loch Coruisk

Sgurr na Stri

Sgurr nan
Gillean

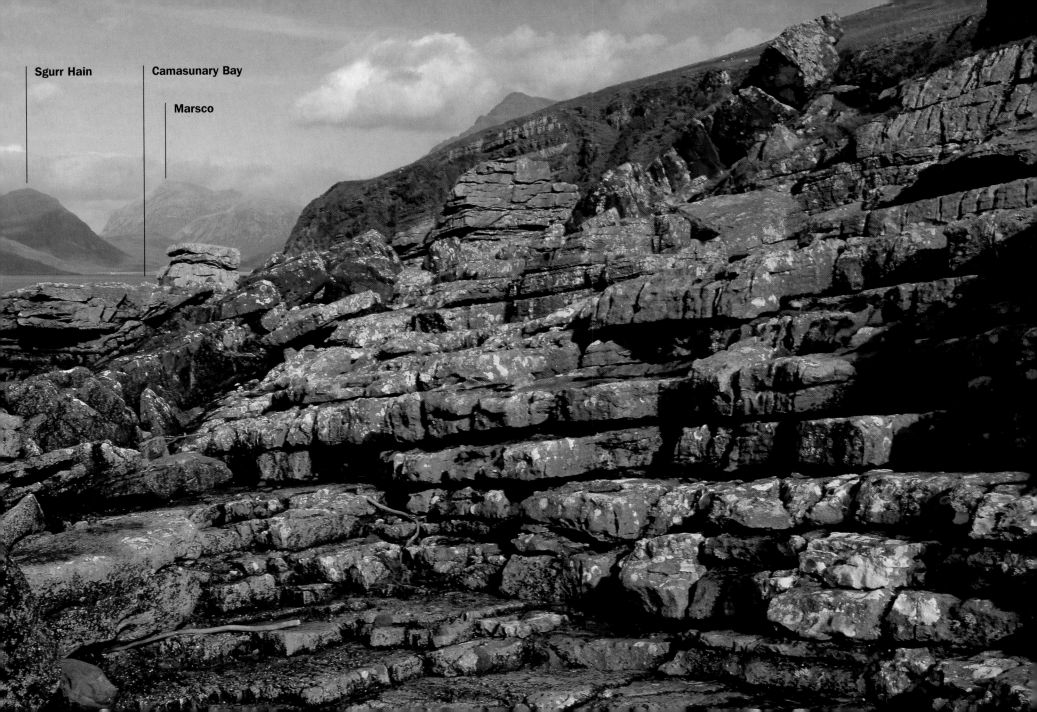

Sgurr Hain

Camasunary Bay

Marsco

Sgurr na Stri with the main Cuillin ridge beyond. *Sgurr*, a recurrent component of mountain names in Skye, is the Gaelic word for 'sharp rock' or 'rugged mountain', and is not bestowed without just cause.

The mountain photographer W. A. Poucher once believably described this as one of the finest views in the world. In geological terms, and by local standards, however, it is not an ancient one. It was only 60 million years ago that a huge series of volcanic eruptions belched out a stream of basaltic magma – much of it still hidden beneath the sea – which hardened into Antrim, Mull and northern Skye. The saw-toothed outline of the Cuillins is the result of basaltic dykes seeping between layers of harder black gabbro and then weathering away. The range contains eleven peaks over 3000 feet, and the seven-mile traverse of the ridge is reckoned to be one of the best days out for mountaineers in Britain.

Heed the word 'mountaineers', however. There are one or two places where the Cuillins may be flirted with on foot (Glen Brittle or Sligachan, for instance) but the ascents are hard going, over massive screes, and the ridge no place for an afternoon stroll. In many places the drops on either side are sheer.

Behind Sgurr na Stri, like a still black moat against the stark rock walls of the Cuillins, is another of Skye's most weird and haunting places – Loch Coruisk.

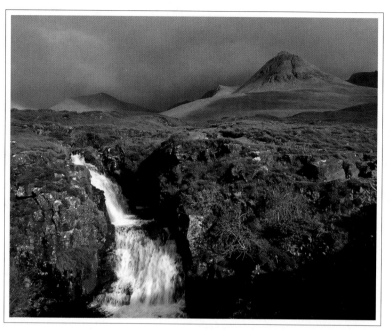

CUILLIN STREAM – WATERFALL AT GLENBRITTLE

This, too, is a prime exhibit from the geology textbooks – a rock-basin lake in a two-mile glacial trough, scoured and deepened by the grinding of ice on rock. The silence here presses down like a weight, each human sound a seeming violation of nature's intent. Everywhere in the Cuillins, and nowhere more than here, you have the sensation of being prey to hidden eyes.

In the season, you may take a 45-minute boat trip from Elgol to the Scavaig shore within a half-mile walk of Coruisk (notice, as you go, Elgol village school, built right on the shore of the loch). 'Bonnie Prince Charlie sailed from here' is as popular a refrain in the Highlands as 'Queen Victoria slept here' is further south. 'Over the sea to Skye', however, was his route both in and out of the Highlands (in retreat, he was famously smuggled to Skye from Benbecula by Flora Macdonald, disguised as her maid), and Elgol is recorded as one of his points of embarkation.

His accidental legacy is all around you – quietness, emptiness, ruined and deserted 'townships' (the local name for what in fact were little more than hamlets). The islanders' reward for their support of the Jacobite Risings was the same as it was throughout the Highlands – the virtual obliteration of their cultural identity. After Culloden in 1746, the English government banned Highlanders not only from possessing weapons but also from playing the bagpipes or – unless they joined an English regiment – wearing tartan. The new laws, coupled with the Highland clearances, put an end to the clan system and coincidentally placed emigrant Scotsmen among the vanguard of New World settlers. In neighbouring Raasay, which sent a hundred men in vain support of the Prince at Culloden, the English revenge extended to destroying all the houses and boats, and killing all the animals.

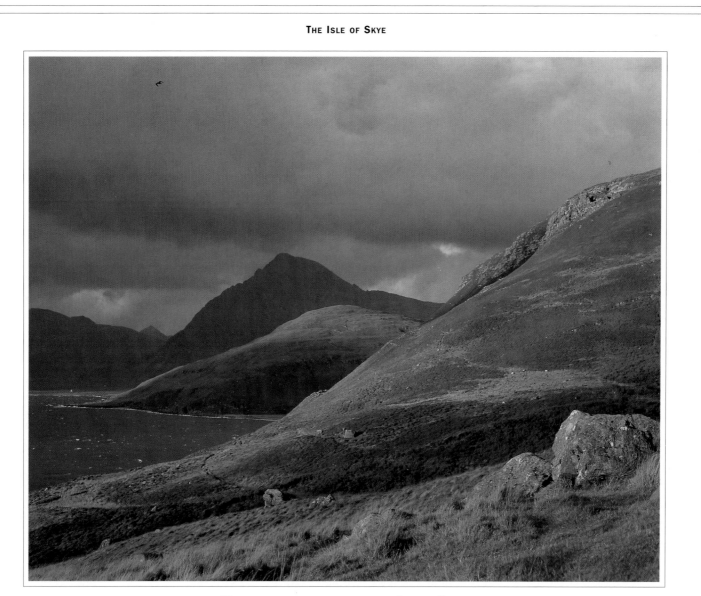

'ONE OF THE FINEST VIEWS IN THE WORLD' – FROM ELGOL

Despite this, the population of Skye did not reach its peak of 23,000 until 1840, but these days the ten thousand permanent residents are easily outnumbered by summer visitors. Some 1800 crofts still survive, though few if any of them are self-sufficient and are run by their owners more as sidelines than as principal sources of income. The main industries are fishing, particularly for lobster and crab, agriculture and, increasingly and overwhelmingly, tourism – a trend which can only be accelerated by the biggest development in the island's modern history, the opening of the toll bridge from Kyle of Lochalsh.

ABOVE: HONEYCOMBED CLIFFS AT ELGOL
RIGHT: THE CUILLINS FROM SLIGACHAN
OVERLEAF: THE SHORE AT ELGOL

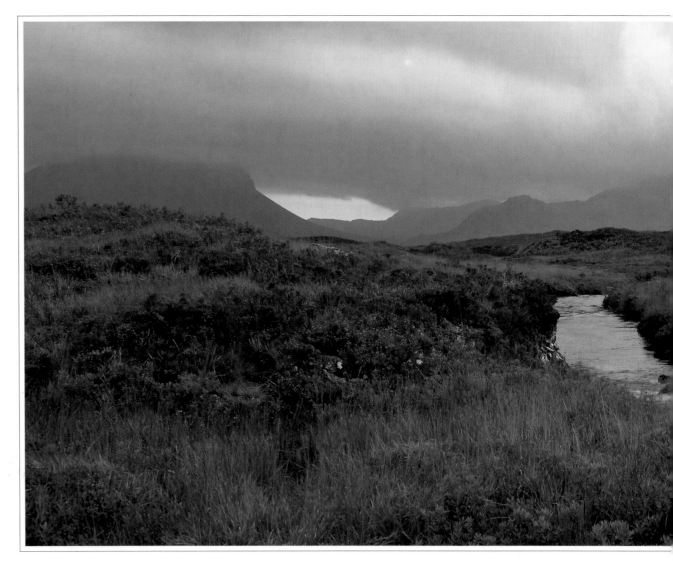

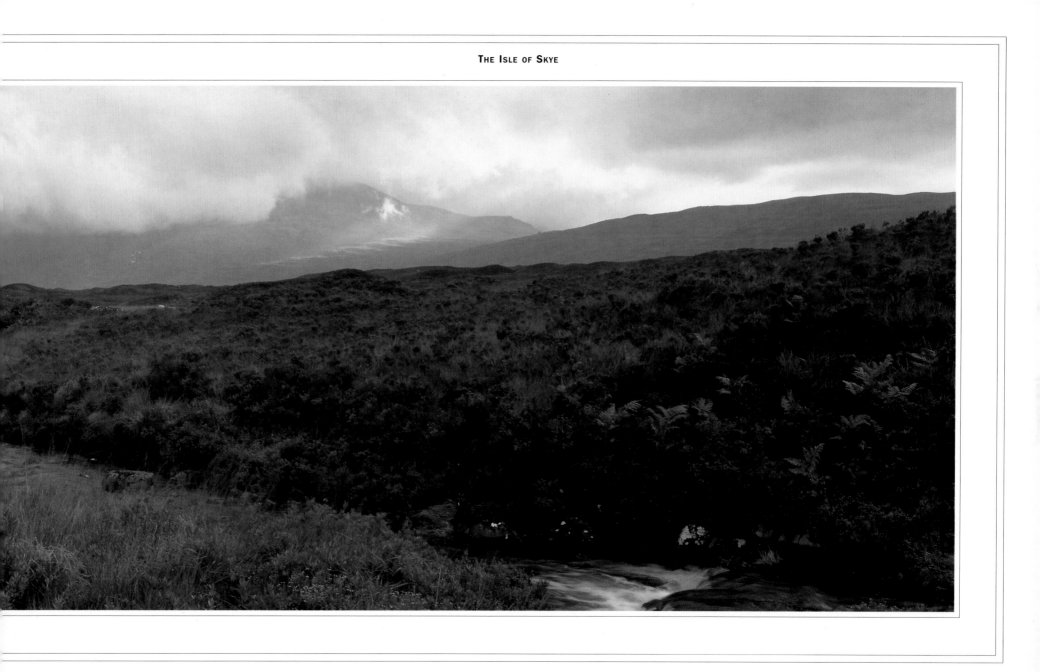

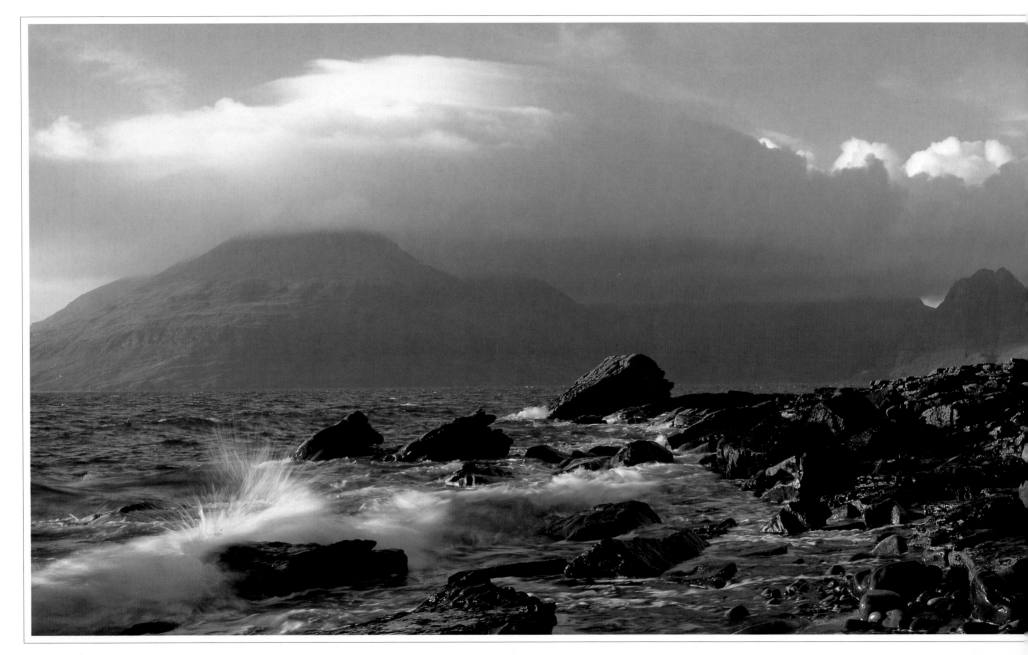

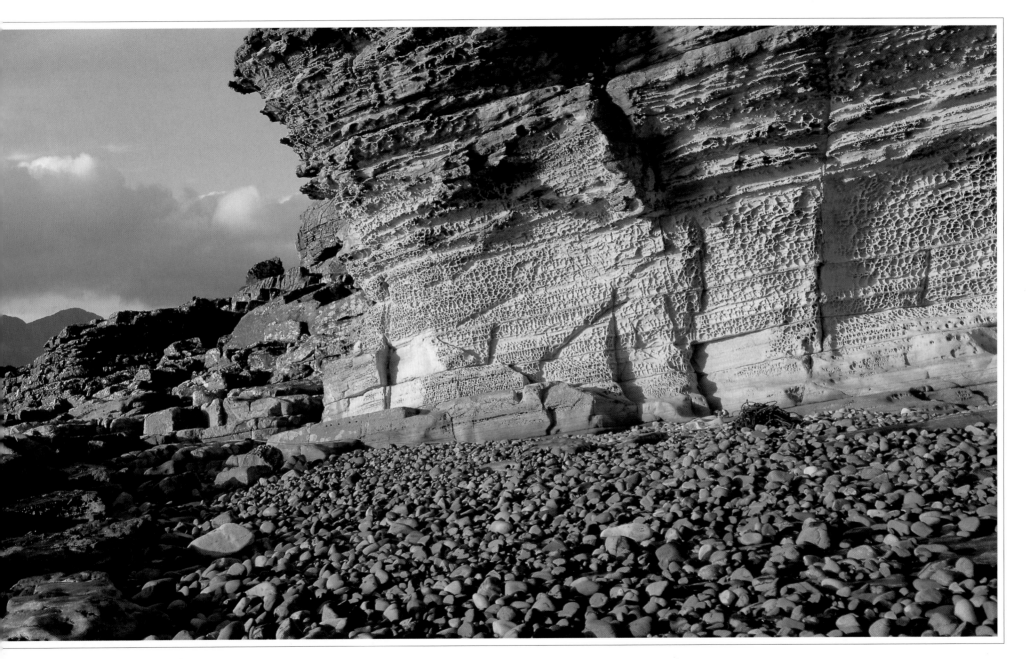

THE NORTH YORK MOORS
Farndale

THE VIEW OF FARNDALE OVERLEAF WAS TAKEN FROM THE NORTH END OF BLAKEY RIDGE. THE ROAD ALONG THE RIDGE MAY BE FOLLOWED FROM HUTTON-LE-HOLE IN THE SOUTH, OR CASTLETON IN THE NORTH. THE VIEW IS FROM A POINT CLOSE TO THE JUNCTION WITH THE STEEP ROAD DOWN TO THE HAMLET OF CHURCH HOUSES.

IF YOU HAD a time-lapse camera set to intervals of 50 million years or so, most landscapes would look less like solid ground than heaving seas. For most of its existence, indeed, the one in the panorama overleaf *was* a heaving sea.

In terms of longevity among Britain's national parks, the rocks of the North York Moors – those that you can see, at least – are scarcely out of their infancy. At the beginning of the Jurassic period, 210 million years ago, the hills and valleys were just beginning to take substance, if not actually shape, as layers of sediment on the seabed. Under pressure, these would later harden and become the grey shales known as 'Lias' – a word which may have come from the Gaelic *leac*, meaning flat stone, but which some lexicographers suggest has reached us from the Old French *liois*, meaning lees, or dregs. This may have to do with the Lias's fairly unprepossessing appearance, or perhaps more likely with its role in the geological hierarchy – that is, rock bottom.

A layer of ferrous limestone (of which more later) came next, after which the whole aspect of the North York Moors underwent something of a sea change. It stopped being an ocean for a while, and became instead an enormous freshwater delta through which Scandinavia poured its rivers into the sea, sending with them vast deposits of sand, mud and silt. These, too, laid themselves down on top of the Lias. These, too, would have their part to play in Yorkshire's future.

Four more times the sea invaded, each time putting down new layers on top of the old – limestone first, then more sandstone, clay and, finally, chalk.

About 60 million years ago the entire multi-layered confection got caught up in the turbulence that was wrenching Europe into new and distorted shapes. Right across the continent, vast new mountain ranges were being pushed up, snapping and bending the strata into shapes and sequences that would at first confound geologists and then, when all the twists and turns were unknotted, solidify their thinking.

Beneath the water, the infant North York Moors were buckling too. When they stopped, they were scoured and flattened again by the sea; then, finally, the monster was wrenched and forced upward by continued movement of the crust until, inch by inch, it arose dripping from the sea.

Water draining from the top – the so-called Cleveland Dome – gradually created the first landscape feature that can be identified on modern maps, the chevron pattern of valleys or 'dales' (this is, after all, Yorkshire) which gives the moorland its unique character. The streams at first cut deep, V-shaped valleys, which were later widened and hollowed by the action of springs – a process known as 'sapping' – when the water cut through the younger rocks on its way down into the Lias.

Glaciers, wind and rain meanwhile stripped away the chalk topping to reveal, in the southern part of the

126

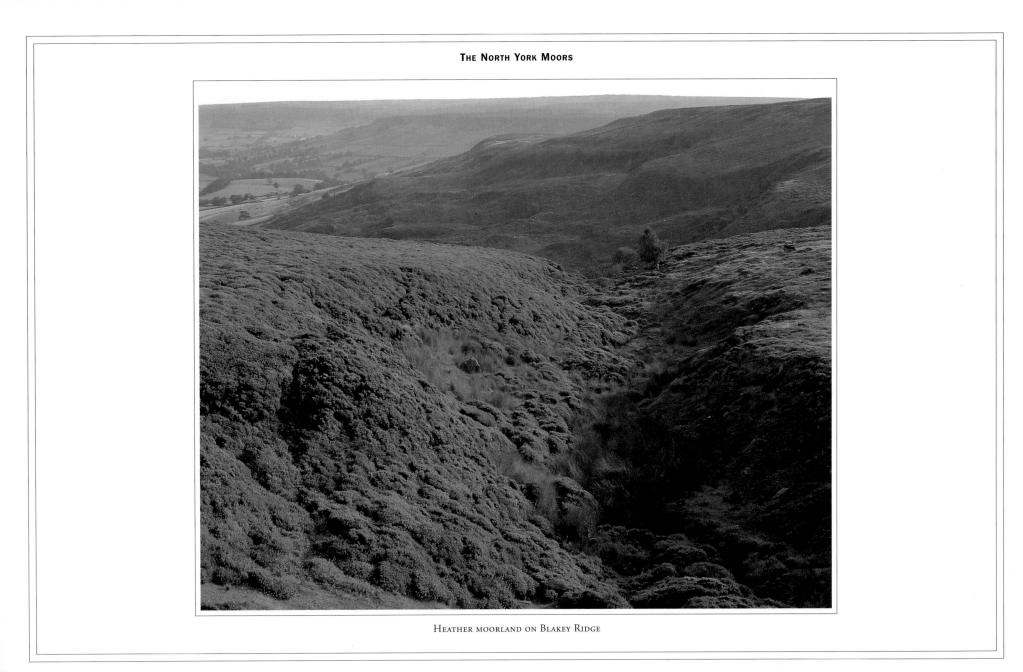

HEATHER MOORLAND ON BLAKEY RIDGE

Heather moorland on Blakey Ridge. The rocks at the top of the valley are mainly sandstones, formed from sand, mud and silt laid down by Scandinavian rivers

Farndale. The rocks on the sides and floor of the valley are the three generations of Lias formed when the area was flooded by tropical seas

Rudland Rigg

Scattered remains of broadleaved woodland on the valley floor

Improved grassland, or pasture, covers most of the valley bottom and sides. The valley roads follow the traditional route halfway up the slope, tracing the contour that divides the pasture below from the rough grazing above

High Blakey Moor

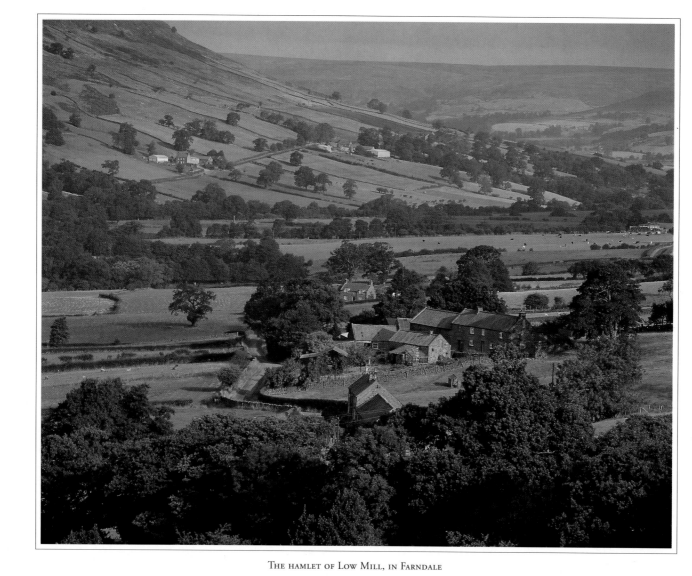

THE HAMLET OF LOW MILL, IN FARNDALE

FOR SEVEN CENTURIES THE MOORS HAVE BEEN SHAPED BY, AND FOR, SHEEP

moor, table-topped hills of limestone and grit, while in the north – the land of the chevron valleys – erosion laid bare the one-time Scandinavian effluvium of sands and silts, now hardened into sandstone. It is here that our panoramic photograph was taken, within walking distance of the Cleveland Dome itself, from Blakey Ridge looking north-west across the nose of Farndale Moor into Farndale.

On a geological map, Farndale is like a knife wound, plunged through the delta sandstones, right down through the Upper and Middle Lias to the Lower Lias where, 210 million years ago, the story began. Its shape was bestowed by meltwater at the end of the last Ice Age.

The story is, of course, not over yet – and nor will it ever be. For as long as rain continues to fall, for as long as water continues to freeze and wind continues to blow, the erosion and reshaping of the moors will continue too. This, however, was roughly the shape of the land which the dinosaurs roamed, and which made a home for later populations of elephant, rhinoceros, lion, hippopotamus, hyena – and, some ten thousand years ago, man. His career here is typical of British uplands, having begun when

THE HAMLET OF CHURCH HOUSES, BELOW BLAKEY RIDGE

he tracked his prey animals into the wooded hills and stayed to hunt and gather food.

He soon realized the value of burning to make clearings, open the tree canopy and create space for animals to breed. Agriculture arrived first in the west and south of the area, in about 3000 BC, and by the height of the Bronze Age – around 2000 BC – it had

spread into the northern hills. It is Bronze Age man who bears responsibility for much of what we see today. He it was who finished off most of the remaining trees, established settlement patterns across the moors and, many people think, laid down clan boundaries which still survive to define the moorland parishes. By Roman times, the extent of woodland cover was very similar to what we find today.

The word 'Howe', which you will see frequently as a component of placenames on the map, derives from the Old Norse for burial mound or 'barrow'. The mounds in question, however, long pre-date any Nordic involvement in the area. They, too, are of the Bronze Age. There are more than three thousand of them scattered throughout the moors, within which the cremated remains of clan chieftains were placed in burial urns.

Iron Age farmers followed Bronze. The Romans came and went, to be replaced by the Angles, Saxons and Danes. Many of the moorland settlements owe their origins to the Saxons (any village suffixed by -ton or -ham is likely to be Saxon), though the farmed landscape has evolved, through subsequent sales and tenancies, from the huge Norman estates that were

established here after 1066. The toughness of the environment is emphasized in the survivals from Norse – *beck* for stream, *rigg* for ridge.

Aside from its landscape, one of the greatest touristic attractions of the North York Moors is its monastic ruins – in particular, Rievaulx and Byland Abbeys, and the priories of Mount Grace and Guisborough. It was these monastic communities that took the next decisive step, in the thirteenth and fourteenth centuries, when they improved the uplands for the convenience of their burgeoning flocks of sheep.

The sheep, of course, are still here, having outlasted the monasteries by more than four hundred years. You will still see some Scottish Blackface, though the favoured breed now is overwhelmingly the Swaledale. Vast areas of heather moorland are managed for their benefit, and for the convenience of that other moorland cash crop, the red grouse. On rambles across the moor you may find areas of burned heather, and low stone walls, arranged roughly in the shape of an H, which are neither enclosures nor relics of old buildings. The burning is to encourage new heather growth for the birds; the walls are butts for shooters.

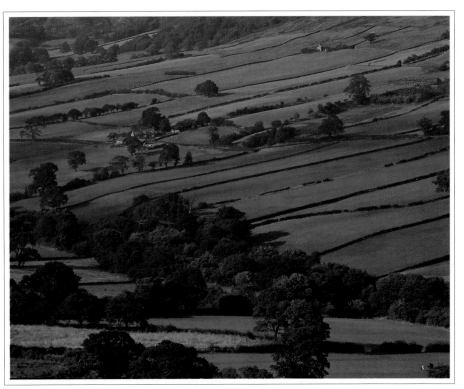

THE EASTERN FLANK OF FARNDALE

Farndale itself offers the twin pleasures of the moorland valley – extreme remoteness combined with a comforting sense of enclosure. It contains three hamlets and a scattering of farmsteads built in local stone. Geology is the architect throughout the North York Moors, and it colours the buildings accordingly: honey-brown or grey limestone in the south, brown sandstone here in the north.

Like Dartmoor, the North York Moors – in their wind-whipped savagery or bucolic indolence, depending on how you catch them – conceal a recent past of improbable grime and industry. Not all the mounds you see on the ridges date from the Bronze Age. Some are less than a hundred years old – not burial mounds at all, but spoil heaps. In deep moorland, along the ridges and in the valleys, even around the rim of Farndale, you will also find the relics of railways and tramways. They are all there for the same reason – the ferrous limestone that was laid down on top of the Lias in the Jurassic.

It is in Farndale's immediate neighbour, Rosedale (it shares the party wall of Blakey Ridge), that the evidence of the North York Moors' industrial past is most clearly displayed. Iron was mined here in the Iron Age, and again in medieval times, though its great age of prosperity belonged to the Victorians. Mining restarted here in 1851, and at one time supported a population of nearly 5000. The bankruptcy of the principal mine-owners caused a rapid decline in the 1880s but it was not until 1926 – the year of the General Strike – that the Rosedale East mines closed down altogether.

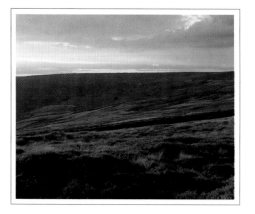

The most spectacular relics – sometimes compared to ancient temples – are the brick-built calcinating kilns in which the ironstone was 'roasted' to burn off moisture and reduce its weight before it was hauled by rail to the Teesside blast furnaces. The railway itself is now a scenic footpath.

In the Liassic depths of Farndale, however, the local scenic attraction is of a different kind altogether. Every spring, for mile after mile along the banks of the River Dove, the wet pastureland, the one-time seabed, is an ocean of wild daffodils.

ABOVE: FARNDALE AT DUSK
RIGHT: BLAKEY RIDGE FROM BLAKEY GILL

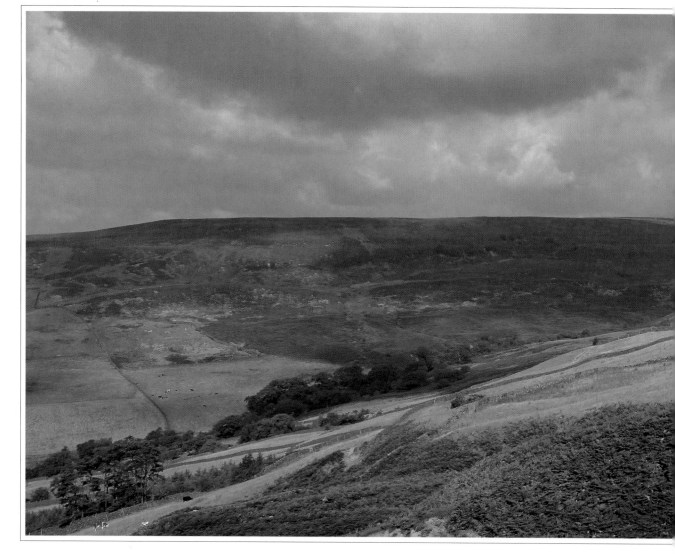

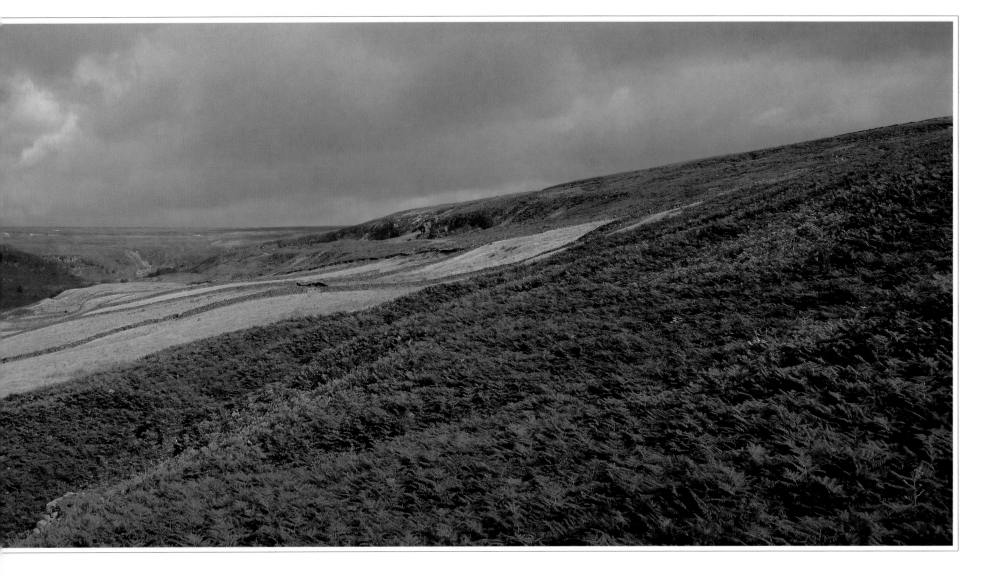

THE BLACK MOUNTAINS
The Twmpa

THE BLACK MOUNTAINS are great deceivers. Their smooth, grassy profiles and level ridges could make you think of chalk country. Scarps and dip-slopes are nowhere more classically defined. You might think you were in the South Downs.

But this is emphatically not chalk, and just as emphatically lacking in southern gentleness. The rock is Old Red Sandstone – the colour of ploughed fields will show you that deep down it is true to its name – and, for all their greenness, these are proper mountains, not downs, with ridge heights of well over 2000 feet.

Nomenclature here is important in more ways than one. The Black Mountains fall within the area of the Brecon Beacons National Park, which serves up its mountains in three distinct portions. The Black Mountains form a wall against the English border to the east; the Brecon Beacons fill the centre of the range, and, confusingly, the Black *Mountain* – a barer, stonier hulk than its plural namesake – occupies the west of the park and slides away towards the South Wales coalfields.

The highest point in South Wales, at 2,907ft (886m), is the summit of Pen y Fan in the Brecon Beacons themselves. But the Black Mountains lose little by comparison. The straight, parallel valleys with

THE PANORAMIC VIEW (OVERLEAF) IS TAKEN FROM THE TWMPA, SOMETIMES KNOWN AS LORD HEREFORD'S KNOB, ONE OF TWO BLUFFS AT THE NORTHERN END OF THE GOSPEL PASS, ON THE MINOR ROAD FROM CAPEL-Y-FFIN TO HAY ON WYE. THE VIEW IS NORTHWARD, TOWARDS HAY.

their well-grassed flanks offer an extreme contrast to the smashed geological wreckage of Snowdonia. Superficially, the Gospel Pass (see the panoramic photograph overleaf) is as much like the Llanberis Pass (pages 46–7) as the Somerset Levels are like the Gobi Desert. But look at the area more carefully, peel away the softening cushion of grass and peat, and you

will begin to see a surprising number of parallels. Here is exactly the same pattern of U-shaped valleys and lakes, in a landscape fretted with innumerable rivers and streams. All were formed by exactly the same force that shaped Snowdonia: ice. The outline is softer only because the rock itself is softer, and smoother for the glaciers to carve.

The Black Mountains do not have Snowdonia's attraction for climbers, but they are paradise for walkers. The initial ascents to ridge-height may put a strain on the calf muscles, but the tops offer fast, level walking with the kind of views that compel you to reshuffle your ideas about scale and distance. The hazard is to be seduced by the easy-going into over-ambition. The weather can change its temper with vicious abruptness, and the ground underfoot is not always as solid as it looks. The rainfall is heavy, and on the peaty tops much of the ground is permanently sodden and boggy.

The range climaxes in the north with two huge bluffs – like East and West Grandstands – from which hundreds of square miles of landscape unfold like a badly crumpled map. These are the Twmpa (or Tumpa as it is sometimes given in English) and Hay Bluff, which together form the gateway to Gospel Pass. The panoramic photograph overleaf is taken

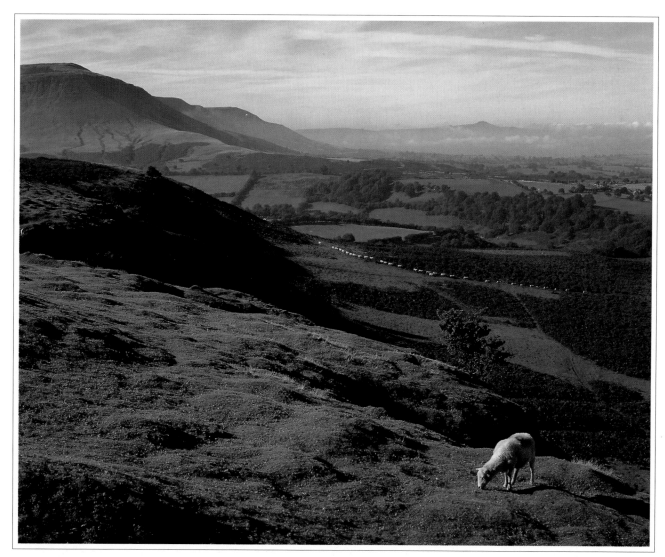

LOOKING WEST FROM THE TWMPA TOWARDS THE BRECON BEACONS

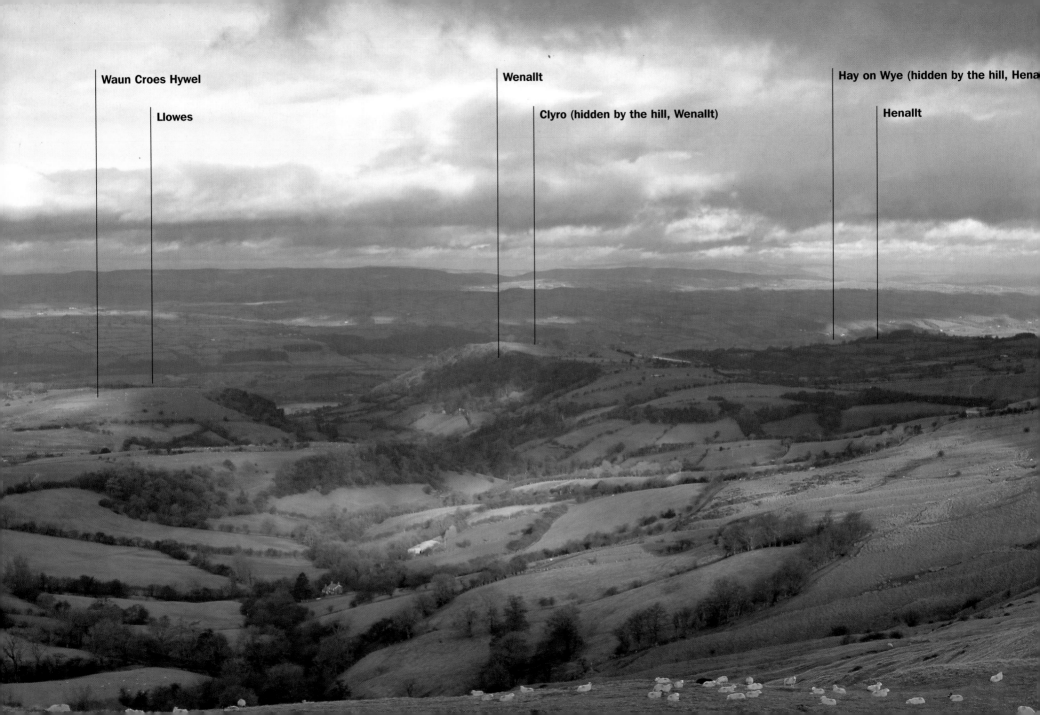

Waun Croes Hywel

Llowes

Wenallt

Clyro (hidden by the hill, Wenallt)

Hay on Wye (hidden by the hill, Hena

Henallt

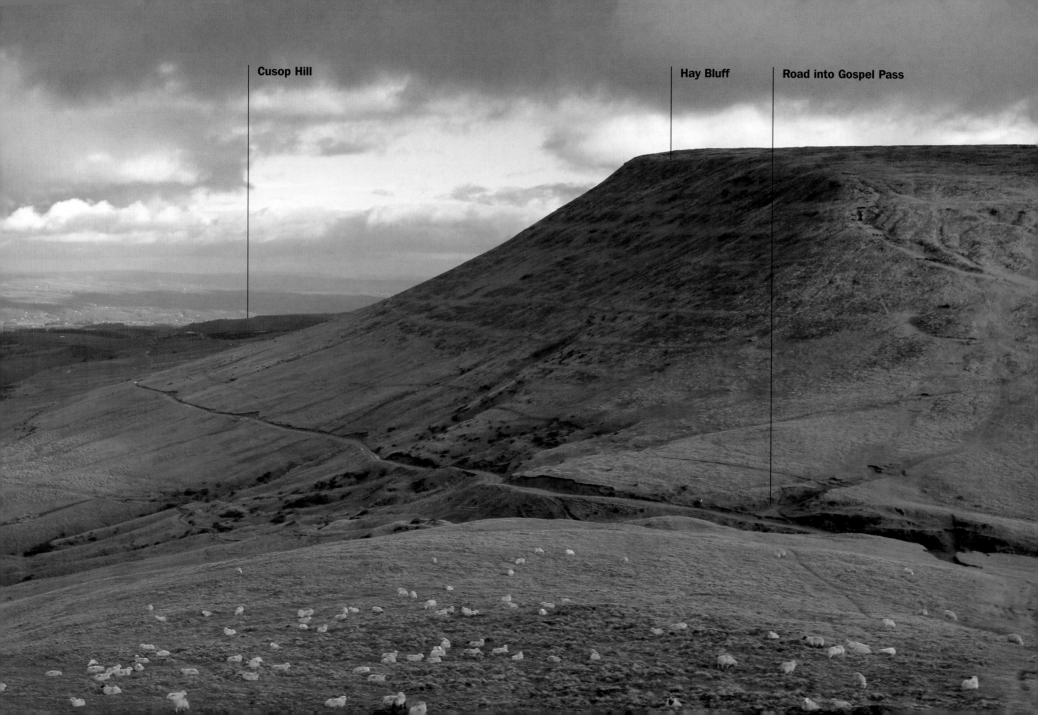

Cusop Hill

Hay Bluff

Road into Gospel Pass

The view from the Twmpa, looking north

from the Twmpa, with Hay Bluff the dominant feature in the view.

The picture looks approximately north across the Wye Valley to the hills of Mid Wales. To the east, hidden by Hay Bluff, is the soft pastoral scenery of Hereford and Worcester. To the west is the high drama of the Brecon Beacons themselves. If you blew a whistle, they'd hear you in England. The national border, which here both follows the route of Offa's Dyke Path (though not the dyke itself) and defines the boundary of the National Park, passes just beneath the summit of Hay Bluff on its eastern flank. Thence it scrambles steeply downhill to clip the edge of Hay on Wye, meanders across the Wye Valley and pursues it way northward in a series of violent, contour-hugging zigzags which were mostly defined during the reign of Offa, the eighth-century king of Mercia who built the famous dyke – a 12-foot ditch stretching (almost) from one end of Wales to the other. As it happens, Offa gave the dyke-builders a break in the Black Mountains: the great natural escarpment alone was enough.

Palaeolithic man may have roamed the hills after the last Ice Age, but he left no trace. Living so close to the wild, hunting and gathering only what nature provided, his touch on the landscape was always light. As ever, it was the farmers of the Neolithic, four to five thousand years ago, who began the process of shaping the landscape to human need. As ever, their first victims were the trees. Bronze and Iron Age cultures

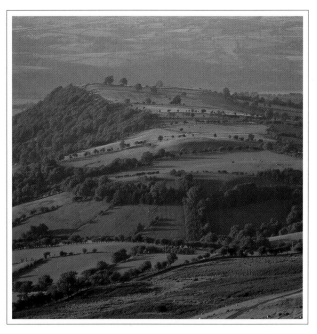

THE VIEW NORTH FROM HAY BLUFF

followed, each with its distinct pattern of burials, cairns and monuments. Standing stones and stone circles in the Brecon Beacons present exactly the same insoluble mysteries, and excite exactly the same rash of untestable theories, as they do in Wessex, Dartmoor and the Lake District. The best of the stone circles, dating from the second millennium BC, is Cerrig Duon, near Craig-y-nos.

The desirability of the landscape is shown by the ferocity with which its occupants were prepared to

defend it. Iron Age hillforts crowd the hilltops, uncompromising symbols of tribal jealousy, anxiety and power. What effect, if any, these fortifications had on the invading Romans is another of those tantalizing secrets which history is likely to keep to itself. That the Romans colonized Wales is true beyond doubt, but their grip in the Welsh highlands was nothing like as complete as their dominance of lowland England, and there is little to show that they left much of a mark on the Black Mountains. Much more obvious and lasting in their impact were the Normans, whose invasion a thousand years later locked the Marches within a ring of castles and laid down the patterns of settlement and farming which provide the framework of what we see today.

Near the centre of the picture is the border town of Hay on Wye (in Welsh, Y Gelli), built around the inevitable Norman castle. Its current boast, peculiar but not immodest, is that it has more second-hand books for sale than any other town in the world – a claim which no librarian so far has volunteered to check. Beyond Hay is the village of Clyro, fixed in Victorian social history – one might almost say soap opera – by *Kilvert's Diaries*, the journals of the Reverend Francis Kilvert who was curate here for seven years from 1865.

The River Wye and its birth twin the Severn have their beginnings only a few miles apart on the wooded high ground west of the beautiful Llyn (Lake) Clywedog, north-west of Llangurig. The Wye is one

of Britain's loveliest rivers, famous above all else for its extraordinary pattern of meanders as it winds its way towards the Severn estuary – seemingly so pleased with itself that it never wants its journey to end. Its progress south is through a visceral mass of coils, climaxed by the huge loop at Symond's Yat and the watchspring turn at Wynd Cliff near Chepstow where it enters a narrow, steep-sided gorge before its final, reluctant surrender to the sea.

High in the Mid Welsh hills, the Wye, like all cold young mountain streams, supports little natural life: small brown trout are about the only species with a taste for such spartan living. By the time it enters our picture near Hay, however, the river has gained both weight and mineral enrichment, and the trout have been supplanted by salmon and seething populations of coarse fish.

In the hills themselves – aside from the sheep – you are in bird country. The stars inevitably are the raptors for which Wales is famous – merlin, buzzard, hen harrier and, ranging a little further to the west, the red kite. The rare and cherished kite may be the ruby in Wales's avian crown, but one bird above all others has made the Welsh uplands its own – the raven. To hear this dark myth-monger croaking in the fog is as searching a test of nerve as most of us are ever likely to endure.

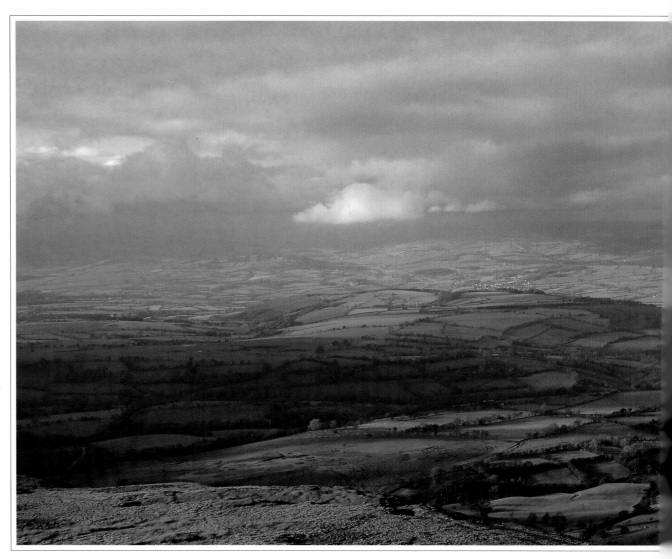

NORTH FROM THE TWMPA, ACROSS THE WYE VALLEY

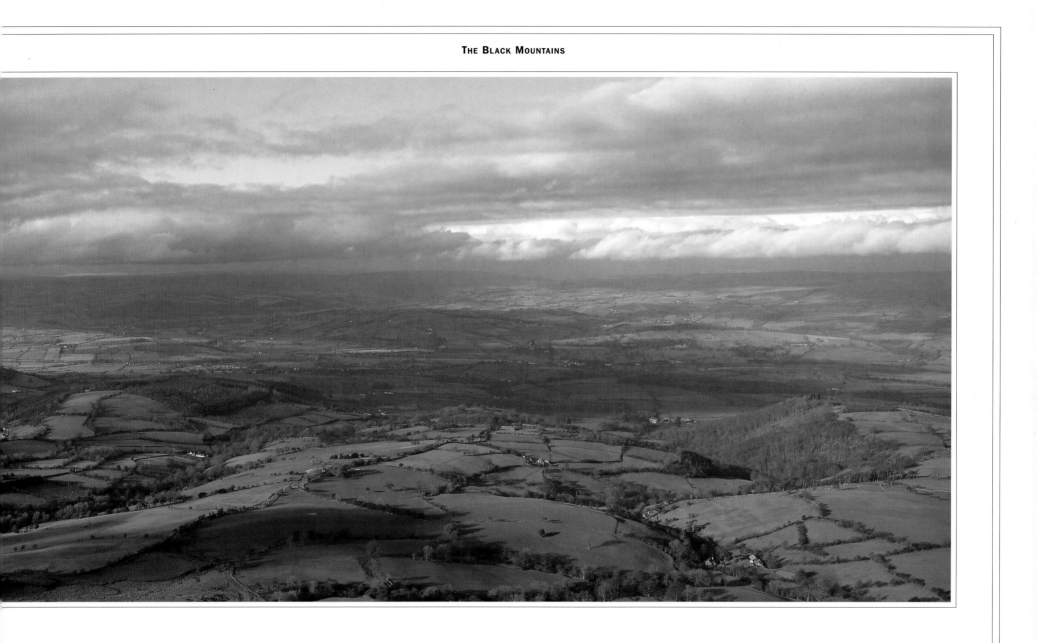

THE 100 BEST VIEWPOINTS IN BRITAIN...

...or, more correctly, one hundred *of* the best. This is a personal choice, based on personal experience. All, however, will give great pleasure, and all will open up important landscapes within which you will discover favourite views of your own. Good maps are essential. Use either Ordnance Survey sheets or the informative AA/Ordnance Survey Leisure Guides which are published for most of Britain's scenic areas, including all the National Parks.

CORNWALL
Kynance Cove, Lizard peninsula
The cliffs at Beeny, near Boscastle
The Rumps and Pentire Head, near Polzeath
The cliffs around Treryn Dinas and Porthcurno
Trencrom Hill, near St Ives

DEVON
North coast:
The cliffs of the Hartland peninsula
Dartmoor:
Hay Tor
Bench Tor, near Venford Reservoir, Holne
Hound Tor
Buckland Beacon
Bellever Tor
Honeybag Tor
Hameldown

Trendlebere Down
Hunter's Tor and Lustleigh Cleave
Kestor Rock, near Chagford

DORSET
Eggardon Hill, near Bridport
White Nothe, near Weymouth
Pilsdon Pen
Castle Hill, near Abbotsbury

SOMERSET
Burrow Mump, near Athelney
Exmoor:
Dunkery Beacon

WILTSHIRE
Hackpen Hill

THE SOUTH DOWNS
Ditchling Beacon
Clayton Windmills
Devil's Dyke

SURREY
Leith Hill

BERKSHIRE
Combe Gibbet, Inkpen Hill, near Hungerford

OXFORDSHIRE
Uffington Castle

BUCKINGHAMSHIRE
Ivinghoe Beacon

HEREFORDSHIRE
Symond's Yat

BRECON BEACONS AND MID WALES
The Twmpa
Mynydd Llangorse
Pen y Fan
Hergist Ridge
Whimble

NORTH WALES
Llanberis Pass
Mount Snowdon
Llyn Gwynant
Great Ormes Head, near Llandudno
Cadair Idris
The western tip of the Lleyn Peninsula

NORFOLK
Burgh Castle, near Great Yarmouth
Ranworth church tower, near Wroxham
Gazebo (viewing tower) at Sheringham Park, North Norfolk

PEAK DISTRICT
Mam Tor
Lose Hill
Win Hill
Holme Moss, near Holmfirth
Nab Head, near Bollington

YORKSHIRE DALES
Sharp Haw
Ingleborough
Dodd Fell
Great Shunner Fell
Askrigg Common, above Swaledale
Kisdon Hill
Hubberholme Wood, Wharfedale
The Howgill Fells
Pen-y-Ghent

NORTH YORK MOORS
Blakey Ridge, Farndale
Rosedale Head
Letter Gate Hills, near Fylingthorpe
Harwood Dale Moor
Beacon Hill, near Danby

LAKE DISTRICT
Langdale Pike
Skiddaw
Helvellyn
Sca Fell
Shap Fells
Friar's Crag, Keswick
Ashness ridge, Derwent Water
Loughrigg Terrace, Grasmere
Jenkin Crag, Windermere
Clappersgate, near Ambleside
Letterbarrow, near Gillbank
Yew Crag, Ullswater
Hallin Fell, Ullswater
Bowness Knott, Ennerdale Water
Grizedale
Birker Fell

NORTHUMBERLAND
Cuddy's Crags
Holy Island
Budle Bay
Harkess Rocks

NORTH PENNINES
High Cup Nick, near Appleby

HIGHLANDS
Cairn Gorm
Ben Macdui
Glencoe
Rannoch Moor
Carn Daimh, above Glenlivet and Strath Avon
Meall Ghiubhais, above Loch Maree
Inverfarigaig, above Loch Ness
Duncansby Head, near John O'Groats
Banavie
Glen Shiel
Mam Rattachan, above Loch Duich
The Loch Torridon road
Lochinver
Brodick, Isle of Arran
Elgol, Isle of Skye